The Upright Brush

THE
UPRIGHT
BRUSH

*Yan Zhenqing's Calligraphy
and Song Literati
Politics*

Amy McNair

University of Hawai'i Press
Honolulu

03 02 01 00 99 98 5 4 3 2 1

Library of Congress Cataloging-in-Publication Data
McNair, Amy.
 The upright brush : Yan Zhenqing's calligraphy and Song literati
politics / Amy McNair.
 p. cm.
 Originally presented as the author's thesis (Ph.D.—University of
Chicago, 1989) under the title: The politics of calligraphic style
in China.
 Includes bibliographical references and index.
 ISBN 0–8248–1922–5 (cloth : alk. paper). — ISBN 0–8248–2002–9
(paper : alk. paper)
 1. Yen, Chen-ch'ing, 709–785—Criticism and interpretation.
2. Calligraphy, Chinese—History—T'ang-Five dynasties, 618–960—
Political aspects. I. Yen, Chen-ch'ing, 709–785. II. Title.
NK3634.Y45M39 1998
745.6'19951'092—dc21 97–39661
 CIP

Book design by Kenneth Miyamoto

To my parents

Contents

.

List of Figures

Acknowledgments

THIS BOOK began as a dissertation written under the direction of Harrie A. Vanderstappen at the University of Chicago. My gratitude to Father Vanderstappen for serving as a model scholar, teacher, and man of God is too profound to express here properly. For support during my time at Chicago, thanks to the American Oriental Society for honoring me with the Louise Wallace Hackney Fellowship for the Study of Chinese Art in 1985–1986 and the Committee on Chinese Studies of the University of Chicago for granting me a fellowship in 1984–1985. I thank my friends and fellow students Margaret Chung and Stanley Murashige for spending long hours looking at Chinese ink rubbings with me in the storerooms of the Field Museum. The photographs of Field Museum ink rubbings were taken by Dr. Murashige.

My dissertation was written in San Diego, where I was sheltered by employment in the library of the University of California. For their kindness, I thank Dorothy Gregor, Marilyn Wilson, and Karen Cargille. This book was written at the University of Kansas, for which I am grateful to Marsha Weidner and the faculty of the Kress Foundation Department of Art History. Travel and writing time were supported by the Art History Faculty Travel Fund and the General Research Fund of the University of Kansas. For their helpful comments on the manuscript, I am grateful to Robert E. Harrist Jr. and Richard M. Barnhart. For their excellent editorial work, I thank Patricia Crosby, Don Yoder, and Masako Ikeda of the University of Hawai'i Press.

I would especially like to acknowledge my teachers in Chinese language and literature at the University of Washington and the University of Chicago: Paul L.-M. Serruys, William G. Boltz, Anthony Yu, and David Roy. I am particularly indebted to Esther Jacobson and Jerome Silbergeld, professors in the history of Chinese art at the University of Oregon and University of Washington. There are no better teachers than these. For encouragement and support, I owe the greatest debt to my dear friend Jay Yancey.

Introduction

FEW WHO STUDY Chinese calligraphy escape learning the style of Yan Zhenqing (709–785). This is true for those who study the history of Chinese calligraphy and for those who practice Chinese calligraphy with the brush. His style is taught today as a standard, and Chinese bookstores all over the world stock inexpensive reproductions of his famous works for sale as copybooks. What a westerner may find curious about this situation is that Yan Zhenqing's style cannot be called conventionally attractive. Upright, correct, severe, serious, and forceful are terms habitually applied to describe his style by traditional and modern critics, but rarely has it been called graceful or beautiful. Of course, the use of terms relating to human character in aesthetic criticism was a long-standing tradition even by Yan Zhenqing's day, but in his case there is a special pertinence to their use. This is because the popularity of the man's style is based as much on his reputation as a person as on the utility of his calligraphic manner.

If Yan Zhenqing's style is not beautiful, how did he earn such an eminent place in the history of calligraphy? That is the question I have set out to answer in this book. Simply put, Yan Zhenqing's prominent place was created by certain literati of the Song dynasty (960–1279)—a handful of influential men in elite positions in society who were highly educated in philosophy, literature, and art. They had their own specific political uses for the reputation Yan Zhenqing left to posterity, and so they adopted his calligraphic style as a way to clothe themselves in his persona. They copied and collected his artworks, incorporated elements of his style into their own, and celebrated his reputation and style as one indissoluble unit in their critical writings on art.

To tell the story of Yan Zhenqing, I begin with a chapter that sets the stage for the many uses to which Yan Zhenqing's style and reputation were put by the Song-dynasty literati. I explain the notion of characterology as the ancient pseudoscience of assessing a man's character and fitness for government office from examination of his aesthetic effect,

both in his physical appearance and comportment and in his practice of the polite arts. Such things as the composing of prose and poetry, the playing of chess or the seven-stringed *qin*, and the writing of calligraphy result from the gesture of the hand in obedience to the mind and thus were seen as outward manifestations of inner character. The practice of characterology began in the Han dynasty (206 B.C.E.–220 C.E.) as part of the Confucian ideology of service in government. In the centuries following, philosophical thought was dominated by Daoist and Buddhist speculation; but in the Song dynasty, Confucian ideas about the role of the educated gentleman in politics and culture were revived. The cultural elite of the eleventh century had an interest in antiquarianism and the objects and styles of the past. Not surprisingly, the Confucian politicians among them made characterology a conspicuous element in the choice of models from the past in art and literature. The model they chose in calligraphy was Yan Zhenqing, a man of upright character and an upright style of writing.

The rest of the book uses an artistic biography of Yan as its matrix. Each chapter treats a discrete period of his life, beginning with his illustrious family background and his meteoric early career and ending with his crowning appointments to high national office and his martyrdom as a loyalist. In each chapter I also focus on a specific work of calligraphy done during the period covered. I explain its content, situate it within Yan's life and contemporary events in Tang-dynasty China (618–907), and place its style within the development of Yan's oeuvre and calligraphy in the eighth century. We then move to investigation of the Song literati response to this specific work and to Yan Zhenqing and his style generally.

Chapter 2 treats Yan Zhenqing's early career as a successful young literatus in and around the capital, Chang'an (modern Xi'an). Here the masterpiece is his *Encomium on a Portrait of Dongfang Shuo* of 754, in which Yan's distinctive style begins to be glimpsed. Spurred by the comment of the Song-dynasty renaissance man Su Shi (1037–1101) that Yan's *Encomium* matched the style of the earlier version by the "Sage of Calligraphy," Wang Xizhi (303–361), I investigate the true relationship between the two works and the various sources that did constitute Yan's foundational study in calligraphy, including the legendary master of "mad cursive," Zhang Xu (675–759), styles favored at court, and the calligraphy of Yan's male relatives.

Chapter 3 narrates the course of the An Lushan Rebellion (755–762) from the point of view of the Yan family, which was shattered by its violent events. In this period, Yan Zhenqing wrote the *Draft of the Eulogy for Nephew Jiming*, which is the only certain autograph work by Yan Zhenqing extant today. American audiences saw it on display at the National Gallery of Art in early 1997 as part of the exhibition

"Splendors of Imperial China: Treasures from the National Palace Museum, Taipei." Many Song-dynasty literati, but especially the poet and calligrapher Huang Tingjian (1045–1105), responded to the immediacy inherent in the draft form, the simplicity of the calligraphic manner, the monumental yet personal events it describes, and the emotion in Yan Zhenqing's voice. The qualities of awkwardness and sincerity in the *Draft of the Eulogy* were the very effects that Huang was predisposed to see in the art and literature of the Rebellion period and that he sought in his own poetry and calligraphy.

In Chapter 4 we follow Yan into exile and service in humble posts far from the capital. Upon his return to court, he threw himself into partisan politics there, writing an insulting letter to a powerful military man, which is known to posterity as the *Letter on the Controversy over Seating Protocol.* This jeremiad was much studied in the 1080s and 1090s by Su Shi, Huang Tingjian, and Mi Fu (1052–1107): all considered it Yan's finest work and admired its plain, natural, and unpremeditated style. Su Shi made many copies of the *Letter,* one of which survives in ink-rubbing form. In a colophon to this copy, he revealed his admiration for the upright, or centered, brush technique of Yan Zhenqing. Yet his own brush technique in the copy is not the centered brush, but the slanted brush, which creates greater visual drama in the brush strokes. I can only conclude that while Su Shi followed the critical line taken by his mentor, the Confucian reformer Ouyang Xiu (1007–1072), that the upright brush of Yan Zhenqing was the appropriate model for the scholar-official, in practice Su Shi continued to use the slanted brush of his early model, Wang Xizhi. Su Shi's relationship to the style of Yan Zhenqing reveals that the paramount symbol of political identification was not the faithful reproduction of the ideal style but the affiliation in one's critical writings with the accepted patriarchs of one's political group.

Chapter 5 traces Yan's resulting exile to the south and explains the circumstances surrounding his writing of the *Record of the Altar of the Immortal of Mount Magu.* Following a translation of this inscription for a Daoist sacred site, I offer documentary evidence for the widespread belief in the ninth and tenth centuries that Yan himself had become a Daoist immortal upon his death. Mi Fu, a connoisseur and art collector who served the Daoist court of Emperor Huizong in the twelfth century, wrote out a Daoist hagiography of Yan in imitation of Yan's own calligraphic style. Mi Fu did so, I argue, in order to recast Yan's image from that of the narrow moralist championed by the Confucian reformers to that of a supernatural immortal the Daoist court could appropriate as their hero.

Chapter 6 tells how Yan Zhenqing arrived as prefect of Huzhou in 773, where he found congenial company, writing poetry and working

on his long-standing dictionary project with the monk poet Jiaoran (ca. 724–ca. 799), the tea expert Lu Yu (733–804), and others. There he transcribed his *Ponds for the Release of Living Creatures Throughout the Subcelestial Realm* inscription of 759, which described the late Emperor Suzong's establishment of ponds to be used for the pious Buddhist practice of releasing captive fish and turtles. Since no evidence exists that Yan was a believer in Buddhism, Su Shi formed the theory that Yan's original memorial was written to criticize Suzong for unfilial behavior toward Retired Emperor Xuanzong. This is a likely explanation, but Yan's later completion of the project should probably be seen as a posthumous reconciliation with Suzong and an offering of gratitude to the reigning Emperor Daizong, both Buddhist believers. This inscription survives only in an engraved calligraphy compendium dedicated to the works of Yan Zhenqing, called the *Hall of Loyalty and Righteousness Compendium (Zhongyi tang tie),* compiled in 1215 by Liu Yuangang, a high official from a prominent Confucian family. The history of engraved calligraphy compendia in the Song dynasty reveals how they embodied the political tensions between the scholar-official class and the throne. The compendia of the late tenth and early eleventh centuries display the universal acceptance of the classical tradition of Six Dynasties calligraphy championed by the throne. The crucial difference between the early compendia created by scholars and the imperial compendia is that only the former contained works by Yan Zhenqing. Scholars' compendia of the mid-eleventh century included epigraphy and other nonclassical calligraphy, but imperial compendia still excluded them. Finally, in 1185, a work by Yan Zhenqing was published in an imperial compendium, thereby signaling imperial acceptance of the Confucian reformers' position that cultural models should be chosen on the basis of their character.

In Chapter 7 we see Yan Zhenqing return to court in 777, where he was named to a succession of high positions. In 780 he wrote a grand summation of his family's achievements, called the *Yan Family Temple Stele.* Its open, even, four-square manner came to be known and imitated in the Song dynasty and afterward as the "Yan style." This was no accident, of course, but a result of the deliberate promotion of Yan's style as a contrast to the court-sponsored style of Wang Xizhi. The revival of Yan Zhenqing's style began in the 1030s, in the circle of the Confucian reformers Han Qi (1008–1075) and Fan Zhongyan (989–1052), but the most zealous propagandist for the regular-script calligraphy of Yan Zhenqing's final decade as the "Yan style" was Ouyang Xiu. His collection of one thousand ink rubbings contained a score of works by Yan Zhenqing and only one or two by Wang Xizhi. The critical comments he wrote on Yan's works reveal that his admiration for Yan's upright regular-script style was due to its manifestation of his upright personality. Ouyang promoted Yan as the Confucian standard in callig-

raphy. In the cultural arena he used Yan's style as a sword in his attack on court styles in the arts; in the coliseum of court politics he used Yan's reputation as a shield, to defend himself against charges of disloyalty.

The artist who made Yan Zhenqing's style a workable tool was the Confucian statesman Cai Xiang (1012–1067). A longtime friend of Ouyang Xiu, he spent more than thirty years discussing and studying the works in Ouyang's collection of ink rubbings, including the many pieces by Yan Zhenqing. Cai Xiang promoted Yan Zhenqing as a moral exemplar in the Confucian fashion, as well, advocating his calligraphy on the basis of the correspondence of personality and handwriting. A superb calligrapher, Cai Xiang not only imitated Yan's style directly but incorporated aspects of it into his own personal style. His imitations of Yan's style followed the monumental regular script of Yan Zhenqing's last decade that predominates in Ouyang Xiu's collection. In his own style, Cai Xiang created a blend of the styles of Yan Zhenqing and Wang Xizhi, executing the firm rectangular structures of Yan's character compositions in the fluid, modulating brush strokes of the Wang style. By offering the possibility of interpretation of Yan's style, he was as responsible as Ouyang for making the study of the "Yan style" part of the standard curriculum of future generations of scholars. So influential were the critical writings of Ouyang Xiu and the art of Cai Xiang that by the end of the Southern Song, their view of Yan Zhenqing prevailed. The visual and critical record is dominated by their image of an upright Confucian martyr who wrote an upright regular script. This image is the one that has come down to us.

The final chapter tells the poignant story of Yan Zhenqing's martyrdom in the cause of loyalty to the dynasty. For his refusal to serve under a rebel leader, he was hanged at the age of seventy-six. His self-sacrifice set the seal on his life as a moral exemplar. Thanks to the belief in characterology, the manner of his life and death made his calligraphy an ideal standard in the Song-dynasty Confucian reformers' struggle to gain political and cultural parity with the throne.

In sum, then, this study seeks to reveal the mechanisms by which art embodies and enacts tensions in philosophy, culture, and politics. The Song-dynasty struggle over the art and reputation of Yan Zhenqing is but one of many episodes in the history of Chinese culture in which the creative reinterpretation of the art of the past has been used to political ends.

The Politics
of Calligraphy

WHAT IS the politics of calligraphic style? How can calligraphy be used to make a political statement? This book explores one very prominent episode in the history of the politics of calligraphy in traditional China. In the eleventh century, historical circumstances converged to allow a highly educated and ambitious group of government officials to involve the art of calligraphy in creating their political identity. These historical circumstances included the persistence of the traditional belief in the personal expressiveness of handwriting and a resurgence of the conviction that Confucian values should be expressed in politics and culture. These themes combined to make calligraphy a significant venue for the public expression of one's self and one's values and to allow the imitation of earlier styles of calligraphy to serve as a sign of those values.

The idea that writing expresses the personality of the writer is at least two thousand years old. The Confucian scholar-official Yang Xiong (53 B.C.E.–18 C.E.) encapsulated it in his famous pithy phrase, "Writing is the delineation of the mind *(shu xin hua ye)*."[1] This simple idea is part of a larger theory of the study of man called characterology. Characterology is based on the belief that because the style of the inner being and the outer person is unitary, moral character can be deduced from an examination of a person's external manifestations, such as appearance, behavior, or aesthetic endeavor. A classic expression of this philosophy is the statement by the historian Sima Qian (145–90 B.C.E.): "When I read the writings of Confucius, I can envision the kind of man he was."[2]

The use of characterology in practical matters can be documented from the Han dynasty onward; its principal use has been to assess the virtue and ability of candidates for government office. Those who would be government officials were judged not only on their ability to express themselves in writing, but also on their appearance, their speech, and their calligraphy. During the Tang dynasty, the criteria were as follows:

> There are four areas considered in the method for choosing men [for office]. The first is stature: a physique and appearance that are handsome and imposing. The second is speech: the vocabulary and diction to debate the truth. The third is calligraphy: a regular script that is powerful and beautiful. The fourth is judgment: logical writing that is excellent and strong. Success in all four areas, then, is the precedent for virtuous conduct [in office].[3]

Thanks to the force of the belief in characterology, calligraphic style was granted moral significance. And due to the equation of moral fitness with fitness for political office, calligraphic style took on political significance, as well.

The correlation between style and personality affects the use of calligraphy in the private sphere also. Since style is believed to communicate the personality of the writer, people collect personal letters and other manuscripts as a souvenir of the writer. This practice, too, may be traced back to the Han dynasty. The *History of the Later Han* records the unusual appearance and behavior of the literatus Chen Zun and says that the recipients of his letters collected them in the belief that his handwriting reflected his extraordinary character.[4]

The concomitant notion that a virtuous character produces good art is also present from at least the Han dynasty. This belief was evidently so broad that even the philosopher Wang Chong (27–97), who was generally skeptical of many Confucian tenets, wrote: "The greater a man's virtue, the more refined is his literary work."[5] In a well-known anecdote from the Tang period, Emperor Muzong (r. 821–824) asked his minister Liu Gongquan (778–865), who was famous as a calligrapher, about the proper method for the brush. Liu's reply taught the emperor a lesson about the role of character in calligraphy (and in rulership): "The use of the brush lies in the heart. If your heart is upright, then your brush will be upright."[6] In other words, good art is founded on good character.

What if a person wants to feign a virtue he does not possess? Could he imitate the writing of a virtuous person and thereby disguise his true character? Other critics seem to have considered this possibility, unsure whether an individual's personality is always cleanly expressed in his aesthetic endeavors. They argued that one's own personality should be expressed naturally: any attempt to create artificial expression or to disguise one's personality was wrong. The Han critic Zhao Yi wrote:

> Now of all men, each one has his particular humours and blood, and different sinews and bones. The mind may be coarse or fine, the hand may be skilled or clumsy. Hence when the beauty or ugliness of a piece of writing must depend both upon the mind and the hand, can there be any question of making (a beautiful writing) by sheer force of

effort? When there are (natural) degrees of difference in beauty and ugliness in peoples' faces, how can one strive to look like someone else?[7]

Zhao Yi believed that one should not try to represent oneself as other than one is. Wang Sengqian (426–485) recorded the view that anything but natural expression would not only falsely represent the writer, but would also result in hackneyed art. He wrote:

> Your mind must lose itself in the brush and your hand lose itself in the writing, so that your mind and hand will convey your feelings. For if calligraphy has not forsaken premeditation, we say that it seeks what it cannot find and examines what is already evident.[8]

Why did the problem of forcing or disguising personal expression in calligraphy arise for the literati? Although traditional Chinese calligraphy criticism often uses the terminology of nature to describe calligraphy—and any number of calligraphers have claimed inspiration from nature itself—the fact remains that writing is an artificial creation, and to learn Chinese characters one must have a model. That model will be the handwriting of another person. Yet if you learn the writing of another and slavishly reproduce it, you have simply adopted someone else's heart/mind and hand and thereby obscured the expression of your own. Somehow the delicate trick of creating your own expression through the style must be achieved. Otherwise you are no better than a sutra scribe or government clerk who must write anonymously and conventionally. By extension the choice of a model becomes utterly crucial, in terms of the character of the calligrapher, rather than simply the beauty of his style. The student will want the style to represent a facet of his personality. If he wishes to paint himself as a man of virtue, how better than to choose as a model a figure from the past with a reputation for virtue? Furthermore, if the same model were adopted by a group, it would become their means of identification.

Gradually this cluster of concepts grew to surround characterology and calligraphy. By the eleventh century, great political significance came to be attached to the choice of a model in calligraphy. An anecdote attributed to the premier Song Neo-Confucian philosopher, Zhu Xi (1130–1200), illustrates the importance that the choice of calligraphic models came to have in the Song dynasty:

> When I was young, I liked to study the calligraphy of Cao Mengde [Cao Cao (155–220)]. At that time, Liu Gongfu [Liu Gong (1122–1178)] was studying the calligraphy of Yan Zhenqing. I ridiculed him for the mixing of modern characters with ancient in [Yan Zhenqing's] *Lexicon for Gaining Employment*. But Gongfu said to me sternly, "The one whom I study was a loyal official of the Tang dynasty, while the one whom you study was but a usurping traitor of the Han." I fell

silent and made no reply. That was how I learned that the choice of a model cannot be made without due consideration.[9]

By the eleventh century, the imperial choice of a calligraphic model had already been firmly established for more than five hundred years. The calligraphy of Wang Xizhi (303–361), a prominent member of the aristocratic ruling class of the Eastern Jin dynasty (317–420), was considered a supreme expression of the sophisticated Chinese culture of the south when China was divided during the Northern and Southern Dynasties period (317–589), and his calligraphic works were handed down within the family and his style practiced in elite circles. Several influential rulers practiced Wang Xizhi's calligraphic style and engaged in discussions of the authenticity of his extant works—notably Emperor Ming of the Liu Song (r. 465–472), Emperor Wu of the Liang (r. 502–549), and Emperor Yang of the Sui (r. 604–617). In the seventh century, when Emperor Taizong of the Tang (r. 626–649) sought to reunify China culturally after his military conquest of the south, he espoused the calligraphic style of Wang Xizhi as a means of gaining the acceptance of the Chinese elite and establishing a cultural standard throughout his empire. He studied calligraphy with his minister Yu Shinan (558–638), who had himself studied with the Sui-dynasty (581–618) monk Zhiyong, a seventh-generation descendant of Wang Xizhi. The emperor also attempted to gather all the works attributed to Wang Xizhi into the palace collection. To get them he confiscated the collections of his political enemies and sent out scouts to appraise and buy other works. In the notorious case of the *Orchid Pavilion Preface (Lantingxu),* he resorted to a cruel ruse to obtain it from an elderly monk. Soon after assuming the throne, Emperor Taizong had amassed an incredibly large number of "authentic" pieces, from which various types of copies were made. One type was the tracing copies produced by the court calligraphers; another was the freehand copies produced by his high officials Yu Shinan, Ouyang Xun (557–641), and Chu Suiliang (596–658). The copies were distributed to court nobles, whose sons were instructed in calligraphy by Yu Shinan and Ouyang Xun at the palace school. When the official history of the Jin dynasty (265–420) was compiled, the emperor himself wrote an imperial postscript to the biography of Wang Xizhi in which he declared Wang the greatest calligrapher of all time.[10]

Emperor Taizong of the Tang fixed the style of Wang Xizhi as the imperial signature with such finality that it was maintained through the Tang dynasty and afterward. While warfare wracked the Central Plains during the Five Dynasties period (907–960), the classical tradition was preserved at the courts of the Shu kingdom, the Southern Tang dynasty, and the kingdom of Wu Yue. As the armies of the Song dynasty con-

quered these states, their calligraphers and calligraphy collections gravitated to the Song capital. Shu surrendered to the Song in 965, and its famous calligraphers, such as Li Jianzhong (945–1013) and Wang Zhu (d. 990), went to Kaifeng. When the Southern Tang capitulated in 975, Su Yijian (957–995), Xu Xuan (916–991), and others moved to the Song court. The kingdom of Wu Yue yielded in 978, and the palace calligraphy collection was offered to the Song throne. The Southern Tang had submitted its collection earlier.

Emperor Taizong of the Song (r. 976–997) also furthered the imperial promotion of the classical tradition as a means to legitimize his political and cultural status. The emperor instructed the calligraphers of the Hanlin Academy to practice the style of Wang Xizhi, and he had the scattered works attributed to Wang Xizhi brought back into the palace. He welcomed Wang Zhu, who had studied the style of Wang Xizhi and was said to be a descendant of the same Wang clan of Langye (Shandong). The emperor appointed Wang Zhu to serve as a court calligrapher, in which capacity he acted as a personal calligraphy tutor to the emperor.[11] Wang was also granted the authority to buy and borrow works from among the private collections in the capital. The emperor then commissioned Wang to select the finest works of calligraphy in the imperial archives, which contained the scrolls acquired from conquered courts and through purchase or tribute. Taizong ordered a set of engravings made of Wang Zhu's selection, which was known as the "Model Letters in the Imperial Archives in the Chunhua Era [990–995]" *(Chunhua ge tie)*. Five of its ten volumes were composed of 233 letters attributed to Wang Xizhi and his son, Wang Xianzhi (344–388). Ink rubbings from the engravings were given to the nobility and to officials on the occasion of their promotions.

The Song-dynasty emphasis on education and the arts, at the expense of military capability, was due largely to the character and influence of the founder of the Song, Zhao Kuangyin (927–976). Zhao had been a general under the Later Zhou (951–960), one of the short-lived dynasties of the Five Dynasties period, when he deposed the child emperor of the Zhou and initiated his own dynasty. Though Zhao was a military man, his plans for a long-lived dynasty did not include a prominent role for the military. After his conquest was complete, he recalled his generals to Kaifeng and hosted a banquet for them, at which he exchanged their military ranks for civilian office. He then reduced the size of the army to half what it had been during the Tang.

To institutionalize stability for his newly established rule, Zhao inaugurated a more inclusive examination system to staff a bureaucracy that would replace the military commissioners who had destroyed the Tang. Under the rule of his successor, Emperor Taizong, the number of degrees awarded through the examinations was increased dramatically

—from an annual average of around sixty degrees conferred in the High Tang period to over two hundred conferred between 976 and 1057.[12] In addition, following the precedent set by Empress Wu Zetian (r. 690–705), scholars from areas outside the capital were recruited to take the examinations and enter government service.[13] The tests themselves were restructured for greater impartiality in grading, and the names of the examinees were concealed. The Song practice of recruitment through examination expanded to the extent that, by 1050, it has been estimated, roughly half the men required to staff the whole civil service were recruited through the palace examinations.

Increasingly, high government positions were available only to those who had performed well in the examinations. This clear correlation between intellectual endeavor and profit, prestige, and power caused an enormous surge in the numbers of men seeking an education. In the early Northern Song period (960–1127), government sponsorship of schools was at a relatively low level, consisting mainly of gifts to private academies that were already established.[14] These academies and private schools were responsible for the education of nearly all the scholars who took office in the early years of the dynasty. Around 1034, however, the first comprehensive governmental education program took shape, in the reign of Emperor Renzong (r. 1022–1063), when the practice of random funding of private schools was replaced with the promotion of greater educational opportunity throughout the realm. Education was further assisted by the rapid expansion of printing that took place in the Northern Song. The printing of books, including the Confucian Classics and the dynastic histories, was carried out by government agencies in the capital and by officials stationed in the prefectures. Sales were brisk for private printers also, who turned a good profit from those who sought advancement through education.

The proliferation of the Confucian canon not only encouraged serious efforts to understand the real meaning of the classics but also prompted rejection of the government-approved version of the classics and their annotations and commentaries.[15] Philological and philosophical inquiry into the words of Confucius (551–479 B.C.E.) and Mencius (372–289 B.C.E.) became the focus of Confucian scholarship. As the leading Confucian scholars began to be appointed to prestigious lectureships at the National University in the mid-eleventh century, they replaced the discredited official commentaries and annotations with their own interpretations of the classics.

This resurgence of Confucian ideals in the Song dynasty resulted in the revival of certain fundamental concepts about the roles of emperor and official and the appropriate relationship between the two. One of these concepts was that the links between governor and governed were cast in the mold of family relationships. As the emperor was the Son of

Heaven, he was the parent and guardian of his people. The official was to regard the people as the younger generation in his family, but his relation to the emperor was more complex. As the servant of the emperor, the official owed him the assistance and honest criticism that a son owes a father. This view of their relationship characterized the attitude of the Song emperors toward scholar-officials' participation in government. The view taken by the scholar-official class, however, was somewhat different. Quoting Mencius, they argued that not only could an official rank equally with the ruler in personal cultivation, but he should actually be considered superior to the ruler in his abilities at statecraft. As the ruler had been tutored by scholar-officials before he ascended the throne, he should continue to receive instruction during his reign.[16] The scholar-officials encouraged the emperor to entrust the planning and implementation of government policy to them on the basis of their proven merits.

The Confucian scholar-officials got the chance to put their beliefs into action in 1043–1044, during the Qingli era (1041–1049), in what came to be known as the Qingli reform, or the minor reform (in contrast to the major reform of 1069–1085). The years preceding the Qingli reform witnessed a struggle for political control between the ministers in power, such as Grand Councillor Lü Yijian (979–1044), mainly aristocratic northerners who were hereditary bureaucrats, and the southern faction, the young, idealistic Confucian scholar-officials who had risen on their native talent through the examination system. These reformers included Fan Zhongyan (989–1052), Han Qi (1008–1075), Cai Xiang (1012–1067), and Ouyang Xiu (1007–1072).[17] In 1036, Fan was demoted for criticizing the policies of Lü Yijian and Emperor Renzong, criticism intended to gain attention for the ideas of the southern faction. To protest Fan's demotion—and gain still further notice—Ouyang Xiu wrote a letter to Gao Ruonuo (997–1055), a policy-criticism adviser and supporter of Lü Yijian's, reprimanding him for not objecting to Fan's demotion. As a result, Ouyang was demoted as well. Cai Xiang wrote a poem, which was widely circulated, entitled "Four Virtuous Men and One Unworthy," in which he made a scathing attack on the character of Gao Ruonuo and praised the courage and independence of Fan Zhongyan, Ouyang Xiu, Yin Shu (1001–1046), and Yu Jing (1000–1064), all scholar-officials of the southern faction who had been dismissed at the same time.

In 1040, Fan Zhongyan and Ouyang Xiu were returned to active service due to Renzong's anxiety over the invasion of China's northwestern border by the Xi Xia (1032–1227). Although he found Fan and Ouyang politically troublesome, he also believed they were the most capable men in a military crisis. In 1043, Lü Yijian retired from office but retained the unusual privilege of "consultation on important state and

military affairs." First Cai Xiang and then Ouyang Xiu protested Lü's role, so the emperor revoked the privilege. Ouyang and two other members of the southern faction, Yu Jing and Wang Su (1007–1073), were made policy-criticism advisers, and upon their recommendation Cai Xiang soon joined their ranks. In the summer of 1043, the zealous young policy-criticism advisers were permitted to make a daily appearance at court to discuss government policy. They recommended that Fan Zhongyan and Han Qi be put at the head of the government. When the emperor then invited those two to set out their goals for government policy, they produced a manifesto called the "Ten-Point Memorial" that served as the ideological blueprint for the Qingli reform. The first five points proposed the reform of the bureaucracy: strict evaluations of performance in office; reduction of apppointments for an official's sons and relatives; reform of the examination standards, stressing discussion of statecraft problems; careful selection of regional officials, who would sponsor their own subordinates; and, to reduce bribery and extortion, an increase in the land attached to regional posts. The last five points of the memorial dealt with the problems of the peasantry: the improvement of land reclamation and the grain transport system, the creation of local peasant militias, strict and egalitarian law enforcement, and reduction of the corvée.

Opposition to these reforms was immediate and vehement. Three measures in particular aroused the greatest ire in the entrenched officials: the limits on appointments for sons and relatives; the change in the examination standards, which disadvantaged those officials and their sons who had emphasized poetry in their examination preparations; and the expansion of the sponsorship system, which they believed would result in widespread sycophancy and corruption. In truth, the antagonism toward the reforms was caused as much by the self-righteousness and intolerance of the reformers as by their radical proposals and haste in implementing them. Their opponents soon set about amassing enough argument and slander to persuade the emperor to reconsider his support for the reformers. By 1044, the threat of the Xi Xia invasion had abated. Accused of factionalism by Censor-in-Chief Wang Gong-chen (1012–1085) and the censors under him, the reformers were dismissed from their positions. One of the damning pieces of evidence for the charge of factionalism was Cai Xiang's caustic poem of 1036, which was offered to Renzong as proof that the southern faction had engaged in conspiracy for nearly a decade.

Far from discrediting the Confucian scholars, however, the Qingli reform, though unsuccessful, consolidated acceptance of the role of scholar-officials in government. Following the minor reform, Confucian scholars began to gain control of the directorate of education, where they changed the examination standards to emphasize prose essays on

the classics. So thoroughly had the scholar-officials permeated the government bureaucracy that in the major reform begun by Wang Anshi (1021–1086) in 1069, though the factional positions were as polarized as in the minor reform, the parties did not constitute a minority scholar-official faction versus an entrenched career bureaucrat faction, but were both composed of scholar-officials.

The Qingli reform also made the reformers' reputations as scholars and policymakers. The tremendous prestige they earned by putting their careers on the line gave them the authority to be arbiters and models in the cultural sphere, as well. This phenomenon was accidentally noticed by the great connoisseur and calligrapher Mi Fu (1052–1107), who was devoted to the study of the Jin masters, especially Wang Xianzhi. In his *History of Calligraphy (Shu shi),* Mi Fu complained that the aping of contemporary political leaders was the reason why ancient methods of calligraphy had been lost:

> When Song Shou [991–1040] was in charge of the government, the whole court studied his style, which was called the "court style." Han Qi loved the calligraphy of Yan [Zhenqing], so scholars and common-folk all studied Yan's calligraphy. And when Cai Xiang was honored, scholars and commoners then all studied him. Then Wang Anshi was made chief minister, and scholars and commonfolk alike all studied his style.[18]

Mi Fu was two generations removed from the reformers and evidently had no particular sympathy for their political goals, so his complaint serves as unintentional testimony to the cultural authority granted the Qingli reformers.

The reformer who made the greatest impact on scholar-official culture was Ouyang Xiu. As a young man, Ouyang discovered the literary works of the Tang-dynasty scholar-official Han Yu (768–824). Han Yu advocated the use of a plainspoken literary style in imitation of the writers of the Warring States (480–221 B.C.E.) and Han periods, a style called *guwen,* or "ancient-style prose." Han Yu was also a bold promoter of Confucian values and virulently anti-Buddhist; in one famous episode in his career as an official, he was degraded for submitting a memorial arguing against allowing a relic of the Buddha to enter the imperial palace.[19] Because Ouyang identified profoundly with Han Yu's ideals, he joined with other scholars of the day in the revival of ancient-style prose. They waged a campaign to replace the palace-sponsored use of parallel prose (*shiwen,* or "current-style prose") in government examinations and memorials, which they criticized for stifling expression of the writer's values in artificial language and rigid rules of composition. When Ouyang was put in charge of the national examinations in 1057, he instituted ancient-style prose as the required style. Ouyang

also promoted a move away from the style of poetry sponsored at court. The "*Xikun* style," named after the influential *Xikun chouchang ji* collection of poems written by seventeen imperial archivists in the early eleventh century, was also "characterized by the use of ornate and allusive language with much parallelism."[20] Though Ouyang admired poets who could work in this constricting idiom, he believed it fostered imitation, not expression. In all forms of writing, Ouyang opposed empty aestheticism and advocated clear and simple expression of Confucian values. For this same reason, he rewrote the official dynastic histories of the Tang and Five Dynasties periods.

Ouyang's contributions to the changes in taste in literature and historiography have been ably examined by James T. C. Liu, Ronald Egan, and Lien-sheng Yang.[21] Ouyang's taste in calligraphy also came to prevail in scholar-official circles down to the present day. Three features were decisively settled by him and his circle of friends: the amateur aesthetic, the equation of style and personality in the choice of models, and the study of epigraphy. Certainly Ouyang was not the first scholar to promote these features. But after his day there were few scholars who did not accept the notion of the moral superiority of the amateur artist, consider carefully their choice of calligraphic models, or see the merit in ancient inscriptions.

According to Ouyang Xiu's concept of the amateur aesthetic, the scholar should not devote an inordinate amount of time to making himself a virtuoso at calligraphy, nor should he slavishly copy a calligraphic model.[22] These two dicta may sound like restatements of earlier pronouncements against gentlemen practicing as professionals, but the implication within the context of Ouyang's campaign against court styles in all the arts was to condemn the current, degraded "Wang style" used for official writing and to demand its replacement. The *Chunhua ge tie,* the imperial showcase for the classical tradition, originally included a substantial number of fakes and had been reengraved several times. By the mid-eleventh century, the main vehicle of propaganda for the imperial style was seen as a collection of poorly reproduced fakes. Even in its degraded condition, however, the *Chunhua ge tie* was the most prestigious model available, so that Ouyang's counsel against slavish copying of a single model became perforce a warning against the imperially sponsored Wang style. His proscription against making oneself a virtuoso at calligraphy was also a condemnation of the Wang style—for the chief reason to be highly skilled at calligraphy was to find employment as a calligrapher at court, and of course the style required at court was that of Wang Xizhi.

Why should a Confucian literatus not serve as a calligrapher at court? Because then one became a mere scribe, a "utensil" for the use of others, not a man of thought and action. This attitude is revealed in an

episode that Ouyang's close friend Cai Xiang related to him in a letter. Emperor Renzong had composed a memorial inscription for a deceased relative and asked Cai to transcribe it. Cai complied, but when he was then asked to transcribe another such text that had been written by an official of the court, he refused:

> Recently I was ordered by imperial edict to write out a stele text composed by the emperor. Those who make a living doing inscribed tablets for palaces and temples have a shallow understanding of calligraphy, so an emperor's orders particularly should be requested of very meritorious and virtuous masters. But when the court issued *this* order for my calligraphy, I said: "In recent times, the transcribing of stele inscriptions has customarily been done for a fee. There is an officer retained for just this kind of order by the court; this is a task for an editorial assistant." Now, is it possible that I would compete for fees with an editorial assistant? I have already forcefully refused this request. I did not make my name by calligraphy![23]

This episode was distilled and retold in virtually every subsequent biographical treatment of Cai Xiang—not only because of what it says about Cai but also because it is such an essential illustration of the literati amateur aesthetic. Its message is that the literati should practice the arts only as an emotional release and a means of communication between members of the scholar class.

Ouyang's promotion of the equation of style and personality represents the culmination of the tradition of characterology. As Stephen Owen writes of him: "Characteristically, the Sung writer takes what had previously been an implicit truth and raises it to the level of an explicit question, calling for reflection and investigation."[24] Ouyang made explicit that one's models in the arts should be chosen on the basis of their character. For example, he praised the calligraphy of Yan Zhenqing for what it revealed of Yan's character:

> This man's loyalty and righteousness emanated from his heaven-sent nature. Thus his brush strokes are firm, strong, and individual, and do not follow in earlier footsteps. Outstanding, unusual, and imposing, they resemble his personality.[25]

In another example, Ouyang condemned the "personality" and the calligraphic style of the entire era of Wang Xizhi:

> The mores of scholars of the Southern Dynasties [317–589] were lowly and unmanly. Those who were skilled at calligraphy all thought the finest style was one of slender intensity and unblemished gracefulness. None of them wrote with such imposing, thick brushstrokes as seen here.[26]

The equation of style and personality afforded Ouyang Xiu yet another opportunity to denigrate the imperially sponsored calligraphic style.

The study of epigraphy in China is generally considered to have
begun with Ouyang Xiu. This reputation, though not undeserved, may
be overplayed due to the fact that contributions by other eleventh-
century students of epigraphy have disappeared. Song Shou, the high
government official and historian, was responsible for what was evi-
dently the first privately engraved calligraphy compendium. His "Model
Letters of the Hall of Inherited Books" *(Cishutang tie)* included inscrip-
tions from ancient bronze ritual vessels and Qin-dynasty (221–206
B.C.E.) stone steles.[27] These were undoubtedly copied from objects or
ink rubbings in Song Shou's personal collection. His *Cishutang tie* had
to have been compiled before his death in 1040—years before Ouyang
began collecting epigraphical material—but it does not survive, nor did
Song Shou publish studies of his collection, as far as we know. Around
1056–1063, Ouyang's younger friend and fellow epigraphy enthusiast
Liu Chang (1019–1068) compiled a work called *Record of Antique
Vessels of Pre-Qin Times (Xian Qin guqi ji)*. It was a reproduction of
the designs and inscriptions on eleven bronze vessels that Liu owned,
engraved into stones, now lost.[28]

Around 1045, Ouyang began to collect ink rubbings of inscriptions
on bronzes and stone steles. His contemporaries were collectors of

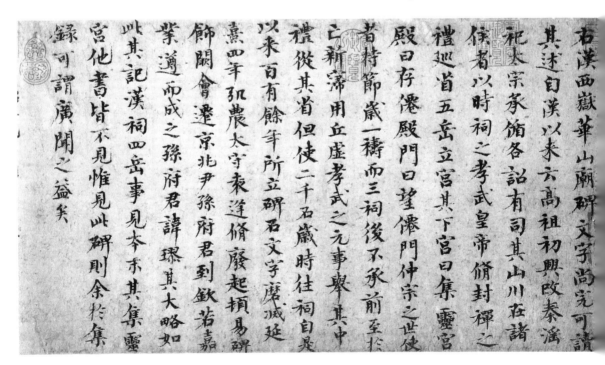

Figure 1. Ouyang Xiu, *Colophon to the Han Inscription for the Temple on the
Western Peak of Mount Hua*, detail, 1064, ink on paper. Collection of the
National Palace Museum, Taiwan, Republic of China.

inscriptions, as well, and many of his friends sent him ink rubbings taken from bronzes they had acquired or stone inscriptions they encountered in the areas where they were posted. Among those who sent him ink rubbings were Liu Chang, Yin Shu, the poet Mei Yaochen (1002–1060), and Ouyang's protégé, Su Shi (1037–1101). By 1062 he had acquired a thousand ink rubbings. He then began to write colophons for them, of which some four hundred are recorded and a handful extant (Figure 1).[29]

Ouyang's collection of ink rubbings and the colophons he wrote for them was called *Collected Records of Antiquity (Jigulu)*. It was profoundly influential. During his lifetime the colophons circulated widely among connoisseurs of antiquities. Ouyang's opinions were quoted by independent scholars far from court—such as Zhu Changwen (1039–1098) in his *Sequel to Calligraphy Judgments (Xu Shu duan)* of 1074—and in the heart of the palace in the *Calligraphy Catalog of the Xuanhe Era (Xuanhe shupu)*, the catalog of the imperial calligraphy collection, written around 1120. The factual information and the subjective analyses in *Collected Records of Antiquity* have been quoted in virtually every catalog and survey of epigraphy written from Ouyang's time to ours, beginning with Zhao Mingcheng's (1081–1129) early twelfth-century work, *Record of Inscriptions on Bronze and Stone (Jinshilu)*.

The influence of Han Yu may be seen here too. Ouyang's interest in epigraphy may have stemmed in part from reading Han Yu's famous poem "The Song of the Stone Drums" *(Shiguge)*. The "Stone Drums" are ten drum-shaped boulders inscribed with poems in the archaic seal script describing the hunting expeditions of the King of Qin during the middle or late Spring and Autumn period (770–481 B.C.E.). They are now in the Beijing Palace Museum. Han Yu's poem extols the ancient seal-script writing of the "Stone Drums," but one line in particular granted permission to promote epigraphy over the calligraphy of the classical tradition. In praising the ancient seal script, Han Yu contrasted it to the style of Wang Xizhi. He dismissed Wang's style with a line that became widely quoted by Song-dynasty critics: "[Wang] Xizhi's vulgar calligraphy took advantage of its seductive beauty."[30]

What exactly did Han Yu mean by "seductive beauty?" No autograph works by Wang Xizhi are extant, but we can examine the handful of Tang-dynasty tracing copies of some of his letters, which are the closest we have to originals. Looking at the copy of Wang Xizhi's *Ping'an Letter* (Figure 2), the most striking quality is the dramatic modulation in the thickness of the brush strokes, fluctuating from the trace of just one hair of the brush tip to the full width of the brush within one stroke alone. The organic, swelling quality of the brushwork is strengthened by the dynamic movement of the brush strokes, which bend and sweep and spring like leaves of bamboo. This variety and opulence is not

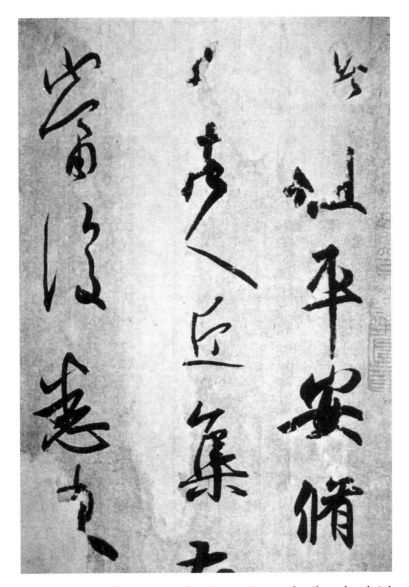

Figure 2. Copy after Wang Xizhi, *Ping'an Letter,* detail, undated, ink on paper. Collection of the National Palace Museum, Taiwan, Republic of China.

created by accident, however. It is quite consciously and painstakingly achieved—rather like the effect of beauty that elaborate hairstyles and makeup produce: stunning, but artificial. Though the term for "seductive beauty," *zimei,* is etymologically feminine, Han Yu did not intend to criticize feminine beauty in its natural state, but rather the laborious and self-conscious use of artifice and embellishment to achieve glamour.

The qualities that Han Yu attributed to the calligraphic style of

Wang Xizhi are the same criticized by Ouyang Xiu in the styles of poetry and prose sponsored by the court. Ouyang never criticized the Wang style as overtly as Han Yu did, but his attitude toward the amateur aesthetic shows he believed that, as with parallel prose and "*Xikun* style" poetry, slavishly following the Wang style could foster artificiality, imitativeness, and a striving for effect—with the same result that natural self-expression and serious content are lost.

Another important idea the Confucian reformers absorbed from Han Yu was his concept of "the succession of the Way," with which he had bolstered his lonely revival of Confucianism in the late Tang dynasty. This "succession" referred to the transmission of the tenets of Confucian thought from one sage to the next, a succession that was modeled on the contemporary Chan Buddhist notion of the direct transmission of teaching from one patriarch to the next.[31] Han Yu did not insist on direct transmission, however, but allowed for a transmission, through writings, between men separated by great stretches of time. Thus Han Yu's "succession of the Way" established a lineage connecting the legendary sage-kings Yao and Shun to Confucius, Mencius, and himself.

As they took up Han Yu's campaign to establish cultural standards based on Confucian thought, Ouyang Xiu and his confederates expanded Han's concept of a succession of Confucian patriarchs beyond literature and philosophy into the other polite arts practiced by the literati. The most important of these, due to the age-old belief in the moral and political significance of personal handwriting, was calligraphy. As a consequence, they were eager to put their own patriarch of calligraphy into competition with the imperial choice. Wang Xizhi had been a hereditary aristocrat and a practicing Daoist; his calligraphic style did not have the Confucian virtues of simplicity and gravity but was highly articulated and inventive, quite consciously so. And it had been promoted by a succession of Buddhist emperors. It was impossible for the reformers to make any political use of a style with such attributes. Their candidate for patriarch had to be a man who rose in the world through talent and education, who spent his life upholding the Confucian tradition of thought and action, and who had gained fame in his own day with a calligraphic style that was forceful and severe. The man they chose was Yan Zhenqing.

2

Yan Zhenqing's Illustrious Background and Early Career

IN THE FINAL YEARS of the Heavenly Treasure era of the Tang dynasty (742–756), tensions grew between the most influential minister at court, Grand Councillor Yang Guozhong (d. 756), and An Lushan (703–757), the military commissioner of the Fanyang, Pinglu, and Hedong frontier commands, which spanned the northeastern borders of China. Emperor Xuanzong (r. 712–756) supported them both, blind to their mutual antagonism, due to their connections with his "Precious Consort," Yang Guifei (d. 756): Yang Guozhong was her second cousin; An Lushan was a favorite she had adopted as her son. As An Lushan consolidated his military power in the northeast, Yang Guozhong systematically eliminated all competitors at court for control of the heart of China.

Yan's Appointment to Pingyuan

In the spring of the twelfth year of the Heavenly Treasure era (753), Emperor Xuanzong decreed that several vacant commandery governor posts were to be filled by officials currently serving as ministers in the capital. Those appointed were feted by the emperor that summer in the Penglai Front Palace, where he composed poetry in their honor and blessed their departure with gifts of silk.[1] In retaliation for Yan's having refused to join his clique, Yang Guozhong recommended Yan Zhenqing for appointment as commandery governor of Pingyuan, a walled city close by the Yellow River in Dezhou prefecture, Hebei circuit (Shandong).[2] He thereby rid himself of this outspoken critic in an apparently gracious manner. Indeed, Yan seems to have been flattered by the appointment. After his arrival, he wrote out a stele inscription celebrating the fact that two of his ancestors had served in the past as governor of Pingyuan: Yan Pei for the Wei kingdom (220–265) and Yan Zhitui (531–591) for the Northern Qi (550–577).[3]

That civil war was the probable, even intended, result of Yang Guo-

zhong pressuring the emperor to break the military power of An Lushan had long been apparent to all but the emperor himself. Soon after Yan Zhenqing arrived in Pingyuan, he began preparations against a siege. He had the city walls repaired and the moats dredged. He secretly stored up matériel and recruited soldiers. Pingyuan lay within An Lushan's jurisdiction as military commissioner, just three hundred kilometers south of his headquarters in Youzhou (modern Beijing). One of his subordinate officials, Ping Lie, had served at court with Yan Zhenqing and knew of his reputation for rectitude. In order to gauge Yan's likely response to rebellion, An Lushan sent Ping Lie and a party of his officials on an investigation tour to Pingyuan in the winter of 753. Yan distracted them by taking them on idle excursions into the countryside, insulated by a band of his friends and relatives, while behind the walls of Pingyuan preparations for the expected siege continued. There were boating parties, with wine drinking and poetry composition, and outings to local sites, such as the temple of Dongfang Shuo.

Notorious for his clever tongue and legendary Daoist supernatural powers, Dongfang Shuo (159–93 B.C.E.) was an intimate adviser to Emperor Wu of the Han dynasty (r. 140–86 B.C.E.). A temple dedicated to his worship stood near his tomb, not far from the ruins of the city of Yanci, which was traditionally held to have been his birthplace. During the third century, the literatus Xiahou Zhan (243–291) visited the locale while his father was serving as governor there, and prompted by seeing a portrait of Dongfang Shuo at the temple, he composed an essay called "Encomium on a Portrait of Dongfang Shuo."[4] In 720, this well-known essay was engraved on a stele set up on the grounds of the temple by the prefect of Dezhou, a man named Han Si. In Yan's record of the outing to the temple, which was engraved on the reverse of the stele that he set up with his version of the *Encomium* on it, Yan described the scene on the day his traveling party visited Dongfang Shuo's temple:

> We wandered up the entrance path to the temple and found that Han Si's engraved stone was still there. All sighed, for the characters of the text were so fine and worn and the encroaching moss so flourishing. In forty years' time it had already been rendered illegible. I therefore had the text engraved into another stone, choosing this time to make the characters large, that they might endure. Though I could not remedy my awkward skill, I did not shirk the task, but took up the brush and wrote.[5]

Ping Lie and the other spies were convinced that Yan was an ineffectual literatus whose notions of government administration were limited to the refurbishment of local landmarks. An Lushan had no cause for worry from that quarter.

Wang Xizhi's *Encomium*

Yan Zhenqing's is not the only famous transcription of Xiahou Zhan's "Encomium on a Portrait of Dongfang Shuo." Wang Xizhi, the most celebrated calligrapher in the Chinese tradition, once copied it out for a younger friend named Wang Xiu (334–357). The traditional anecdote has it that Wang Xiu had been so fond of this piece of calligraphy that when he died his mother had it put into the coffin with him, and so the masterpiece departed from the face of the earth.[6] References to it later in the Six Dynasties period (317–589) seemed to corroborate the story. The learned connoisseur Tao Hongjing (456–536) once told Emperor Wu of Liang that "of all the famous pieces by Wang Xizhi, there are only a few remaining. One cannot determine if some of these works, such as the *Encomium*, are extant any longer."[7] Curiously, however, the calligraphy experts of the Tang dynasty dealt with the work as if it had never left the mortal realm. Chu Suiliang cited it in his list of the regular-script works by Wang Xizhi held in the Tang imperial collection. Sun Guoting, too, must have seen a version of the *Encomium*, for in his essay on calligraphy (*Shupu,* dated to 687), he described its style, calling it "extraordinary and unconventional."[8] Yan Zhenqing may have seen the *Encomium* in the imperial collection also, perhaps during the Opened Prime era (713–742), when his uncle by marriage, Wei Shu (d. 757), compiled a list of works by the two Wangs in the imperial collection.[9] He could also have been invited to view the imperial collection when he took the emperor's special examination in 742 or when Xuanzong favored him with a gift of his own calligraphy in 750.[10] If Yan did see the *Encomium*, did he shape his verson to respond to Wang's?

One opinion has been offered by Su Shi:

> After [I had seen Yan Zhenqing's *Encomium*], I saw the version by Wang Xizhi, and I realized that, character for character, the Duke of Lu's [Yan Zhenqing's] was a copy of this calligraphy. Although the sizes of the two are very different, the spirit resonance is very similar.[11]

Let us examine this assertion through the material available to us. The earliest extant copy of the Wang Xizhi *Encomium* is found in the engraved calligraphy compendium known as the *Jiang tie,* or "Model Calligraphies of Jiang Prefecture," which was compiled in 1049–1064 (Figure 3).[12] The ink rubbing of Yan's *Encomium* reproduced here is considered to have been taken during the Song or Yuan dynasties (tenth–fourteenth centuries) (Figure 4).[13] Unhappily, this rough date allows for the possibility that this ink rubbing could have been taken from the reengraving said to have been made during the Jin dynasty (1115–1234). In embarking on a comparison between the two, we should keep in mind that one and probably both are reengravings whose fidelity to

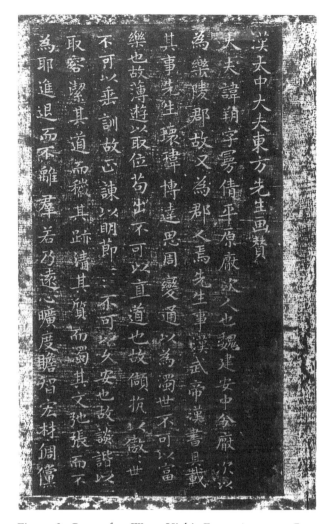

Figure 3. Copy after Wang Xizhi, *Encomium on a Portrait of Dongfang Shuo*, detail, 356, ink rubbing, from the *Jiang tie*. Collection of the National Palace Museum, Taiwan, Republic of China.

the original is hard to gauge. Even with this caveat, the two versions still seem to differ markedly both in content and style.

There are a substantial number of textual variations between the Wang and Yan versions. In each instance where they differ, Yan Zhenqing's text is in exact agreement with the text of the "Encomium" as it appears in the standard sixth-century anthology of literature, the *Wen xuan*. During the eighth century, at the time Yan Zhenqing studied for the Presented Scholar degree, the principal text memorized for the examination was the *Wen xuan*, so unquestionably he knew the text by heart from that source.[14] The differences in the version attributed to Wang

Figure 4. Yan Zhenqing, *Encomium on a Portrait of Dongfang Shuo*, detail, 754, ink rubbing. Beijing Palace Museum.

Xizhi suggest it may preserve a fourth-century textual variation of the "Encomium," different from the one codified in the sixth century. Although this variation bolsters the connection between the eleventh-century engraved version and the ink-written original, it also shows that Yan did not copy Wang's version "character for character."

In terms of style, the Wang rendition shows the hallmark of the Wang style that has been described with the phrase "left tight, right loose"—meaning that in each character the strokes are clustered more densely on the left-hand side, while the right-hand strokes fan out, creating an open, dynamic structure. The characters in Yan Zhenqing's version show much less inclination to movement; they are quite four-square and solidly placed on the ground line, with only a slight rising right-hand tilt to the horizontal strokes and no clustering of strokes on the left side. Yan Zhenqing's characters describe self-contained squares and rectangles, whereas the Wang characters are less ruled by core gravity and more as if by a centrifugal force that throws off the outer strokes. Compare, for example, the character "*xian*" in both pieces (the

eleventh character in the third column of the Wang piece and the fourth character of the second column in the Yan version). With Su Shi's reputation as a connoisseur in mind, I can only think that his real motive was to praise Yan by claiming he had achieved the same exquisite quality of "spirit resonance" found in the art of the Sage of Calligraphy. In short, based on the admittedly problematic visual evidence available today, I cannot accept the idea that Yan's version of the "Encomium" followed that of Wang Xizhi. One last argument can be cited against Su Shi's view. This argument was made by the Qing-dynasty connoisseur Liang Zhangju (1775–1849), who observed that Yan very clearly stated his motive in writing out the "Encomium" essay in his record of the event.[15] Yan said: "I therefore had the text engraved into another stone, choosing this time to make the characters large, that they might endure. Though I could not remedy my awkward skill, I did not shirk the task, but took up the brush and wrote." This, of course, would have been the moment to announce that he was writing out the piece in the style of Wang Xizhi. Since he did not, we may accept that he was not.

The modern Japanese scholar Toyama Gunji looked at the obvious differences in style of the two and proposed the possibility that Yan Zhenqing wrote out his *Encomium* in his own style "in conscious opposition to Wang Xizhi."[16] I find this proposal anachronistic. My argument in this volume is that the concept of opposition to the style of Wang Xizhi and the advocacy for the style of Yan Zhenqing as an alternative crystalized as part of a program of political propaganda in the eleventh century. This point of view did not exist before the Song dynasty and certainly not in the mind of Yan Zhenqing. Although considerable chauvinism about a "Tang style" can be readily discerned in Tang texts about calligraphy, particularly in those by Dou Ji (died ca. 769) and Xu Hao (703–782), Yan himself never expressed anything but admiration for the style of Wang Xizhi.[17] In fact, he went to some lengths to become affiliated with that tradition in the practice of cursive script.

Study with Zhang Xu

As a young man, Yan studied with the famous eccentric cursive-script master Zhang Xu (675–759). Zhang was known to Yan through family connections; Zhang's friend and relative He Zhizhang (659–744) was a member of the social circle that included Yan Zhenqing's father Yan Weizhen (670–712), his uncle Yin Jianyou (674–721), and his wife's uncle Wei Shu.[18] In his *Cursive and Seal Script Letter,* Yan referred to his study with Zhang:

> Since the time of the Southern Dynasties, many of my ancestors have
> been famous in their own day for their cursive, clerical, small seal,

and large seal scripts, but in their descendants that path has fallen into disrepair. Yet I once met with Administrator Zhang Xu and demonstrated my youthful lack of expertise to him. But since he was loath to part with his method, I could not gain any skill at calligraphy.[19]

We may brush aside his conventionally modest assertion that he gained nothing from Zhang Xu. Any testimony to personal contact with the glamorous figure of the great cursive-script master would suffice to establish the truth of the transmission of calligraphic style in the mind of the traditional reader.

Zhang Xu was depicted by his contemporaries in the conventional role of the artist whose genius is released by wine. In the poem by Du Fu (712–770) called "The Eight Immortals in Drink," the lines describing Zhang read:

> In Zhang Xu, three cups summon forth the Cursive Script Sage:
> he strips off his cap and bares his head before princes and lords,
> wielding his brush over the paper like clouds and mist.[20]

Another poet of the time, Li Qi (Presented Scholar, 735), wrote a "character sketch" poem about Zhang Xu, which begins with the lines:

> Master Zhang has an inborn craving for wine,
> Free and easy, no care for the world's business.
> Snow-white hair, total master of cursive and clerical scripts,
> Named by the age "Genius of Great Lake."[21]

Zhang Xu was a great celebrity of the High Tang period, and his legend throve posthumously. The following is the ninth-century account of his creative process from which the standard dynastic histories were later to draw:

> Zhang Xu's cursive script had its own brush method, which was handed down to Cui Miao and Yan Zhenqing. Xu said, "First I witnessed a noblewoman's porters racing each other down the road and from that I obtained my concept of a brush method. Later I witnessed Lady Gongsun dancing the *Jianqi* and from that [my cursive script] gained its spirit."
>
> Xu would drink wine and then execute his cursive script, wielding the brush and shouting, or dip his head into the ink and write with it, so that the whole world referred to him as Crazy Zhang. After he had sobered up, he would look at what he had done. He pronounced it demonic and prodigious, and he was never able to reproduce it.[22]

The wild and ragged cursive script produced by these unorthodox methods is called "mad cursive." The term "mad cursive" *(kuang cao)* was derived from "Mad Monk" (Kuangseng), a reference to another of its early practitioners, the Buddhist monk Huaisu (ca. 735–ca. 800). It

is characterized by radically simplified (sometimes illegible) character forms that often vary extremely in size and tend to be linked in a continuous movement. Its desired aesthetic effect is one of eccentricity and expressiveness. Even though he was one of the first to perform what came to be known as mad cursive, Zhang Xu's calligraphic pedigree was orthodox. He is said to have studied calligraphy with his uncle Lu Yanyuan, the son of Lu Jianzhi (585–638), who was a nephew and student of Yu Shinan, the high official and connoisseur of calligraphy for Emperor Taizong of the Tang dynasty.[23] Yu Shinan had studied calligraphy with the Buddhist monk Zhiyong (fl. ca. 557–617), a seventh-generation descendant of Wang Xizhi. Thus Zhang Xu may be said to be affiliated with the classical tradition.

Whether Yan Zhenqing sought out Zhang Xu because of his eccentric cursive style or because of his connection to the classical tradition is difficult to say, but he does seem to have considered Zhang a part of the Wang tradition. In his preface to a set of poems on the cursive script of his younger contemporary, the Buddhist monk Huaisu, Yan described himself as the latest generation in a genealogy of the cursive-script tradition of Wang Xizhi:

> The writing of cursive drafts arose in the Han dynasty. Du Du [first century] and Cui Yuan [77–142] were the first to gain fame by their marvelous ability. It then came to Boying [Zhang Zhi (died ca. 192)], who was particularly adept at its beauties. Then it descended to Wang Xizhi and Wang Xianzhi, after which Yu [Shinan] and Lu [Jianzhi] together inherited it. The oral formula was manually received, until it got to the administrator of Wu commandery, Zhang Xu . . . When I was young, I once went to stay with him and many times met with him to implore and urge him to teach me his brush method.[24]

This documentary material needs to be examined carefully for its veracity because the contact between Yan and Zhang is traditionally proved with the famous text called *The Twelve Concepts of the Brush Method of Administrator Zhang*, which purports to be Yan's record of his Socratic dialogue with Zhang on the subject of calligraphic technique.[25] This text is a fabrication of the Song dynasty.[26] Yan's letters discussing his study with Zhang are authentic, however, as far as I know, and they convince me that the meeting between Yan Zhenqing and Zhang Xu was not an invention of later writers. One further corroboration of their contact is this letter by Huaisu:

> When in my later years I took to roaming across China, what I regretted most was never having known Crazy Zhang the Administrator. Recently in Luoyang I accidentally encountered Minister Yan Zhenqing, who said that he had received the administrator's brush method. Hearing this method from Yan Zhenqing was like having had the chance to hear it from Zhang Xu.[27]

Our other resource to demonstrate a connection between the two is the extant visual material, which is admittedly problematic. No autograph work in cursive script by Zhang Xu survives. Of those few works commonly attributed to him, the stone-engraved *"Broken Stele" Thousand Character Classic* in the Forest of Steles in Xi'an is in fragmentary condition, as is another version called the *Cursive-Script Thousand Character Classic*.[28] There is also an engraved cursive-script *Heart Sutra* with a questionable attribution.[29] The unsigned *Stomachache Letter,* also in the Forest of Steles, is a reengraving of Ming date. The ink-written *Four Ancient-Style Poems* scroll in the Liaoning Provincial Museum is the subject of much disagreement: major connoisseurs of the past and present, such as Dong Qichang (1555–1636) and Yang Renkai, consider it a genuine work by Zhang Xu, but the compilers of the *Shiqu baoji* catalog of the Qing imperial collection (1745), for example, declared it fake.[30] The *Ziyan Letter,* now in Japan, is considered too tame in style and too poor in quality to be reliable.[31] I myself find the calligraphy in both the *Four Ancient-Style Poems* and the *Ziyan Letter*

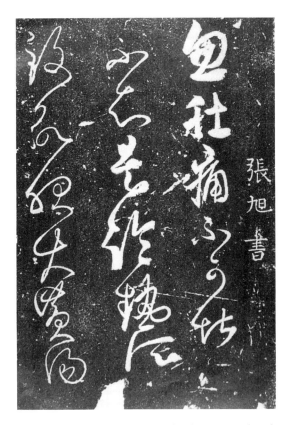

Figure 5. Zhang Xu, *Stomachache Letter,* detail, undated, ink rubbing. Shaanxi Provincial Museum. From *Shaanxi lidai beishi xuanji,* p. 130.

Figure 6. Yan Zhenqing, *Manjusri Letter*, detail, undated, ink rubbing, from the *Hall of Loyalty and Righteousness Compendium*. Zhejiang Provincial Museum.

stilted and wooden. The *"Broken Stele" Thousand Character Classic* and the *Stomachache Letter* are more complex and varied in terms of composition and line.

Let us compare the *Stomachache Letter* to the ink rubbing of the *Manjusri Letter* by Yan Zhenqing (Figures 5 and 6). In both we see large,

loosely organized characters spread openly across the paper, with several characters expanding beyond the borders of their column into the one adjacent. Many characters display looping, circular forms that impart a sense of entropy; many individual characters have compositions that would seem unbalanced were they taken out of context, but which are actually fully integrated into the structure of their respective columns. Interesting contrasts are created in the juxtaposition of straight lines and curving lines, giving the writing a feeling of being at once organic and geometric. While this comparison cannot offer definitive proof that Yan Zhenqing was a student of Zhang Xu, Yan's running-script style does seem much closer to Zhang's cursive script than to extant examples of Wang Xizhi's running script (Figure 2). Combined with the reliable documentary evidence, it convinces me that the transmission of style between the old eccentric and his self-appointed apprentice did take place.

Development of Regular-Script Style

In terms of his cursive-script manner, Yan Zhenqing believed himself a part of the classical tradition. His regular script seems to have followed a different development, however. During his years as an examination student and government official in Chang'an, he learned the Wang style of regular script taught at the imperial academy, mastery of which was necessary for the imperial examinations. This training produced the sort of calligraphy expected at the court of Emperor Xuanzong: characters are tightly composed, strokes are vibrantly modulated, and stroke ends are crisply pointed. Yan's contemporary Xu Hao, for example, was famous for his rendition of the court style (Figure 7).

The only extant inscription by Yan that shows his proficiency is the earliest, the *Prabhutaratna Pagoda Stele* of 752, which was written in Chang'an (Figure 8). Soon after that, with the *Encomium on a Portrait of Dongfang Shuo* of 754, he began to slough the piquancy associated with that style. The manner of the *Encomium* is noticeably different from the *Prabhutaratna Pagoda Stele*: much less modulation in stroke thickness is evident and the sharp stroke ends have been blunted. What was once a highly articulated manner became plainer and more severe. Here I would like to explore several possible explanations for this change in manner just two years after his departure from Chang'an into the provinces.

I have found no statement in which Yan affiliated himself with any particular tradition in terms of regular script. What we do know about his early training is that he was taught to write by family members, who would have used the writing of their illustrious ancestors as a model. The concept of clan identification in calligraphic style is rarely articu-

Figure 7. Xu Hao, *Epitaph for Amoghavajra*, detail, 781, ink rubbing. Shaanxi Provincial Museum. From *Shodō zen-shū*, 3rd ed., vol. 10, pl. 10.

lated in the traditional critical literature, perhaps because it was so obvious as to require no comment. One person who did remark on it was the Qing-dynasty critic Ruan Yuan (1764–1849). He wrote: "Yin Zhongrong and Yan Zhenqing of the Tang dynasty both employed the family style handed down from generation to generation in their steles in clerical and regular script."[32] Yin Zhongrong was Yan Zhenqing's great-uncle. Noted for his clerical script, he was one of the two out-

standing calligraphers at the courts of Emperor Gaozong and Empress Wu (r. 649–705). He served in a number of important government posts and was responsible for some of the epitaphs written for the high officials buried at the Zhaoling mausoleum of Emperor Taizong.[33] When his brother-in-law Yan Zhaofu died, Yin Zhongrong took over the education of his sons, Yan Yuansun (668–732) and Yan Weizhen, thereby transmitting his calligraphic style to Yan Zhenqing's uncle and father.[34] Yan Yuansun's style was said to be indistinguishable from Yin Zhongrong's, and it was Yuansun whom Yan Zhenqing credited with personally educating him.[35] Thus the foundation of Yan Zhenqing's style must have been the style of Yin Zhongrong.

If the manner seen in the *Prabhutaratna Pagoda Stele* resulted from

Figure 8. Yan Zhenqing, *Prabhutaratna Pagoda Stele*, detail, 752, ink rubbing. Shaanxi Provincial Museum. From *Zhongguo shufa quanji*, vol. 25: *Sui Tang Wudai bian, Yan Zhenqing* 1, p. 40.

Figure 9. Yin Zhongrong, *Stele for Li Shenfu*, detail, 651, ink rubbing. Zhaoling, Shaanxi. From *Shodō zenshū*, 3rd ed., vol. 8, p. 187.

his synthesis of the Yan and Yin clan styles taught to him in childhood and the Wang-style regular script taught in the Tang imperial academy, then one possible explanation for the change in manner evinced by the *Encomium* is that Yan elected for some reason to allow the influence of Yin Zhongrong's style to come to the fore. His four-square, open compositions seem to have more in common with Yin Zhongrong's clerical-script *Stele for Li Shenfu* (Figure 9) than with Wang Xizhi's *Encomium*. I see this not as a conscious rejection of the Wang style, however, but as a conscious affirmation of clan ties. Ancient clan connections were brought into Yan's consciousness by his posting at Pingyuan. His pride in family achievements is embodied in the inscription he wrote celebrating the three Yans who governed Pingyuan in the third, sixth, and eighth centuries—and, too, Pingyuan was close to Linyi, the ancestral family place in ancient Langye (modern Shandong).

Another theory to explain the stylistic differences between the *Prabhutaratna Pagoda Stele* and the *Encomium* was broached by the seventeenth-century connoisseur Sun Chengze (1592–1676) and embroidered further by the modern scholar Zhu Guantian. Concerning the *Encomium*, Sun Chengze wrote: "This calligraphy, compared to his other engraved works, is severe and ordered. I think that since Manqing's [Dongfang Shuo's] life was one of such extreme craftiness, later generations had to use extreme measures to rectify him."[36] In other words, Yan Zhenqing felt compelled to use an open and forthright manner in his calligraphy to counteract all the Daoist cleverness and trickery described in the biography of Dongfang Shuo. Yan's "upright" calligraphic manner would visually "rectify" Dongfang Shuo's crooked character. Zhu Guantian further contrasts the "severe and ordered" manner of the *Encomium* with the manner used for the *Prabhutaratna Pagoda Stele*.[37] He observes that since the literary style of the *Prabhutaratna Pagoda Stele* text is overwrought and the religious "miracles" described would not bear close examination, it was only appropriate for Yan to employ the ornate and mannered court style for this metropolitan inscription. The explanation advanced by these two historians is that Yan Zhenqing modified his style to reflect the content of the literary works he transcribed. I might extend their idea to the notion that since Yan was not the author of either text, speaking in his own voice, he was not compelled to represent himself in his calligraphic manner. Rather, it was appropriate to use his calligraphic manner to respond to the content of the text, either to conform to it or contradict it.

Another explanation for the change seen in the *Encomium* stele is that it reflects the influence of another format—that of cliff engravings, or *moya*. "*Moya*" literally means "smoothed cliff," so named from the common practice of planing a smooth surface on the face of a natural stone formation to engrave characters on it. Seeking another artistic

source for the open character structure and rounded strokes of the *Encomium* stele, Zhu Guantian and other contemporary historians of art in China have fastened on its stylistic similiarities to the Buddhist sutras engraved into the living rock at "Sutra Valley," on Mount Tai, in Shandong province.[38] Most often mentioned is the anonymous *Diamond Sutra* (Figure 10)—generally considered to have been written around 570.[39] Engraved into a dry creek bed, the characters are quite large (45 × 50 cm) and have expansive structures and blunt-ended, unmodulated brushwork. What makes this comparison particularly tantalizing is that Mount Tai is only about 110 kilometers south of Pingyuan.

Figure 10. *Diamond Sutra*, detail, ca. 570, ink rubbing. Mount Tai, Shandong. From *Shodō zenshū*, 3rd ed., vol. 6, pl. 93.

Yet we have absolutely no evidence that Yan ever visited Sutra Valley or saw ink rubbings taken from the inscriptions. The connection cannot be substantiated through documentary evidence, nor is the visual evidence compelling. The critical practice of locating the stylistic sources for the writing of well-known calligraphers in certain exceptional anonymous engraved stele inscriptions from the Northern Dynasties period (386–581) arose during the resurgence of epigraphic study that began during the reign of the Qianlong emperor (1735–1796). Chinese scholars are still wedded to this questionable practice today, as are some Western historians of calligraphy.[40] As I have argued elsewhere, the notion that anonymous calligraphy would have any place in the development of one's personal style ran counter to the class and clan consciousness of the traditional scholar-official.[41] They were freed from this bias only under the changed historical circumstances that led to the rise of the epigraphy studies movement in the eighteenth century.

The explanations we have looked at so far include a reassertion of clan style, a response to the content of the text, and the influence of an earlier monument. The move away from court, out into the provinces, for some reason caused Yan to abandon his metropolitan style. Could he have adopted a self-consciously "provincial" style? If a metropolitan style is crisp and mannered, would a provincial style be rustic, archaic? If he had indeed embraced such an aesthetic, it would bind together two of the proposed explanations for his change of manner. *Moya* such as the Sutra Valley engravings are not produced in metropolitan areas; they are found in mountain wilderness, where they are viewed as part of the natural scene, as if emanating organically from the fissured depths of the rock. Their character structures are loose and their strokes blunt, not artificially sharp and refined like a court production. Archaic qualities, too, would be instantly conveyed by echoes of the style of Yin Zhongrong, who was a master of the even, square forms of the antique clerical script.

Another missing piece of the puzzle is Han Si's stele of 720 that Yan replaced. In his record of the event, Yan never mentions Yin Zhongrong, Wang Xizhi, or Mount Tai, but he does speak sadly of the corrosion of Han Si's inscription. Did Yan's version respond to Han's in some way? This question must remain unanswered. Though three broken pieces of the Jin-dynasty reengraving of Yan's stele remain in Dezhou, Han's stele, as far as I know, is lost entirely. Yan's *Encomium* was not so much about Wang Xizhi's as it was about Han's stele, whose worn and mossy face he confronted during a period of personal and national insecurity. His reaction in such a case would not be to assert his individualism and mount an aesthetic challenge to Wang Xizhi, but to reaffirm tradition and attach himself to the stable weight of the centuries. Given the evidence at hand, I conclude that the style of Yin Zhongrong was

the strongest influence in Yan Zhenqing's development away from the manner of the court of Emperor Xuanzong.

Although I maintain that Yan Zhenqing's transcription of the "Encomium" was neither a copy of the work by Wang Xizhi nor a challenge to it, the words of his predecessor may have resonated in his mind as he looked on the stele that had been all but obliterated in less than forty years. At the end of his famous "Preface to the Poems Written at the Orchid Pavilion Preface" *(Lantingxu),* Wang Xizhi wrote:

> Whether long or short our lives follow fate and at last must end. The ancients said, "Great indeed are life and death." Is this not painful? Whenever I ponder the men of old their sources of feeling agree with ours.[42]

This poignant awareness of the brevity of life is expressed in Yan Zhenqing's description of the discovery of the stele of 720 on the temple grounds:

> We wandered up the entrance path to the temple and found that Han Si's engraved stone was still there. All sighed, for the characters of the text were so fine and worn and the encroaching moss so flourishing. In forty years' time it had already been rendered illegible.

The "Orchid Pavilion Preface" continues:

> Men in after time will look back upon us as we look back upon those who have gone before us, alas! . . . Though times and happenings alter and differ, may men in what moves them be brought together. They who regard us from the future will also be touched by these writings.

Wang Xizhi gained immortality through the words and calligraphy of the "Orchid Pavilion Preface." Han Si, too, participated in the endless flow of Chinese cultural history by putting his name to his *Encomium,* but his bid for immortality was on the brink of extinction when Yan Zhenqing and his party came upon it. Yan saved his name, but Han's brush with oblivion made a sobering warning. Yan described his response in the record on the *Encomium* stele reverse:

> I therefore had the text engraved into another stone, choosing this time to make the characters large, that they might endure.

As Han Si had done, Yan Zhenqing would connect himself with the cultural immortality of Dongfang Shuo, Xiahou Zhan, and Wang Xizhi and thereby fix for the future his name and his confrontation with time.

Yan Zhenqing's Antebellum Career

Yan Zhenqing's appointment to Pingyuan represented the first check to an official career in which he had progressed steadily upward

through the ranks of official positions and prestige titles. The Yan family had lived in Chang'an and served in official positions for five generations since Yan Zhitui moved there in the sixth century. Though Zhenqing's ancestors Yan Zhitui and Yan Shigu (581–645) were quite illustrious, his grandfather Yan Zhaofu never held a policymaking position but served as reader-in-waiting to the Princes of Jin and Cao. His father, Yan Weizhen, rose only to the midlevel post of companion to Li Longye (ca. 687–734), the Prince of Xue. Thus Yan Zhenqing's older brothers had to begin their more distinguished careers with degrees earned through the examination system. His brother Yunnan (694–762) was particularly successful, and it seems he was able to help the younger brothers Zhenqing and Yunzang (710–768) in their careers. Following the untimely death of Yan Weizhen in 712, Lady Yin and her children moved to the home of her brother Yin Jianyou in another ward of Chang'an. After Yin Jianyou's death in 721, the family went to live in Wu (modern Suzhou, Jiangsu) with Lady Yin's father, Yin Zijing, where he served as district magistrate. Later the family moved to Luoyang, where Zhenqing's paternal uncle Yan Yuansun continued Zhenqing's education. Luoyang is where Yan apprenticed himself to Zhang Xu.

Yan Zhenqing was taught to read by his mother and instructed in poetry and pronunciation by his aunt, Yan Zhending (654–737). It might seem unusual that Yan would have such close contact with his father's married sister, but Yan Zhending was married to Yin Lüzhi, his mother's brother. The clans of Yin and Yan had become enmeshed over the years, as Yan sons had married Yin daughters six times in five generations. The extent of pedigree collapse was considerable: not only was Yan Zhending married to Yin Lüzhi, and Yan Weizhen to Yin Zijing's daughter, but in Zhenqing's own generation two of his brothers married their cousins from the Yin clan.[43]

His older brother Yunnan also had a great influence on him. The didactic tenor of the relationship between the two brothers comes out in an episode from his childhood that Yan Zhenqing recounted in the epitaph he wrote for Yunnan:

> Our family had a crane with a broken leg. When I was small, I would play by writing on its back. Yunnan rebuked me severely, saying, "Even though it cannot fly away, is it not terribly inhumane to have no consideration for its wings and feathers?" I have remembered that all my life.[44]

In 734, Yan passed the examination for the Presented Scholar degree. That year the chief examiner was Vice Director of the Bureau of Evaluations Sun Di (696–761), the man responsible for granting the degrees of many of the other eminent men of the age, including Du Hongjian (709–769), Li Hua (ca. 710–767), and Xiao Yingshi (706–758).[45] Some thirty years later, Yan Zhenqing wrote the preface to Sun Di's collected

literary works.[46] Yan Zhenqing was also married that year to a daughter of Wei Di. Wei Di was the brother of Wei Shu, the great historiographer and genealogist who was a close friend of Sun Di and of Yan Zhenqing's uncles, Yan Yuansun and Yin Jianyou.[47]

For the early part of Yan Zhenqing's career as an official, he served mostly in coveted positions in and around Chang'an. In 736 he was recommended for the Examination for Selecting the Preeminent, a test of ability in rhymed prose and poetry composition. After an evaluation by the Ministry of Personnel, he was given the prestige title of Gentleman for Closing Court and an appointment as an editor in the Palace Library, a post given only to men of unusual literary promise. When his mother died in 738, he and his brothers left their official posts for the prescribed three years of mourning. In 741 he resumed his offices in Chang'an. Following his service as editor in the Palace Library, Yan Zhenqing was recommended in 742 for the Examination for Erudites of Outstanding and Extraordinary Literary Expression. This special examination was held in the Hall of Diligent Administration and supervised by Emperor Xuanzong himself, who passed Yan in the first rank. As a result, early that winter he was rewarded with an appointment as district defender of Liquan, near the summer pleasure palaces of the Tang emperors and the imperial mausoleums.

By this time he counted among his friends several young men who would become the leading literary personalities of their day, including Xiao Yingshi, Li Hua, and Yuan Jie (719–772). These men were the dominant members of a group of Confucian intellectuals who were opposed to the excessive ornamentation of language and obfuscation of meaning found in court poetry. In its stead they promoted a return to the expression of Confucian moral and social values expressed through classical prose.[48] That Yan was associated with a group of scholars advocating *fugu,* "a return to antiquity," made him a particularly attractive candidate for promotion by Han Yu and Ouyang Xiu, both later proponents of "antique" Confucian values.

Based on the recommendation earned by his capable administration of Liquan, Yan Zhenqing was granted the higher prestige title of Court Gentleman for Comprehensive Duty in 746 and an appointment as district defender of Chang'an, a post his uncle Yan Yuansun had once filled. Chang'an district comprised all wards of the city west of the Gate of the Vermilion Bird Street, so that half of the Western Capital came under Yan Zhenqing's administration. Then, from 747 to 749, he served as an investigating censor and filled two military supervisory positions: first as probationary army commissioner of state farms and tributary trade for the Hedong and Shuofang Armies, then the following year in the same post for the Hexi and Longyou Armies, and the year after that in the former position again.

In the autumn of 749, Yan Zhenqing returned to the capital, where he was appointed a palace censor. Quite soon he offended his superiors with a forthright criticism, as he was to do afterward, again and again, for the rest of his life. In this particular case, Vice Censor-in-Chief Ji Wen had the son of the late revered statesman Song Jing (663–737) sent out into the provinces in disgrace because of some private grievance. "Why endanger the progeny of Song Jing in a moment of anger?" Yan protested—which earned him the enmity not only of Ji Wen but of Yang Guozhong, as well, who recognized the danger to himself in an honest, outspoken official. Yang Guozhong had Yan Zhenqing sent to Luoyang as an investigating censor and administrative assistant, but he was soon transferred back to Chang'an as a palace censor late in 750.

Yan Zhenqing served as a palace censor for two years and was then transferred in 752 to the post of vice director in the Ministry of War. The demand for his services as a calligrapher appears to have begun around this time. As a high-ranking minister serving in the capital who was the descendant of illustrious statesmen and renowned calligraphers, he was asked to write out the texts of important inscriptions to be engraved for public monuments. He composed and transcribed epitaph steles for the minister of works, Guo Xuji, and the administrator of Henanfu, Guo Kui (no longer extant). Sometime around 754, Yan wrote out the epitaph for the eminent Confucian teacher Yuan Dexiu (696–754), a cousin of Yuan Jie. Though no longer extant, the stele inscription was famous enough to be noted in Li Hua's biography in the *Tang History*. The text was composed by Li Hua and written out by Yan Zhenqing, with a heading in seal script by Li Yangbing (ca. 722–ca. 785), who was known not only as the preeminent master of seal script in the Tang but as a poetry scholar, official, and friend of the great poet Li Bai (701–763).

The earliest surviving work of Yan's is dated to 752: the *Prabhutaratna Pagoda Stele* discussed earlier (Figure 8). This stele was erected for the Dharma Master Chujin at the Prabhutaratna Pagoda on the grounds of the Thousand Blessings Monastery (Qianfusi) in the Anding ward, in the northwestern sector of Chang'an. The text, called "Gratitude for Prayers Answered," was written by Cen Xun, transcribed in regular script by Yan Zhenqing, and given a heading in clerical script by Xu Hao. Known familiarly as the *Prabhutaratna Pagoda Stele (Duobaota bei)*, it stands today in the Forest of Steles of the Shaanxi Provincial Museum in modern Xi'an. Yan Zhenqing was also asked to transcribe the text for a Confucian monument during this time —a stele for the Temple of Confucius in Fufeng (Shaanxi), one hundred kilometers west of Chang'an. The text was composed by Cheng Hao, and it too had a heading written out by Xu Hao. This stele was excavated late in the sixteenth century in a ruinous state, with only some

Figure 11. Yan Zhenqing, *Stele for the Temple of Confucius in Fufeng*, detail, ca. 742–756, ink rubbing. Beijing Library.

eight lines of the text still legible. Only ink rubbings are extant now (Figure 11).

By 754, then, Yan been exposed to the styles of the greatest names in calligraphy of his day—Xu Hao, Li Yangbing, Emperor Xuanzong, and Zhang Xu—not to mention his own relatives who were famous for their calligraphy: Yan Yuansun and Yin Zhongrong. The forces that shaped Yan's early style to fit the court style of Xu Hao and Emperor Xuanzong we have already seen, and I have argued for the importance of his family's traditions. The profound influence of Li Yangbing's seal script on Yan's regular script will be treated later.

When the emperor issued his proclamation of 753 ordering dozens of ministers out of the capital to fill commandery governor positions, Yan Zhenqing's post as vice director in the Ministry of War qualified him for selection for this unenviable honor. His brother-in-law Cen Shen (715–770) composed a poem for him on the occasion of his departure for Pingyuan. The closing couplet reads: "The people already yearn for you, but a Huang Ba will never remain for long!"[49] Huang Ba (d. 51 B.C.E.) was a Han-dynasty official who was elevated to high national

office on the basis of his excellent record as a local administrator. Although Cen Shen proved remarkably prescient in forecasting that Yan Zhenqing's service at Pingyuan would gain him a national reputation, he surely must have envisioned it being earned in the calm routine of provincial life, not in the chaos of war.

3

"The Nest Tipped and the Eggs Overturned": The An Lushan Rebellion

THE ARMIES OF An Lushan sacked Luoyang just thirty-three days after they rose against the Tang from Youzhou. The rebels had encountered virtually no resistance from the officials and populace in the commandery cities of Hebei through which they marched southward. Their route took them west of Pingyuan, leaving Yan Zhenqing's siege preparations untested, and through Changshan, where his cousin Yan Gaoqing (692–756) was serving as governor.[1] Since there were no forces with which to resist him, when the rebel general passed through the city, Yan Gaoqing and his deputy, Yuan Lüqian, made their obeisances to him on the road. An Lushan confirmed their allegiance by presenting them with official robes and securing several Yan clansmen as hostages. He further ordered them to provide assistance to the forces of his generals Li Qincou, Gao Miao, and He Qiannian in guarding Tumen Pass near Changshan, a critical gateway into Hebei.

Yan Zhenqing at War

An Lushan sent a dispatch to Yan Zhenqing ordering him to combine the troops stationed at Pingyuan and Boping to defend the river ford at Bozhou against the imperial armies. Instead Yan Zhenqing recruited local men to supplement the Pingyuan garrison and made generals of other local officials. Within a week, he had assembled ten thousand troops. Outside the western gate of the city, he held a great banquet for the officers, at which he made an impassioned call for loyalty and then reviewed the troops personally. This show of force inspired the governors of Raoyang and Jinan to return their garrisons to the loyalist cause.

At this time, early in 756, Yan Gaoqing conceived a plan to destroy the rebel defense of Tumen Pass, which would then permit the imperial armies to enter Hebei from the west and cut the rebels' supply line to the north. He issued a false order in An Lushan's name calling Li

Qincou to Changshan. Li was killed outside the city walls, and the rest of his party was seized and executed the following day, causing the rebel troops at Tumen to scatter. Gao Miao and He Qiannian were captured alive on their return and transported, along with the head of Li Qincou, to the capital by Gaoqing's son Quanming. On the way, however, Quanming was detained by Wang Chengye, the governor of Taiyuan (Shanxi), who substituted Gaoqing's memorial to the throne with one of his own claiming the capture of the generals and the opening of Tumen Pass as his own achievement. Deceived by Wang Chengye's memorial, the emperor promoted him. But soon the truth came to light and Yan Gaoqing was rewarded with the exalted positions of chief minister of the Court of Imperial Regalia and vice censor-in-chief, positions he was never to fill.

When Yan Gaoqing opened Tumen Pass, seventeen Hebei commanderies came back to the throne in one day, declaring Yan Zhenqing their leader. The Hebei loyalists now had a total force of two hundred thousand troops and had cut the rebels off from their supply base in the north. An Lushan had already marched his forces westward out of Luoyang toward Chang'an when news reached him that Hebei had risen in resistance. He returned to Luoyang and ordered a combined assault on Changshan: the rebel forces under Shi Siming (d. 761) were to drive southward to attack Changshan while Cai Xide led another army north to join in the siege. Changshan was not heavily garrisoned or prepared for a siege. After six days of constant battle, its wells and stores of grain were exhausted, and it was compelled to surrender. Gaoqing's son Jiming and grandson Lu Di were beheaded there, but Gaoqing and Yuan Lüqian were taken alive to Luoyang and brought before An Lushan.

"I secured your appointment as governor!" An Lushan raged at Gaoqing. "Why did you revolt when I trusted you?"

"I received the favor of the state," Gaoqing replied. "Official positions are all granted by the Son of Heaven. You received that favor and now you dare to rebel. You would trust me, but you cannot be trusted by your own dynasty! Stinking barbarian dog, why not kill me quickly?"[2] An Lushan's soldiers bound Gaoqing to the pillar of a bridge, displayed before the brother of He Qiannian and a crowd of spectators, and as he continued to rail at his captors, his tongue was cut out. He was then executed by dismemberment.

As surprising as the behavior of Gaoqing proved to An Lushan, so that of Zhenqing seemed to the throne, even though early in 755 he had sent one of Yang Guozhong's own spies to court with a memorial reporting An Lushan's preparations for revolt.[3] When Emperor Xuanzong was first informed of An Lushan's initial success, it is said that he cried in despair, "In all twenty-four commanderies of Hebei is there not one loyal official?" But Yan Zhenqing sent his military administrator

flying to Chang'an to register his loyalty. When he arrived, the emperor sent several imperial commissioners out to welcome him, and he was instructed to gallop straight through the Forbidden City to the gates of the inner palace. After Yan Zhenqing's memorial was read, the emperor declared to his courtiers: "We never knew what kind of man Zhenqing was, that he could be such as this!"

The dreadful news of the sack of Luoyang reached Hebei with an envoy from the rebels. Duan Ziguang had been instructed to display to the loyalists the heads of three high officials of Luoyang, and he traveled from one commandery to the next with his intimidating exhibition. According to Yin Liang, Yan's biographer nephew, when Duan Ziguang came through the city gate of Pingyuan, dragging the heads in the dust behind him, he shouted: "The vice director [An Lushan] entered the Eastern Capital on the thirteenth. All areas near and far have surrendered. Now he hears that the commanderies of Hebei have not conceded, so he orders me to make this report. Do not harm me or your day of regret will soon come!" Then he pointed to each head in turn and announced its identity. Yan Zhenqing did indeed recognize the murdered officials, but to prevent panic he told his officers that Duan Ziguang was lying and had him cut in half. Secretly, however, he saved the three heads. On a later day they were washed and dressed, bodies of straw were fashioned for them, and they were buried with full sacrificial rites outside the city. Yan Zhenqing mourned three days for them.

On the winter day Duan Ziguang was executed, the rebel army under Shi Siming commenced the fatal attack on Changshan and several Hebei commanderies reverted to the rebel side. For his success in holding his city, Yan Zhenqing was appointed vice minister of revenue as a show of appreciation, but he was ordered to remain as governor and defense commissioner of Pingyuan. Soon after, he was also made Hebei Bandit Suppression and Investigation Commissioner, a position that until recently had been An Lushan's post. Following the sack of Changshan, Shi Siming's rebel forces moved east and laid siege to Raoyang. Early in the spring, however, the imperial army under Li Guangbi (708–764) came through Tumen Pass and returned Changshan to the Tang. Shi Siming attacked Changshan once again, but he suffered a defeat and was forced to regroup.

Yan Zhenqing then devised a plan to open the pass at Guokou, in the southwest corner of Hebei, to allow the entry of imperial forces. He dispatched the Pingyuan troops, who joined forces with the Qinghe garrison and volunteers from Boping, to take Wei commandery and expel its rebel governor. The rebels fielded an army of twenty thousand against the smaller force from the three loyalist commanderies, but after a full day of bitter fighting, the rebels were routed and the governor fled.

To prevent any rescue of Raoyang by the victorious loyalist volun-

teers, Shi Siming sent an expeditionary force to surround Pingyuan. Fearing his men outnumbered, Yan Zhenqing called upon Helan Jinming, the governor of Beihai (Shandong), to lead his cavalry and infantry north across the Yellow River to aid them. Yan Zhenqing arrayed his troops on the riverbank to welcome them, and the two leaders exchanged their bows and ritual expressions of mourning on horseback. Gradually, Yan Zhenqing transferred the management of military affairs to Helan and ceded credit for the victory at Wei commandery to him. As a result, Yan Zhenqing's post as commissioner of bandit suppression in Hebei was given to Helan by imperial decree.

During this time, the Tang general Guo Ziyi (697–781) and his forces had come through Tumen Pass to join Li Guangbi in battle against the rebel armies under Shi Siming and Cai Xide. They split the rebels and regained the areas south of Changshan. In a second, massive engagement, the armies of Shi Siming and Cai Xide, reinforced by troops sent by An Lushan from Luoyang and Youzhou, hurled themselves against the imperial armies at Jiashan and were decimated. In their flight, the siege of Pingyuan was lifted.

The loyalist forces promptly took Jizhou and consolidated their hold on the center swath of Hebei. Heartened by the loyalists' success, the Pinglu military commissioner Liu Zhengchen brought the area under his control, immediately northeast of the rebel base at Youzhou, back to the Tang. To solidify his commitment, Yan Zhenqing sent a contingent from Pingyuan over the Bohai Sea to present Liu Zhengchen with a good faith guarantee: a shipment of matériel and a ten-year-old boy named Yan Po, Yan Zhenqing's only son. The forces loyal to the Tang were now in a position to undertake a final march on Youzhou.

That summer, however, Grand Councillor Yang Guozhong ordered the imperial army under Qosu Khan (Geshu Han, d. 756) out of its defensive position at Tong Pass and into a rebel ambush. The Tang army was destroyed, and An Lushan's troops came through the pass to take Chang'an. When Li Guangbi and Guo Ziyi heard of the disaster at Tong Pass and the flight of Emperor Xuanzong to Sichuan, they marched their troops out of Hebei through Tumen Pass and set out for the capital. Soon they learned the heir apparent had escaped to Lingwu (Ningxia) in the northwest and proclaimed himself emperor there, and so they marched westward to his defense.

With the retreat of the imperial armies, the loyalist commanderies of Hebei stood alone against the rebels. Supplies and munitions were virtually exhausted, so Yan Zhenqing resorted to unorthodox methods to raise money, including the seizure of the salt in the Jingcheng depot, which he then sold among the other commanderies. High honors continued to flow from the throne. Emperor Suzong granted Yan Zhenqing

the positions of minister of works and censor-in-chief and reappointed him Hebei commissioner of bandit suppression and investigation.

Early that autumn, An Lushan dispatched Shi Siming and Yin Ziqi to subdue the commanderies of Hebei. Over the next three months, their city gates opened to the rebels one by one. At last only Pingyuan, Boping, and Qinghe remained, bereft of soldiers, the loyalty of their terrified citizens wavering. Knowing that surrender would bring him only a senseless death or a treasonous acceptance of office under the rebels, Yan Zhenqing led a small cavalry force out of Pingyuan and across the river. He traveled westward through the winter, dodging rebel forces, until he came to a safe haven at Wudang (Hubei).

Emperor Suzong returned from Lingwu to set up a temporary imperial court at Fengxiang (Shaanxi) in the second month of 757. Partly to acknowledge Yan's heroic performance and partly to increase the slender ranks of officials at the temporary court, the emperor honored Yan Zhenqing as a paragon of loyalty and sent an announcement of office to Wudang, granting him the exalted post of minister of justice. Two months later, Yan presented himself at the temporary court with a memorial arguing that a better service to justice would be punishment for having deserted his commission. His memorial of refusal concludes:

> Then the rebels Shi Siming and Yin Ziqi took advantage of Liu Zheng-chen not yet having arrived and attacked us with all their might. No aid came to the commanderies, and so they were overwhelmed one after the other. All because I was inadequate and weak, without device, I caused this disaster. Integrity would demand that I risk death amid danger and defend the orphaned city to the last, but I believed that returning to indict myself at the imperial court would be better than being seized by rebel hands. Therefore, I escaped with my life and crossed the river. . . .
>
> I received repeated imperial edicts permitting me to come to court, which arrived at Wudang commandery. Then I received this gracious mandate appointing me minister of justice and director of the censorate, and the announcement of office was sent to me. Though to take up these posts would be extremely selfish, refusal to serve is fearful. . . .
>
> Furthermore, though my reputation is negligible, these positions are very important. The corpus of government must be composed of exemplary men. The imperial grace is what first reaches subordinates, but punishment, too, should come from on high. If one man is indicted, then thousands will know fear. If I presume on favored status, then how will the empire remain in awe? My humble desire is for Your Majesty to censure heavily this one official, myself, in order to demonstrate the justice of heaven and to let the subcelestial realm know there are laws that must be followed and commands that must be appreciated. Favor and honor far surpass the post of minister. Not to take office would be the most earnest and sincere course.[4]

The emperor rejected his argument for refusal to serve:

> Though you did not hold Pingyuan, your efficacy was great. From afar you returned to court, profoundly aiding Our aspirations.
>
> > We grant you receipt of a mandate to serve on winged feet,
> > but your request to indict yourself We cannot meet.[5]

Yan Zhenqing had always been an outspoken advocate of traditional Confucian values at court, ever conscious of his clan connections to the eight disciples of Confucius surnamed Yan, but after his return from Pingyuan his criticisms of the conduct of other court officials became more frequent.[6] Issues of ritual nomenclature and proper behavior at court assumed great importance as symbols of the restoration of normal political life. The court to which Yan returned was hardly the brilliant assembly that had flourished under Emperor Xuanzong just two years before. Emperor Suzong now held court, not in Chang'an or Luoyang, but in Fengxiang, the headquarters of a military commission up the Wei River from Chang'an, supported by a tiny remnant of the armies and official ranks of the Tang government. While Retired Emperor Xuanzong still lived, the possible accusation of usurpation threatened Suzong and rumors of factional intrigue loomed. This unorthodox, provisional situation seemed to provoke a heightened vigilance in Yan Zhenqing. In the eight months he remained at court, he lodged several charges against his fellow officials, impeaching one for drunkenness at court, another for disrespectfulness in the court ranks, and he complained to the emperor that a third had mounted his horse prior to the heir apparent. He also criticized the actions of the throne. In one case, he objected to the use of a certain ritual epithet for the emperor; in another, he argued that the emperor should mourn for three days before rebuilding the imperial ancestral temple in Chang'an, which had been destroyed by An Lushan.

Yan's fame from resisting the rebels and the high positions of his brothers (Yunzang served as a palace censor and Yunnan served in the Ministry of Personnel) made him a threat to the Grand Councillors Cui Yuan, Li Lin, and Miao Jinqing. At the end of 757, after the two capitals had been retaken and the retired emperor had been summoned back to Chang'an, Yan was sent out to Tongzhou (Shaanxi), one hundred kilometers northeast of Chang'an, to serve as prefect there. The standard histories of the Tang assert that he was degraded "because of the enmity of the grand councillors," but in the account of his life written by his nephew Yin Liang, the cause is given as having "opposed the imperial will."[7] Evidently, both statements were true.

Why did Yan Zhenqing embrace the role of the prickly Confucianist upon his return? Why did he refuse the appointment as minister of justice with a self-indictment and alienate his supporters by criticizing

every lapse in behavior that he perceived at court? In the Confucian ideal, a gentleman should know when to serve and when to retire. Surely to have stayed in Pingyuan would have been suicide. But by taking the sensible course, Yan Zhenqing failed to sustain a perfect expression of loyalty to the throne. Mencius said: "I desire life, but I also desire righteousness. If I cannot have both, I will let life go and choose righteousness."[8] Yan Zhenqing chose life, but he knew one who had died with integrity intact. In his epitaph for his cousin Yan Gaoqing, he wrote:

> Gaoqing and I were both defeated on rebel soil, but we are separated now by a thousand leagues. Although his natural endowment of righteousness was without compare, heaven was not trustworthy, for Gaoqing died, while I did not. How bitter, indeed![9]

That he was not martyred at Pingyuan distressed him the remainder of his life. And when he did meet his end at the hands of another rebel some thirty years later, he told his captors that he would die with loyalty unwavering, just as his cousin Gaoqing had done.[10]

In the spring of 758, Yan Zhenqing was transferred from Tongzhou to serve as prefect of Puzhou (Shanxi), some forty kilometers to the east, and he was enfeoffed as Dynasty-Founding Marquis of Danyang District (near modern Nanjing, Jiangsu). The Tang armies had regained both capitals, An Lushan was dead, and Shi Siming had, for the time being, shifted his allegiance back to the throne. One surviving son of Yan Gaoqing, Yan Quanming, was released from the rebels' prison. Quanming returned to Luoyang to retrieve his father's corpse for burial at the family cemetery in Chang'an. Yan Zhenqing asked him also to gather the subordinate officials, wives, children, and servants of Yan Gaoqing and Yuan Lüqian who had spent the last two years at Changshan and the members of the Yan clan who had been held hostage by the rebel forces. Quanming returned more than three hundred people to Puzhou, and Yan Zhenqing had them all generously supplied and escorted to their chosen destinations.

The *Draft Eulogy for Nephew Jiming*

Quanming also brought to Puzhou the head of his brother Jiming, who had been decapitated by the rebels after the fall of Changshan in the winter of 756. Before Jiming's head was returned to Chang'an for burial, Yan Zhenqing drafted a haunting eulogy for his nephew:

> On the third, a *renshen* day, of the ninth month, in which the first was a *gengwu* day, of a *xuwu* year, the inaugural year of the reign period Supernal Prime [9 October 758], his thirteenth uncle, Grand Master of Imperial Entertainments with Silver Seal and Blue Ribbon, Com-

missioner with Extraordinary Powers Over All Military Affairs in Puzhou, Prefect of Puzhou, Senior Commandant of Light Chariots, and Dynasty-Founding Marquis of Danyang District, Yan Zhenqing, with pure wine and a complement of delicacies, sacrifices to the spirit of Jiming, his late nephew, who was granted the posthumous title of Grand Master Admonisher:

From your birth, you showed your youthful virtue early. Like sacrificial vessels in the ancestral temple and fragrant plants in the courtyard, you were a comfort to our hearts. In those days, you were blessed and happy. How could we have imagined that rebel traitors would commence our misfortune? But they took up arms and violated their submission [to the throne].

Your father [Yan Gaoqing] expended his integrity as commandery governor of Changshan, while I, too, had received a mandate at that time, in Pingyuan. My selfless older brother so loved me that he employed you to send word to me. You had already returned home when Tumen Pass was opened, but with the opening of Tumen Pass, the villains feared they would be pressed on all sides. A traitorous official [Wang Chengye] failed the rescue and so the orphaned city was besieged and compelled to submit. The father was taken and the son killed, the nest tipped and the eggs overturned. Heaven has no regret for this calamity, but who else could cause such suffering? I remember how you met with your cruel death, but how could we ransom all those people? Alas, how I grieve!

Since that time, I have been graced with the Beneficence of Heaven and transferred to shepherd the flock on the He-Guan border [Puzhou]. After Quanming found me and Changshan was retaken, he retrieved your encoffined head and has now returned together with it. The memory of your destruction is revived in me and the shock of grief in my heart and my face is just as it was on that distant day. I send this announcement to your abode in the nether world, that your spirit may have knowledge of it. Do not weep there long. Alas, how I grieve! May you accept this offering.[11]

The *Eulogy* as Art Object

The *Draft of the Eulogy for Nephew Jiming* is now in the collection of the National Palace Museum in Taipei, mounted in brocade covers and embellished with the inscriptions and seal impressions of centuries of collectors (Figure 12).[12] There are nine colophons on the scroll of the *Eulogy*, ranging in date from the Yuan dynasty (1279–1368) through the eighteenth century. Xianyu Shu (1257?–1302), who acquired the scroll in 1283, stated that traces of a small Xuanhe imperial seal and Emperor Huizong's (r. 1100–1126) round *Tianshui* seal could still be seen. Zhang Yan, who obtained the scroll from the Xianyu family in 1301, wrote that a clumsy mounter had cut off the Xuanhe imperial seals and inscriptions; all that remained was a partial impression of the

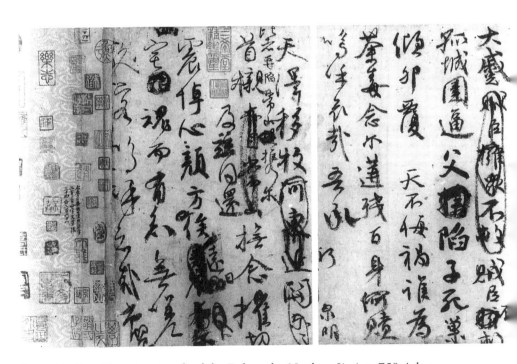

Figure 12. Yan Zhenqing, *Draft of the Eulogy for Nephew Jiming*, 758, ink on paper. Collection of the National Palace Museum, Taiwan, Republic of China.

round *Tianshui* seal. If this testimony about the seals is correct, then the scroll was once part of the imperial collection during the Xuanhe era (1119–1125), which is corroborated by its listing in the *Calligraphy Catalog of the Xuanhe Era*. There are also two seals still visible on the scroll that can be linked to female connoisseurs at the court of Emperor Gaozong (r. 1127–1162) of the Southern Song dynasty (1127–1279): Empress Wu (1115–1197) and the concubine Liu Niangzi. The scroll probably remained in the imperial collection until the Mongol conquest. During the Yuan dynasty, the scroll was passed around in the circle of the artist and high official Zhao Mengfu (1254–1322). One of his seals appears on it, as well as colophons by his friends Xianyu Shu and Zhou Mi (1232–1298). Although no colophons of Ming date appear on the scroll, a number of seals of Ming collectors can be seen, and the scroll is recorded in several Ming-dynasty catalogs of art. Two colophons dated to 1694 and 1724 describe a succession of private owners in the late seventeenth and early eighteenth centuries. The scroll has a heading written by the Qianlong emperor and is recorded in the imperial catalog *Shiqu baoji xubian* of 1793, indicating that it entered the Qing imperial collection during his reign.

To sum up its history, the scroll was probably handed down privately during the Tang and Five Dynasties periods, perhaps within the Yan family. The wealthy Chang'an collector An Shiwen owned this scroll and several other works by Yan in the late eleventh century.[13] In the early twelfth century, it entered the Song imperial collection, only to reemerge in the public domain after the fall of the Southern Song, where it passed between private collectors until it was again submitted to the throne during the Qianlong era. There the scroll remained until a portion of the old imperial collection was seized by officials of the Nationalist government and ultimately taken to Taiwan in 1948.

Aesthetic Reception of the *Eulogy*

The enduring appeal of the *Eulogy* lies in the immediacy inherent in the draft form, the simplicity of the calligraphic manner, the monumental yet personal events it describes, and the emotion in Yan Zhenqing's voice. At the start of the draft, the characters are written in a calm, legible running script. But as the draft progresses, the writing grows more urgent, until the final lines are hastily scribbled in cursive script. The blotting out of lines and characters also increases toward the end. Yan Zhenqing's distress is most evident at the critical point in the narrative when he comes to describe how Changshan was lost. He first wrote: "A traitorous official contained his forces and failed the rescue." Then he blotted it out and tried again: "A traitorous official contained . . ." But he could not bring himself to spell out so clearly the terrible thing Wang Chengye had done, so he blotted out the word "contained" once again

and simply wrote: "A traitorous official failed the rescue and so the orphaned city was besieged and compelled to submit."

It was not the content of the eulogy alone that earned it fame, but also the aesthetic effect of the calligraphy. The Northern Song poet, official, and calligrapher Huang Tingjian (1045–1105) once remarked on the impact of the *Eulogy* as both literature and visual art: "The Duke of Lu's *Eulogy for Nephew Jiming,* both as a literary composition and as calligraphy, is emotionally moving."[14] To understand Huang Tingjian's point of view (which is generally accepted today), we must first admit that the *Eulogy* is not a conventionally attractive work of art. One could even argue whether it should be called a work of art at all, since it is really no more than the rough draft of a funeral speech. In the eyes of most people who are not versed in the values of traditional literati art, it would appear to be a piece of paper covered with scribbled characters and ink blots. There is no drama in the shaping of strokes; there is little structural tension in the forming of characters. In terms of the literati aesthetic, however, these are the positive features of a great work of art.

To understand how a bland calligraphic manner can be considered emotionally meaningful, we can turn to the critical terminology that Chinese connoisseurs have used to describe the degrees of intentionality expressed by the artist. One pair of opposed terms that may illuminate the traditional enthusiasm for the *Eulogy* is "clever" *(qiao)* and "clumsy" *(zhuo).* The opposition of these two terms dates back at least as early as the Han dynasty, when the first-century dictionary *Shuowen jiezi* defined clumsy as "not clever." Although these terms retained their original meanings when applied strictly as judgments of performance—as in clever or clumsy speech—when applied to a person's character their connotations were reversed. Confucius is disparaged in the *Zhuangzi* as "clever and false," for example, meaning crafty and artificial.[15] By contrast, the sixth-century scholar-official Cui Ling'en is praised in the *History of the Southern Dynasties* for having a "clumsy and honest nature."[16] Though the reversal of the normal value of these terms appears in Daoist texts such as the *Zhuangzi,* it was not restricted to Daoist thought. In the Confucian view, clumsiness is seen as the physical manifestation of the virtue of sincerity, or artlessness.

In Tang-dynasty texts on calligraphy, "clever" and "clumsy" were commonly used as aesthetic terminology for assessing calligraphy. Yu Shinan, in his *Narrative Guide to Calligraphy,* said in admiration of two artists of antiquity that in their writing "clever and clumsy were both handed down."[17] In the glossary he wrote for his brother's *History of Calligraphy in Rhapsody Form* (775), the critic Dou Meng defined "clumsy" in calligraphic style as "that which does not depend on being fine or clever."[18]

In psychological terms, "cleverness" in calligraphic style is considered a result of intention and premeditation in the execution of the individual strokes and the composition of the characters. "Clumsiness," by contrast, involves letting go of the desire to manipulate the elements of writing in favor of direct expression. These two creative states are associated with two techniques for holding the brush: "cleverness" is attained with the brush held at an acute angle to the paper and "clumsiness" with the brush held perpendicularly. These two brush grips are known as "the slanted brush" *(ce bi)* and "the centered brush" *(zhong bi),* or "the upright brush" *(zheng bi).* The slanted-brush technique was traditionally used to write clerical script, in which the width of the strokes fluctuates widely, by varying the angle of the brush on the paper. The shapes produced by the slanted brush have sharp angles at the tips of the strokes, the strokes in the characters meet at pronounced right angles, the composition of characters shows a pronounced left-to-right movement, and the overall shapes of the individual characters basically describe long rectangles. The upright brush, which is constantly maintained in the perpendicular position, is necessary for the unmodulated strokes of seal script. Seal-script characters have rounded stroke ends and an emphasis on curving stroke forms, the composition of characters tends to be symmetrical, and the overall shape is usually a tall rectangle or oval. For these reasons, clerical script and the slanted brush are categorized as "square," meaning man-made, artificial, and cutting across the grain of the natural world, whereas seal script and the upright brush are categorized as "round," or natural, organic, and going with the flow of nature. Since the imperially sponsored Wang style is produced with the slanted brush, the Song Confucian reformers chose the style of Yan Zhenqing as the one to promote because, among other reasons, Yan wrote with a centered brush.

Let us compare a work in the Wang Xizhi tradition, written with the slanted brush, to the *Draft of the Eulogy,* which was written with the centered brush. In the Tang copy of Wang Xizhi's *Ping'an tie* (Figure 2), the tip of the horizontal stroke that runs through the center of the character *"an,"* for example (1/4), reveals the use of the slanted brush. (The notation "1/4" indicates the fourth character in the first column.) The sharp point of the upper-left corner exposes how the brush was laid down at an angle to begin the stroke. The body of the stroke itself swells and recedes along the bottom because the underside of the angled brush was lowered and raised on the paper. By contrast, the horizontal strokes in the *Eulogy,* as in the character *"dan,"* for example (4/8), have rounded ends, with no trace of the brush tip visible, and the body of the stroke is virtually unmodulated.

In terms of technique, the Wang Xizhi piece uses the slanted brush; within the morally charged realm of Confucian aesthetics, it is "square"

and "clever." Yan Zhenqing's work uses the upright brush; it is "round" and "clumsy." The conclusion, to the mind of the Confucian reformer, was that the style of Wang Xizhi, though sophisticated and skillful, was also calculated and exhibitionistic, and therefore vulgar. Thus it is of a piece with all court-sponsored art in its artificiality of form and emptiness of expression. By contrast, Yan Zhenqing's calligraphic manner, lacking a superficial appeal to the senses, naturally manifests a sincere expression of the man's virtuous character. Thus when Huang Tingjian declared the style of the calligraphy in the *Eulogy* "emotionally moving," he meant that its "clumsiness" lent a feeling of sincerity to the work that engaged his sympathy with Yan Zhenqing's emotions.

The Rebellion through Song-Dynasty Eyes

Famous works such as Yan Zhenqing's *Eulogy* or Wang Xizhi's *Orchid Pavilion Preface* have not survived the centuries because they are idiosyncratic. Terms such as "clever" and "clumsy" are not only applied descriptively to various styles of calligraphy, they also operate prescriptively toward the preservation of works of calligraphy. Because calligraphic style has a powerful but limited means of conveying meaning, it must be susceptible to categorization into recognized traditions in order for its meaning to be understood. Calligraphy that lacks an appropriate aesthetic setting lacks meaning. The calligraphic style of Wang Xizhi's *Orchid Pavilion Preface,* for example, has been perceived as "clever" in the same way that the preface itself is seen as "clever" in its depiction of an aristocratic wine-and-poetry outing in nature and its ruminations on the vanity of pleasure. The horizon of expectation against which it is seen is the perception of the Eastern Jin dynasty as a "clever" time—an age populated by skilled strategists, witty conversationalists, learned alchemists, and ingenious artists. In the same vein, the style of Yan Zhenqing's *Eulogy* is seen as "clumsy" in line with the evident sincerity of expression in the text. This reading fits comfortably with the later view of the Rebellion era as a time of patriotism, sincerity, and solemnity, as embodied in the prose of Yuan Jie (719–772) and the poetry of Du Fu (712–770).

Although Huang's simple remark about the *Eulogy* suggests an immediate, personal response, it also reflects his view of the *Eulogy* as an expression of a Rebellion-period aesthetic. His focus on Yan's tragedy fit the Song-dynasty expectation for the literature and art of the Rebellion period. This is revealed more clearly through another Rebellion-period work of calligraphy by Yan Zhenqing that Huang admired, one that had a different author and a rather different content. In the spring of 1104, on his way south to political exile in Yizhou (Guangxi), Huang Tingjian traveled up the Xiang River, stopping at Qiyang (Hunan), where

he spent three days visiting the local sites. One of these was Wu Creek, where a famous poem by Yuan Jie, "The Paean to the Resurgence of the Great Tang Dynasty," was inscribed on the cliff above the water.[19] This poem, a euphoric celebration of the recovery of the empire from An Lushan, was written in 761 and inscribed by Yan Zhenqing in large regular-script characters in 771.[20] The poem, with preface, reads as follows:

> In the fourteenth year of the Heavenly Treasure era [755], An Lushan sacked Luoyang. The following year, he sacked Chang'an, the Son of Heaven graced Shu, and the heir apparent ascended the throne at Lingwu. The year after that, the emperor moved his armies to Feng-xiang. That year he regained both capitals. The retired emperor returned to the capital. Alas! For the virtuous rule of the emperors of earlier dynasties, one must look to songs of praise. Now if a song of praise for [Suzong's] rule is to be engraved in stone, who would be suited to write it, if not one who has grown old in literature?

> Alas! In the bygone court, perverse ministers,
> traitorous and arrogant, caused disorder and weird portents.

> Frontier generals galloped their troops and brutally
> rebelled against the state, and the populace lost its tranquility.

> When the emperor made his southern inspection tour, the court
> officials skulked away and offered themselves to the brigands as
> ministers.

> But heaven shone on Tang and dawned on our emperor,
> that solitary steed in the north.

> He stood alone with a single cry against the thousand battle flags
> and myriad emblazoned banners of the barbarian troops'
> vanguard.

> Then our armies came from the east, and the heir apparent pacified
> the barbarians, destroying and driving out that mob of murderers.

> After such terrible suffering, the imperial temples were again secure
> and the two emperors were welcomed in the capital once more.

> The earth emerged and the heavens opened, all terrestrial and celestial
> calamities were relieved, and auspicious blessings arrived in great
> number.

> The murderers and rebels were saturated with heaven's blessings, and,
> dead or alive, they endured their shame.

> Honorable rank was given the meritorious, the names of the loyalist
> martyrs were immortalized, and the imperial favor flowed over
> their sons and grandsons.

> The great virtue was in resurgence, like a mountain towering or the
> sun ascending, and a myriad blessings were thus received.
>
> The many heroes who might be honored here, though their faces
> pass before me, are not found in this poem.
>
> The Xiang River runs round to the east and west; Wu Creek runs
> straight into it, and here the stone cliffs align against the sky.
>
> Let the cliff be polished and chiseled, to engrave this song of praise
> therein, for the thousands of years to come.

Huang Tingjian composed a poem in response to Yuan Jie's, which was later carved into the cliff as well. It is called simply "Written on the Cliff After the Stele." The import of his poem is quite different, however:

> Spring winds have blown my boat to Wu Creek,
> and leaning on a briar staff, I read the *Resurgence Stele*.
> A middle-aged man, all my life I've looked at the ink rubbing;
> stroking the stone engraving, the hair at my temples becomes silken
> again.
>
> Emperor Minghuang had no strategy to remain strong and endure,
> so the empire was overturned by his adopted son Lushan.
> The imperial temples were lost when the carriages fled west,
> while the myriad officials had already nested in new trees.
>
> To control the armies and oversee the state were the tasks of the heir
> apparent,
> but how could he hasten to seize the realm?
> After terrible suffering, heaven graced him,
> and the retired emperor, bent and broken, returned to the capital.
>
> In the inner chambers, Empress Zhang's behavior invited censure;
> in the outer chambers, Li Fuguo's nod gave orders.
> The Southern Inner Palace was desolate, only weeds living there.
> Gao Lishi had departed, to serve in terrible danger.
>
> Take Yuan Jie's "Ballad of Chongling,"
> or Du Fu's poem in which he pays his respects to the cuckoo:
> Who could understand how these loyal ministers were anguished to
> the marrow,
> when the world values these works merely as precious and beautiful
> words?
>
> Generations of rustic monks have since come this way,
> as well as the scholars who have followed one after the other.

> The broken cliff with its gray-green mosses has stood here all this
> time,
> while storms and rains wash from it the sorrows of dynasties past.[21]

Where Yuan Jie's poem praised the heroic heir apparent, who was the reigning emperor at the time the poem was written, Huang Tingjian's poem focuses on the tragic figure of Xuanzong and the sordid aspects of Suzong's treatment of him. Huang devotes only one line to the heir apparent, in which he hints that Suzong usurped his father's throne, while the plot between Empress Zhang and the powerful eunuch official Li Fuguo (d. 762) to denigrate the retired emperor by moving him from his Southern Palace away to the Western Palace is given an entire stanza. The tone of Yuan Jie's poem is exultant. Huang Tingjian's is nostalgic and melancholy, ignoring Yuan Jie's triumphant testimony that the dynasty had been saved and was in resurgence. This sense of melancholy over the loss of Xuanzong's court comes from the poetry of Du Fu, who was already considered China's premier poet by the time of the Northern Song. In particular, his elegiac eight-poem cycle called "Autumn Meditations" expresses Du Fu's mourning for the court under Xuanzong and a past reclaimable only in memory.[22] These well-known poems, I suspect, had so colored the image of the Rebellion era for later poets like Huang Tingjian that he was nearly incapable of seeing Yuan Jie's point of view.

The calligraphic style of Huang Tingjian's poem maintains its distance from its model as well, for by 1104 Huang Tingjian had already worked through Yan Zhenqing's style and absorbed what he could use of it into his own manner. Fu Shen has argued that Huang Tingjian studied the style of Yan Zhenqing early in his career, and he points to the "regularity and severity" and the "square and stable formal structure" in such works as Huang's *Shuitou huoming* of 1087 as reflecting this study. But Fu Shen further contends that Huang's "later works show that he did not retain the strong Yan Zhenqing influence of his earlier period."[23] Huang's poem of 1104 certainly accords with this assessment (Figure 13). In such superficial aspects as script type and size, his poem matches Yan Zhenqing's transcription of the "Paean," but the style is simply his usual large regular-running-script manner. This is not to say that his usual manner owed no debt to his earlier study of Yan Zhenqing; rather, it already incorporated a thorough grounding in Yan's style. Comparing the characters *"zhong xing"* in Yan Zhenqing's *Paean* (Figure 14) to those in Huang Tingjian's poem (2/1–2), we see not only the debt Huang Tingjian's manner owes to the solid, spacious structures of Yan Zhenqing's characters, but also the dynamic asymmetry of form and the fluctuating brush

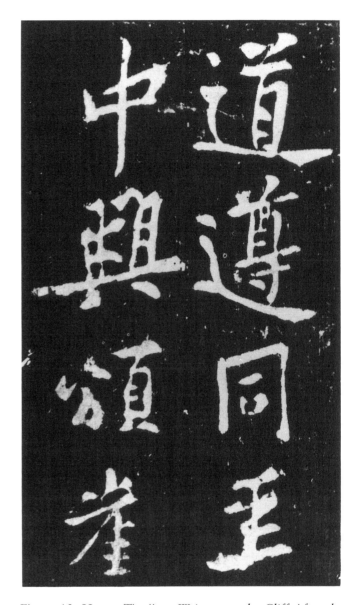

Figure 13. Huang Tingjian, *Written on the Cliff After the Stele*, detail, 1104. Qiyang, Hunan. From *Shodō zenshū*, 3rd ed., vol. 15, fig. 36.

stroke that are Huang Tingjian's own invention and contribution to Song calligraphy.

The fact that Huang Tingjian made no special effort to reflect the style of Yan Zhenqing in his poem responding to the *Paean* stands in striking contrast to the generation preceding his. Many of those men did imitate the style of Yan Zhenqing. Huang's mentor in poetry, Su Shi, was especially adept at the game of stylistic quotation and interpreta-

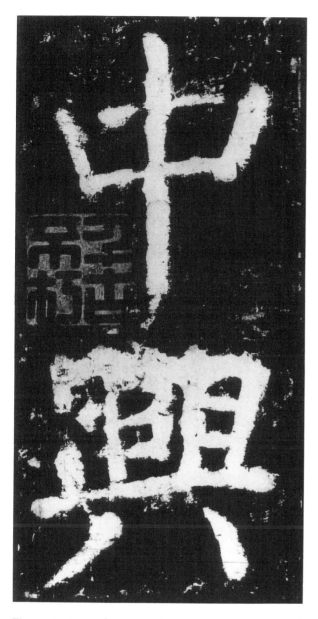

Figure 14. Yan Zhenqing, *Paean to the Resurgence of the Great Tang Dynasty,* detail, 771, ink rubbing. Qiyang, Hunan. From *Shodō zenshū,* 3rd ed., vol. 10, pl. 45.

tion of Yan's style. In his transcription of Ouyang Xiu's "Record of Enjoying Rich Harvests Pavilion" (Figure 15), done around 1091, Su Shi copied out an essay in which Ouyang describes the happiness enjoyed by the people of Chuzhou while he governed them. Ouyang paints the classic picture of peaceful village life, ostensibly praising the emperor's

Figure 15. Su Shi, *Record of Enjoying Rich Harvests Pavilion,* detail, ca. 1091, ink rubbing. Chuzhou, Anhui. From *Shodō zenshū,* 3rd ed., vol. 15, pl. 43.

enlightened rule, but making clear that this tranquility was also due to his benevolent administration. Su Shi's tribute to his sponsor did not end with simply transcribing the essay. He also chose to execute it in the style of Yan Zhenqing's *Lidui Record of Mr. Xianyu* (Figure 16).

In this inscription of 762, Yan portrayed the good government of his friend Xianyu Zhongtong, a national-level official who also served as a local governor. Not only did Su Shi make the style of Yan's *Lidui Record of Mr. Xianyu* work cleverly with the content of his *Record of Enjoying Rich Harvests Pavilion* to reinforce the notion of Ouyang Xiu as the same sort of nationally renowned, local "good official" as Xianyu

Figure 16. Yan Zhenqing, *Lidui Record of Mr. Xianyu*, detail, 762, ink rubbing. Mount Lidui, Langxian, Sichuan. From *Shodō zenshū*, 3rd ed., vol. 10, pl. 32.

Zhongtong and Yan Zhenqing, it also conveyed meaning in terms of politics at court. Yan Zhenqing was renowned as a loyalist martyr. By contrast, Ouyang Xiu had been charged with partisan activity during the minor reform of 1043–1044, while Su Shi himself had been jailed in 1079, threatened with death, and finally banished to Huangzhou in 1080, persecuted by the court censors on the basis of antiauthoritarian passages in his letters and poems. The reputations of both men could

only profit from association with a famous loyalist. Su Shi may have deliberately chosen the style of Yan's *Lidui Record of Mr. Xianyu* to write out Ouyang's *Record of Enjoying Rich Harvests Pavilion*—using the reputation of the loyal, good officials Yan Zhenqing and Xianyu Zhongtong to defend Ouyang and Su personally against the charge of disloyalty, as well as to represent generally the political and cultural ideals of the conservative reformers.

Although Huang Tingjian was on his way into exile from court when he encountered Yan Zhenqing's *Paean,* he seems not to have needed to borrow Yan's reputation or style. I suspect he made no more immediate response to the style of Yan's *Paean* than he did because the question of Yan Zhenqing's suitability as a model had already been decided by the influential men of the generation that preceded him, the most decisive of whom for him was Su Shi. Yan Zhenqing could not have been his personal discovery, since he had been discovered already by the heroes of the minor reform: Han Qi, Cai Xiang, and Ouyang Xiu. Of the generation following theirs, the artist who most vigorously exploited the style of Yan Zhenqing was Huang's mentor, Su Shi. Huang remarked more than once that he studied Yan Zhenqing's calligraphy with Su Shi, that Su Shi studied Yan Zhenqing exhaustively, and that Su Shi was better than himself at capturing the essence of Yan's style:

> I am really fond of the Duke of Lu's [Yan Zhenqing's] calligraphy, and I often practice his style based on my own conceptions. When I look at my work, there seems to be some resemblance of style and spirit, but compared to Zizhan's [Su Shi's], I'm left far behind. The other day, Zizhan copied a dozen sheets of calligraphy for me in the Duke of Lu's style. His characters look like the sons and grandsons of Yan's characters: even though father and son are not the same, they both have the spirit and frame of the grandfather.[24]

> Master Dongpo [Su Shi] once made copies for me of several works [by Yan Zhenqing], including the *Letter for Cai Mingyuan*, the *Eulogy for Uncle Yan Yuansun*, the *Draft for Nephew Jiming*, and *On the Seating Order of Inspector of the Armies Yu* [the *Letter on the Controversy Over Seating Protocol*]. . . . All were quite close to the originals.[25]

> Recently when writing characters I tried to imitate the Duke of Lu's brush gestures. But I still cannot achieve the kind of unconscious and intrinsic match of spirit that Zizhan could. . . . Dongpo and I studied Yan Pingyuan's calligraphy together, but my hand was so clumsy that I never got close.[26]

Due to the sponsorship of the calligraphy of Yan Zhenqing by the heroes of the minor reform and its vigorous promotion by Su Shi, the study of Yan's style had become an accepted, even de rigueur, cultural

pursuit. By Huang Tingjian's day, any scholar could, by copying or advocating the style of Yan Zhenqing, or by merely uttering a phrase such as "all my life I've looked at the ink rubbing of the *Resurgence Stele,*" identify himself with the conservative reformers who had chosen Yan Zhenqing as the patriarch of Song Confucian calligraphy. Huang Tingjian was too independent and nonpolitical artistically, I think, to produce the kind of clever interpretations of Yan Zhenqing made by Su Shi. In his last years, though his visit to Wu Creek shows he was eager to venerate the cultural patriarchs of his political group, he was not interested in playing political games with calligraphic quotation as Su Shi had done. Huang was speaking in his own voice but responding to the content of Yuan Jie's poem and the style of Yan's calligraphy from the distance of settled Song attitudes about the meaning of the Rebellion era and its aesthetic products. In all ways, his poem is an exercise in nostalgia.

4

Partisan Politics at the Postrebellion Court

WHILE SERVING as prefect of Puzhou in the autumn of 758, Yan Zhenqing was impeached by one of the censors at court and further degraded to the post of prefect of Raozhou (Jiangxi). Raozhou lay on the shore of Lake Poyang in the south. The position was not any lower in rank, but the post was much farther away, nearly a thousand kilometers from Chang'an. Traveling east on his way to Raozhou, Yan Zhenqing passed through Luoyang, and there he composed a eulogy and performed the sacrificial rites at the tomb of his uncle Yan Yuansun. The eulogy reports to the spirit of his uncle all the achievements of his descendants and the horrors suffered during the An Lushan Rebellion, in which more than thirty members of the Yan clan lost their lives. The draft of the eulogy, which is identical in style and tone to the eulogy for his nephew Jiming, is extant only as poor reproductions in various Ming- and Qing-dynasty engraved calligraphy compendia.[1] Once in Raozhou, Yan relieved the populace of the scourge of bandits.

In the summer of 759, Yan Zhenqing was appointed prefect of Shengzhou and military commissioner of the Western Zhejiang circuit. When he arrived in Shengzhou (near modern Nanjing), he discovered that Liu Zhan, the prefectural aide of Yangzhou, was planning to revolt. As before, Yan Zhenqing appointed generals, recruited soldiers, and stockpiled equipment in preparation for battle on land or on the Yangzi River. But a secret memorial was sent to the throne reporting him. Emperor Suzong evidently agreed that Yan's presentiment of rebellion was in error, and so he was called back to the capital. (In 761, Liu Zhan did raise an army against the Tang.) En route he was given an appointment as vice minister of justice. Back in Chang'an, Yan again offended a powerful person with his defense of ritual propriety. At this time, the eunuch Li Fuguo controlled the maintenance of the imperial palaces; his approval was required for the imperial edicts that passed through his office to be carried out. In 760, he informed Emperor Suzong that his father should be moved from the Southern Palace to the Western Palace

to keep him from conspiring to return to the throne. The emperor simply wept in response. On his own initiative, Li Fuguo moved Retired Emperor Xuanzong to the Western Palace. Yan immediately led his fellow officials in submitting memorials of inquiry. In retaliation, Li Fuguo had Yan impeached by Vice Censor-in-Chief Jing Yu and degraded to serve as prefectural aide of Pengzhou (Sichuan).

On his journey south to Pengzhou that winter, Yan Zhenqing traveled down the Jialing River. Disembarking at the district seat of Xinzheng for the final ten kilometers across land to Pengzhou, Yan Zhenqing stopped to visit the famous site of Mount Lidui on the banks of the Jialing. In response to a request by the son of his old friend Xianyu Zhongtong, with whom he had served as a palace censor in 747, he composed and transcribed on a stele the *Lidui Record of Mr. Xianyu*. The stele was engraved and set up later, in 762, near a stone pavilion Xianyu Zhongtong had built on the east side of Mount Lidui. In this record, Yan Zhenqing narrates Xianyu's honorable career as an official. He also cites his own clansmen who had served as officials in Sichuan in the past and describes the political events that led to his own journey into exile there.[2] In Pengzhou, Yan earned the praise of the populace with his efforts at famine relief.

In the summer of 762, Emperor Daizong (r. 762–779) succeeded to the throne. Shortly thereafter, the much-feared Li Fuguo was murdered and Yan Zhenqing was promoted to prefect of Lizhou (Sichuan), some 130 kilometers nearer the capital. Yan Zhenqing traveled to his new post but was unable to enter the city because it was under siege by Qiang tribesmen. He was then called to court that winter. Liu Yan (715–780), the vice minister of revenue, had nominated Yan Zhenqing as his own replacement, enlisting him as an ally in his struggle against the clique of his archenemy Yang Yan (727–781), a faction headed by Grand Councillor Yuan Zai (d. 777). From this point onward (if not earlier), Yan Zhenqing was allied with the clique of Liu Yan in court politics, which resulted in persecution by Yuan Zai in the 760s and 770s and by Yang Yan in 780. Yan Zhenqing served as vice minister of revenue until the autumn of 763, when he was transferred to act as military, surveillance, and supervisory commissioner of Jingnan and granted the prestige title of Grand Master of Imperial Entertainments with Gold Seal and Purple Ribbon. But he had not yet departed from the capital to fill the post when he was slandered to the throne and dismissed.

As a result of the retreat of Tang troops and officials to central China to aid against An Lushan, the northwestern border areas (modern Gansu and Ningxia) were occupied by the Tibetan armies. In late autumn of 763, they crossed the frontier. Since no intervention was offered by either the local provincial governors or Pugu Huaien (d. 765), the Uighur commander of the Shuofang Army, the Tibetans went on to take

Chang'an.[3] The imperial court fled east to a temporary site in Shanzhou (Henan), and there Yan Zhenqing was appointed vice director of the right. Two months later, when the Tibetans had departed and the court was preparing to return to the capital, Yan Zhenqing suggested to the emperor that he offer sacrifices at the tombs of his royal ancestors before reoccupying the palace. Yuan Zai objected to the idea. He said to Yan in court: "Although what you envision is lovely, is it not rather unsuited to the occasion?" Yan Zhenqing lost his temper and replied: "To use or discard my idea lies with the grand councillor, but what harm was there in my words? The affairs of court can hardly expect to endure the repetition of such abuse!"[4] From the moment of this public humiliation, Yuan Zai waited for the chance to have Yan Zhenqing sent out into the provinces once more.

Though he was now an open enemy of Yuan Zai and his clique, Yan reached the height of Emperor Daizong's favor in 764. He was appointed acting minister of justice and censor-in-chief and, as Shuofang Mobile Brigade pacification commissioner, entrusted with making a personal appeal to Pugu Huaien to demonstrate his allegiance to the throne after his shocking failure to rescue Chang'an from the Tibetans. In the end, Yan did not actually confront Pugu Huaien, but he did persuade the emperor to replace Pugu with Guo Ziyi. (The replacement ended Pugu's loyalty. In the autumn of 764, Pugu led another Tibetan invasion against the Tang, with limited success. In 765, he gathered a great army of Tibetan and Uighur troops, but, fortunately for the Tang, he died suddenly before the campaign could begin, and the army dispersed.) Yan was then enfeoffed (in 764) as Dynasty-Founding Duke of Lu Commandery (Shandong). Later that year he composed the *Spirit Way Stele* inscription for the Hezheng Princess, a recently deceased sister of the emperor.

Throughout the same year, tensions also grew between the outer-court officials and the most influential eunuch in the ranks of the inner court, Inspector of the Armies Yu Chaoen (d. 770). Yu Chaoen had earned his position of prominence in Emperor Daizong's court by protecting the emperor in Shanzhou when the court fled from the Tibetans in 763. After the return to the capital, Yu Chaoen was allowed to retain his post as commander of the Army of Divine Strategy, which was incorporated into the palace guards, to provide a ready military force to the throne. The regular officials were gravely concerned by the unhappy possibilities offered by a eunuch in such a powerful position, and Yu Chaoen's personal behavior, such as his vulgar displays of wealth and inappropriate meddling in other court institutions, caused considerable revulsion.[5]

Not all the regular officials were disgusted by Yu Chaoen, however. One of those who curried favor with the eunuch commander was Guo

Yingyi (d. 765), a career military officer who had earned Emperor Suzong's gratitude by offering his troops in the desperate early days of the rebellion. Since then he had moved rapidly up through several important military posts, including military commissioner of the Army of Divine Strategy, and when Emperor Daizong took the throne he was transferred to high civil offices. In 763, he was made vice director of the right, and he joined the clique of Yuan Zai.[6]

The *Letter on the Controversy over Seating Protocol*

As vice director of the right, Guo Yingyi was charged with making arrangements for special court functions. His malfeasance in this duty is the ostensible subject of a lengthy letter, known to posterity as the *Letter on the Controversy over Seating Protocol,* that Yan Zhenqing wrote to Guo Yingyi in the eleventh month of 764. The tension underlying the letter, of course, was the long-standing rivalry between Commander Yu Chaoen and General Guo Ziyi in the military sphere and between the cliques allied to them in the civil arena, to which Yuan Zai and Yan Zhenqing belonged. In this letter Yan indicts Guo Yingyi for allowing allegiance to his clique to lead him astray in the enactment of proper court ritual. It is a singular display of wrath and righteous indignation in defense of the Confucian norms, spurred by personal offense and the bitter rivalry between the two cliques. The letter opens with a flattering résumé of Guo Yingyi's career:

> It is said that "the finest [type of a thing that dies but does not decay] is an established virtue, while the next best is an established meritorious achievement. . . . These are what is meant by 'that which does not decay.' "[7] Further, I have also heard that the grand councillor is the superintendent of all the officials, while the feudal lords and kings are examples for their people. Now your eminent and imperishable meritorious achievements stand as an example to the people. How but through your talent have you stood out? Your meritorious achievements crown the age. You drove back Shi Siming's recalcitrant army and resisted the Uighurs' insatiable demands,[8] by which you gained your portrait painted in the Hall of Ascending to the Clouds and your name reposited in the Imperial Ancestral Temple.[9] How awe-inspiring!

Then the possibility is introduced that Guo Yingyi has gone astray after such a glorious career:

> A career so praiseworthy should be praised, even though the finale may present the real difficulty. Thus is it said: "To fill but not overflow is how long to retain riches; to be lofty but not precipitous is how long to retain honor." Can this be but a warning? The *Book of History* says: "You do not brag, yet no one contends your merit. You

do not boast, yet no one contends your ability." [10] . . . Therefore, there
is the saying, "To break off a journey of one hundred *li* at ninety *li*,"
which refers to the difficulty of the last stretch of the road.

Now, Yan levels the specific charge:

> At the earlier incense-burning ceremony in the street before the Bodhi
> Monastery, [11] you arranged for one row of seats for the grand council-
> lor and the consultants-in-ordinary in the Secretariat, the Chancellery,
> and the Department of State Affairs together and one row of seats for
> Commander Yu and yourself, at the head of all the generals.

Yan accused Guo Yingyi of violating the ritual protocol for the seating
of officials. The problem with Guo's arrangements is as follows: vice
directors, such as Guo Yingyi, were Rank Two civil officials; generals of
the guards, such as Yu Chaoen, were Rank Three military officials and
in a proper arrangement, would follow the Rank Three civil officials.
Therefore, by placing Yu Chaoen next to him, Guo Yingyi elevated him
above his rank, thereby degrading the Rank Three civil officials, of
whom Yan Zhenqing was one. Worse yet, Guo Yingyi committed this
breach a second time:

> Were this even a case of just once acting in an irregular manner to
> comply with abnormal circumstances, it would still not be acceptable.
> How much the worse when it is a long-standing practice engaged in
> repeatedly? Recently the populace rejoiced over Guo Linggong [Guo
> Ziyi] and the armies of father and son [Guo Xi] that destroyed the
> host of the fierce rebels from the west. [12] To crown the occasion, the
> Xingdao [ward] banquet was held. But still unaware of your previous
> error, you ended by following your own notions and made the arrange-
> ments without concern for the relative status of the official ranks and
> without regard for the relative position of civil and military officials.
> You set your heart solely upon pleasing the inspector of the armies
> [Yu Chaoen]. Not once did you heed the sidelong glances of the offi-
> cials. How does this differ from knaves who steal money in broad
> daylight? It is utterly unheard of. The gentleman's feelings for others
> are expressed through ritual. One never hears of self-indulgence in this.
> Do you not have a profound concern for it?

Yan Zhenqing further reminds Guo Yingyi that one man alone has the
right to elevate an official arbitrarily:

> The imperial favor is unique. The emperor mandates dispatches and
> recalls. The multitude dare not stand next to him, nor may they order
> the filling of their own positions. He must discriminate as to who is
> honored and respected. None but he is permitted to sit facing south
> toward the grand councillors, preceptors, and guardians. A single
> throne is fixed on the east-west axis, although a popularly revered

general-purpose censor from the Censorate may occupy a separate bench [near the throne], so that all the officials may look up to them with reverence. Could it be acceptable otherwise?

Moreover, though eunuchs had been elevated by emperors to inappropriately high positions in the recent past, these precedents were considered extremely inauspicious by the regular officials:

> In the time of Emperor Xuanzong, when [the eunuch] Commander Gao Lishi's receipt of imperial favor was proclaimed, he was also permitted a similar seat on the east-west axis. Any other form of etiquette has never been heard of. Why must you order others to lose their places? When [the eunuch] Li Fuguo was entrusted with the imperial favor, he went directly to a position above the vice directors of the left and right and the three dukes, which was considered suspicious and strange throughout the subcelestial realm, was it not?
> A man of antiquity [Confucius] said: "There are three friendships that are advantageous and three that are injurious."[13] I hope that you and the inspector of the armies have a friendship between "the honest and the sincere," not a friendship between "the acquiescent and the insinuating."

Yan closes his letter by throwing down the gauntlet:

> When a court official first becomes a secretariat director, he hopes for no confusion or disorder, but makes an effort to follow orders and never twist his principles. We must all preserve and uphold the laws and regulations of the court. I blame you for allowing them to fall into a ruinous state, which I fear has reached you personally as well. Tomorrow you will suddenly find yourself in a towering rage. If I condemn you as a man who destroys the social relationships, what will you have to say in reply?

The answer, if any, has gone unrecorded. The antagonists apparently remained in a stalemate through the following year. But at the beginning of 766, Yuan Zai instituted a novel policy of having all memorials to the throne first pass under his review in order to keep criticism of himself and his policies from the emperor. In protest, Yan Zhenqing submitted a memorial arguing that all written documents presented at court should be published.[14] Yuan Zai was now avid for an excuse to force Yan Zhenqing out of the capital. In the second month, Yan Zhenqing was entrusted with performing the ceremonies at the imperial temple. When it was said at court that Yan Zhenqing had not had the ceremonial implements refurbished, Yuan Zai charged him with denigrating the current regime and had him degraded to serve as an administrative aide in Xiazhou (Hubei), nearly two thousand kilometers southeast of Chang'an. Not content with this punishment, the follow-

ing month Emperor Daizong had him banished even farther, to fill the same lowly position in Jizhou (Jiangxi), eighteen hundred kilometers farther to the southeast.

The *Letter* as Art Object

We do not know how the *Letter on the Controversy over Seating Protocol* was preserved through the Tang, but in the mid-Northern Song it was in the possession of a wealthy family from Chang'an surnamed An. After An Shiwen and his brother came into their inheritance, they decided to split the family property. In an effort, perhaps, to divide the family art collection fairly, they also separated the *Letter* in two and had it remounted as two scrolls. One scroll contained the first part of the *Letter*—through the line "I hope that you and the inspector of the armies have a friendship between the honest and the sincere"—while the other scroll consisted of the remainder of the *Letter* with another shorter letter by Yan Zhenqing attached.[15]

The two halves of the *Letter* were brought together once by Huang Tingjian sometime between 1086 and 1094. In a colophon written on an ink rubbing taken from a stone engraving of the *Letter,* he said: "During the Yuanyou period, in the capital, for the first time I was able to borrow the last three sheets [the second half] from An Shiwen and put [the two halves] together as one."[16] The two halves of the *Letter* were apparently soon reunited in the imperial collection of Emperor Huizong. The *Calligraphy Catalog of the Xuanhe Era,* dated around 1120, lists a "preceding" and a "succeeding" *Letter on the Controversy over Seating,* which must refer to the two halves of the original manuscript.[17]

The *Letter* had a busy public life as an object of criticism and study during the Yuanyou period (1086–1094). The *Letter* came to Kaifeng in the collection of An Shiwen, who arrived in the capital as an official in the government salt monopoly sometime before 1086.[18] The officials of the conservative party, including Su Shi and Huang Tingjian, returned to high office when Sima Guang (1019–1086) was put in charge of government at the start of the Yuanyou era. Huang Tingjian served in the capital, in the Institute of Veritable Records, throughout the Yuanyou period, and Su Shi served as a secretariat drafter from 1086 to 1089. An Shiwen was apparently quite generous in loaning the *Letter* to these men whose criticial opinions, framed mainly in extemporaneous colophons, were collected and published and remain highly influential down to the present day. Apparently he also had a stone engraving made of the *Letter.* Mi Fu must have seen the *Letter* around this time as well, because his *Record of Searches for Precious Scrolls (Baozhang daifang lu),* in which his earliest remarks about the *Letter* appear, is dated to 1086. As a result, perhaps, of this exposure, the *Letter on the Controversy over Seating Protocol* was the work by Yan Zhenqing most fre-

quently discussed by the Song connoisseurs. Although Huang Tingjian ranked it second to the eulogy for his uncle Yan Yuansun, still he praised it as "extraordinary."[19] Mi Fu admired it enormously, as well, calling it "the premier calligraphy among the running-script works by Yan Zhenqing in our day."[20] Su Shi concurred: "Compared to my lord's other writings, it is quite extraordinary."[21]

The original manuscript is no longer extant. It exists now only in the form of engraved steles and ink rubbings. Of the several versions, the most familiar is in the Forest of Steles in the Shaanxi Provincial Museum in Xi'an. Known as the "Xi'an version" or the "Guanzhong version," this version is traditionally believed to be the one An Shiwen had engraved from the original manuscript during the Yuanyou era.[22] Huang Tingjian, Su Shi, and Mi Fu were all familiar with ink rubbings from the stone engraving. Su Shi personally made several ink rubbings from the engraving,[23] and from the colophon quoted earlier we know that Huang Tingjian copied it. Typically Mi Fu turned up his nose at it, since he believed that only ink-written calligraphy could serve as an acceptable model. He declared that "the stone engravings preserve only a rough impression [of the original brushwork]."[24]

Aesthetic Reception of the *Letter*

Of these three connoisseurs, Su Shi had the most extensive and profound aesthetic encounter with the *Letter.* In a colophon that was probably appended to the original, he wrote:

> Yesterday An Shiwen of Chang'an brought out his several pages of the draft from Yan, Duke of Lu, to the Prince of Dingxiang Commandery [Guo Yingyi], which is in his collection. Compared to my lord's other writings, it is quite extraordinary. He entrusted his hand to write naturally, so that with each movement an attractive appearance was created. From this we see that even for this gentleman, it was true that "you shoot more skillfully when betting for tiles than when betting for real gold."[25]

"Betting for tiles" is a reference to a parable attributed to Confucius in the *Zhuangzi:*

> When you're betting for tiles in an archery contest, you shoot with skill. When you're betting for fancy belt buckles, you worry about your aim. And when you're betting for real gold, you're a nervous wreck. Your skill is the same in all three cases—but because one prize means more to you than another, you let outside considerations weigh on your mind.[26]

In other words, Su Shi believed that Yan was expressing himself quite unselfconsciously, thereby creating great art. The term often used in traditional Chinese criticism for this manner is "unintentional" *(wuyi).* Su

Shi had an entire philosophy of *wuyi,* which he used interchangeably with *wuxin* ("no mind"). Ronald Egan has explained how Su conceived of a person with *wuyi* as being free from prejudice and acting spontaneously in accord with things encountered. With the absence of intention comes the ability to gain insight into the patterns of the world.[27] Similarly, "unintentional" calligraphy is writing that does not strive for any particular visual effect and makes no conscious stylistic references. Mi Fu said of the *Letter:* "Each character from the worn brush is intentionally connected to the next in a flying movement, yet their fantastic shapes and strange forms are unpremeditated *(de yu yi wai)."*[28] He also praised its unlabored, unconstructed quality: "Pauses, checks, and sluggish bends—these signs of intention are not in these characters *(yi bu zai zi)*; complete naturalness dwells in this writing."[29] Huang Tingjian also commented on Yan's freedom from artifice:

> When I look at [the Tang classical-tradition calligraphers] Ouyang Xun, Yu Shinan, Chu Suiliang, Xue Ji, Xu Hao, and Shen Chuanshi, they were all limited by regulations. How could they compare with the Duke of Lu, who calmly went beyond the carpenter's line marker?[30]

"Unintentional" writing is believed to communicate directly the personality of the writer and thus to possess genuineness and sincerity. The great flaw in the Wang style promoted at court, according to this system of belief, is that it is "intentional," or *youyi.* A style based on copying the *Chunhua ge tie,* for example, would be seen as premeditated and striving for effect, with all the negative associations such as cleverness, mannerism, and disguising the self behind stylistic quotation.

Yan's *Letter on the Controversy,* just like the *Draft of the Eulogy for Nephew Jiming,* is quite lacking in dramatic visual effects (Figure 17). No careful shaping or modulating of strokes may be seen, nor do we find any cleverly designed character compositions or practiced repetition of canonical motifs or manners. Strokes are blunt; character forms lack structural tension. Its manner is *pingdan,* or bland. This very lack of conventional attractiveness made the *Letter* attractive to the Northern Song critics. The circle of poets and artists around Ouyang Xiu, Cai Xiang, and Mei Yaochen (1002–1060) prized the qualities of simplicity, informality, and blandness in literature.[31] These qualities were prized because they were believed to allow for the maximum amount of self-expression. The following generation applied these same standards of judgment to their criticism of calligraphy. For Su Shi, Huang Tingjian, and Mi Fu, simplicity, informality, and blandness were to be achieved by allowing expression to flow naturally from the brush. Yan Zhenqing's *Letter* contains these qualities inherently. For indeed it was a draft, scribbled informally, with no concern for visual effect.

Su Shi's Copy of the *Letter*

Su Shi's involvement with the *Letter* outlasted his stay in office at court. He made numerous copies of the *Letter,* one of which is still extant in ink-rubbing form (Figure 18). Dated to 1091, it is followed by a lengthy colophon (Figure 19). In it he explains the stylistic qualities that made him claim Yan Zhenqing as his choice of model:

Figure 17. Yan Zhenqing, *Letter on the Controversy over Seating Protocol,* detail of opening section, 764, ink rubbing, "Xi'an version." Shaanxi Provincial Museum. From *Shaanxi lidai beishi xuanji,* p. 102.

Figure 18. Su Shi, *Copy of the Letter on the Controversy over Seating Protocol*, detail of opening section, 1091, ink rubbing. Courtesy of Field Museum of Natural History, Chicago.

I once declared that the apogee in painting was reached by Wu Daozi [fl. ca. 710–760], in literature by Ouyang Xiu, and in calligraphy by Yan, Duke of Lu, for they were the most capable practitioners in the subcelestial realm. Someone said, "This may be so for painting and literature, but as for calligraphy, in the Han dynasty there were Cui Yuan [77–142] and Zhang Zhi [fl. ca. 150], and in the Jin there were Wang Xizhi and Wang Xianzhi, so how can you extol the Duke of Lu's skills alone?" I replied that he was wrong. In high antiquity there was only seal script and no cursive or regular scripts. Once when the emperor granted me a viewing of calligraphy and paintings in the palace storeroom, I saw the traces of the brush in extant writings of high antiquity. They were done with a centered brush tip, applied perpendicularly, and were absolutely free of any seductive demeanor. From the Han and Jin dynasties onward, beauty was attained solely by means of a slanted brush tip, so that the original intent of the men of antiquity was largely lost. But then came the Duke of Lu, whose brush was as centered and upright as that of [the mythical inventor of writing] Cang Jie himself, like an awl drawing in sand or a seal stamped in clay. He swept away the seductive habits of the Han and Jin and established himself as a master.

Figure 19. Su Shi, *Colophon to the Copy of the Letter on the Controversy over Seating Protocol*, 1091, ink rubbing. Courtesy of Field Museum of Natural History, Chicago.

The centered, or upright, brush is a metaphor for moral probity that dates back at least to the Tang dynasty. As the well-known anecdote has it, the ninth-century emperor Muzong once asked his minister, the calligrapher Liu Gongquan, about the proper method for the brush. Liu had been trying to direct the emperor's attention to matters of state, so he cleverly used the rather more trivial subject of calligraphy to make a point about statecraft: "The use of the brush lies in the heart. If your heart is upright, then your brush will be upright."[32] Emperor Muzong understood Liu's reply as a remonstration couched in the metaphor of calligraphy, but this association between centered-brush writing and the morally upright man was promoted quite literally by the Confucian critics of the early Northern Song:

> Su Shi once commented on this famous episode. He wrote, [Liu Gong-quan's] statement that "if the heart is upright, the brush will be upright" was not only remonstration but a true principle. Petty men of this world may have skill in writing characters, but in the end the spirit and feeling of their calligraphy just appears eager to please and flatter.[33]

This "true principle" became one of the central concepts in Song-dynasty Confucian calligraphy criticism. Witness this complaint by the Neo-Confucian philosopher-official Zhu Xi about the calligraphy of Huang Tingjian:

> When I look at Huang Tingjian's calligraphy, it definitely has its good points. But since he can write so well, why did he fail to learn the squareness and uprightness in other people's writing? Why did he have to write in such a slanted manner?[34]

This belief dictates that the modesty and sincerity of "upright" calligraphy—that is, calligraphy written with a centered brush—makes it the most appropriate artistic model, just as the "upright" conduct of the man behind it makes him an appropriate moral and political model. Conversely, calligraphy written with a slanted brush seduces eye and mind with its facile charms and so both the style and the man behind it are no standard to follow. Thus does calligraphic style gain moral import and the artist's choice of a hand to emulate become a statement of his moral and political identification.

Su Shi concluded his colophon to his copy of the *Letter on the Controversy*:

> Without discussing his other works, but by looking only at his *Letter on the Controversy over Seating Protocol*, you will realize that my statement [that Yan revolutionized calligraphy] is no exaggeration. In leisure among my books, whenever I wash my hands, burn incense, and make a few copies of it in different sizes, although they do not

resemble the original, my calligraphy has already improved a great deal over what it was before.[35]

Indeed, his copies do have a complicated resemblance to the original, if the ink rubbing from the engraving of the 1091 copy is any indication. If we compare passages from the copy by Su Shi and an ink rubbing from the engraving of Yan Zhenqing's *Letter,* it is readily apparent that Su Shi followed the original in terms of the text itself and the composition of the characters (Figure 20 [the tenth character in the fourth column through the fifth character in the fifth column] and Figure 21). The only difference with regard to the text is that Su Shi did not reproduce the lined-out characters or transposition marks in the original but made a "clean copy" of it. No doubt Su Shi had memorized the entire letter. Yet the first thing that strikes us about these two works is how much the style and expression of the copy by Su Shi are at variance from its model. Where Yan Zhenqing's line is blunt and virtually unmodulated and the composition of his characters is awkward to the point of homeliness, in Su Shi's copy the modulation and shaping of the brush strokes display tremendous variation and the compositions of his characters exhibit unusual constructions that are unconventional without being bizarre. Still, it was exactly the use of a blunt, unmodulated line in the *Letter* that made the Song critics admire this calligraphy, above all others by Yan Zhenqing, as an expression of the aesthetic ideal of *pingdan,* or blandness.

Su Shi had been the protégé of Ouyang Xiu, but he was also an artist with a lifelong passion for stylistic innovation and self-expression. Where Ouyang seemed often to speak programmatically for the Qingli reformers, Su Shi expressed his emotions more as an individual. Yet he had no intention of refuting the aesthetic models set up by Ouyang or rejecting his cultural and political identification with the reformers. Thus a subtle conflict arose between theory and practice. In his critical writings, Su Shi continued to repeat the same kind of praise for the same virtues that Ouyang Xiu had declared present in the regular script of Yan Zhenqing. But in his running-script calligraphy, Su Shi's own aesthetic prevailed. Instead of the manner that Yan Zhenqing used in his running-script drafts, which was admired for its *pingdan* quality, or the manner of Yan's regular script, which was deemed by the Confucian reformers and others the perfect calligraphic expression of moral rectitude, Su Shi chose to rework his copy of the *Letter on the Controversy* in the manner of a part of Yan's oeuvre that was otherwise ignored in the Northern Song.

This part of the oeuvre of Yan Zhenqing consists of a handful of works done in an eccentric mix of large, loose-jointed regular, running, and cursive characters: the *Defending Government Letter* (Figure 22),

Figure 20. Yan Zhenqing, *Letter on the Controversy over Seating Protocol*, detail, 764. Shaanxi Provincial Museum. From *Shaanxi lidai beishi xuanji*.

Writing a Letter Letter (Figure 23), *Guangping Letter* (Figure 24), and the *Poem for General Pei* (Figure 25). The three letters are distinct in manner from Yan Zhenqing's other cursive-script letters, such as the *Cursive and Seal Script Letter,* though not so strongly that they suggest the style of another hand, and there is a certain uniformity among them. The *Poem for General Pei,* however, seems to be of another magnitude —the most extreme expression of the mode seen in the three letters, un-equaled in the other works of Yan Zhenqing, unprecedented in any ear-lier calligrapher. What makes the *Poem for General Pei* so different from the rest of Yan Zhenqing's oeuvre is the unusual variety in type of script and character size exhibited throughout the piece. Delicate, looping cur-sive-script characters are startlingly juxtaposed with massive, square, running-script characters. The arrangement of the characters seems al-most pictorial in design. The effect is at once contrived yet somehow natural, deliberate yet unrestrained. Why was such a uniquely expres-sive and individualistic work not noticed by the calligraphy connoisseurs of the Northern Song?

The *Poem for General Pei* was not included in the earliest collection

Figure 21. Su Shi, *Copy of the Letter on the Controversy over Seating Protocol,* detail, 1091. Courtesy of Field Museum of Natural History, Chicago.

Figure 22. Yan Zhenqing, *Defending Government Letter*, detail, ca. 767, ink rubbing, from the *Hall of Loyalty and Righteousness Compendium*. Zhejiang Provincial Museum.

of Yan Zhenqing's writings, compiled by Song Minqiu (1019–1079) in 1056–1064. The only Song-dynasty person known to have commented on it was the high official Lou Yue (1137–1213).[36] He admired the *Poem* for its "sword-pulling, crossbow-drawing gestures," with the implication that the calligraphic style nicely matched the subject matter of the dashing military man, Pei Min. Lou Yue was compelled to note, however, that the work was not signed and not recorded in Yan's collected works. No ink-written original is extant.[37] The earliest version of the *Poem* as calligraphy is in the engraved *Hall of Loyalty and Righteousness Compendium (Zhongyitang tie),* and it appears in Yan's col-

Figure 24. Yan Zhenqing, *Guangping Letter,* detail, ca. 778, ink rubbing, from the *Hall of Loyalty and Righteousness Compendium.* Zhejiang Provincial Museum.

Figure 23. Yan Zhenqing, *Writing a Letter Letter,* detail, undated, ink rubbing, from the *Hall of Loyalty and Righteousness Compendium.* Zhejiang Provincial Museum.

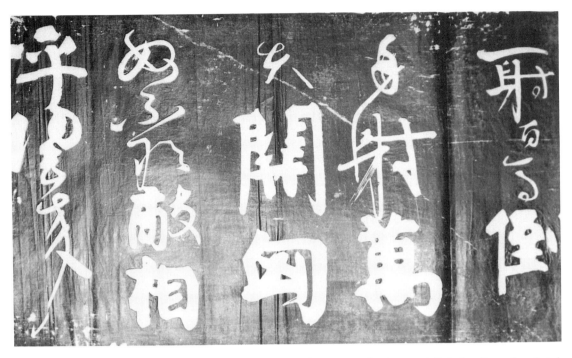

Figure 25. Yan Zhenqing (attrib.), *Poem for General Pei*, detail, undated, ink rubbing, from the *Hall of Loyalty and Righteousness Compendium*. Courtesy of Field Museum of Natural History, Chicago.

lected works only in the second edition. Both were edited by Liu Yuan-gang (1180–1268) in 1215. Liu Yuangang was more an enthusiast than a connoisseur, and his decision to include certain questionable works in his compilations may have been based more upon their previous lack of exposure than on any considered judgment of their authenticity. Yet it is also possible that Liu Yuangang either discovered a work unknown to the Northern Song champions of Yan Zhenqing or that he was willing to publish a work that was known to them but which they excluded from discussion because they judged it unorthodox in style.

Aside from the claim for authenticity based on the similarity in style between the *Poem for General Pei* and the three letters (which themselves have no pedigree before their appearance in the *Hall of Loyalty and Righteousness Compendium* of 1215), we should note that the content of the poem is perfectly plausible for a person of Yan Zhenqing's background. Pei Min was a friend and contemporary of Zhang Xu, under whom Yan Zhenqing studied cursive script, and other poems celebrating the general's daring exploits were written by Wang Wei (701–761) and Yan's brother-in-law Cen Shen.[38] It seems quite likely that Yan also knew Pei Min, as well, so that he too could have written an admiring poem for him. Thus the poem itself could be authentic.

Let us suppose, for the sake of argument, that the *Poem for General Pei* was known to Su Shi as a work by Yan Zhenqing. It was not a work that was collected or discussed, so far as we know, by any other connoisseur of the Northern Song, including Ouyang Xiu. And yet it is the one piece out of Yan Zhenqing's entire oeuvre in which the brushwork may be called *haofang,* or "bold and uninhibited." His other works, exemplary as they may be, are either consciously connected to a particular stylistic lineage (clan tradition in regular script; style of Zhang Xu in running cursive-script letters) or virtually without conscious stylistic reference (*pingdan* running-script drafts). Only the *Poem for General Pei* reveals the kind of individualism and stylistic innovation that the artists and critics of the Song dynasty so admired. Perhaps the artist in Su Shi asserted his equality with the moralist, and he copied Yan Zhenqing's exemplary *pingdan*-style *Letter on the Controversy* in the manner of the dubious, exciting *Poem for General Pei.*

Let us compare details from the ink rubbing of Su Shi's copy of Yan Zhenqing's *Letter on the Controversy* with an ink rubbing after Yan Zhenqing's *Poem for General Pei* (Figures 21 and 25). Several points of similarity are evident: both are done in large-scale characters, up to ten centimeters in height, arranged in compositionally dynamic columns of around three to five characters. Compare this to Yan's *Letter on the Controversy,* which has columns of 14 to 20 two-centimeter-high characters. In both we see striking contrasts in the sizes of characters used (Yan 3/1–2; Su 1/1–2) and in the variation in line—from heavy, unmodulated strokes (Yan 3/3; Su 2/1) to delicate ligatures (Yan 4/2–3; Su 1/3). Both use exaggerated extensions of outer strokes to provide balance (Yan 1/5; Su 3/2). Yet the differences are equally vivid. Many of the characters in Yan Zhenqing's work incorporate strong vertical and horizontal lines, so that the overall shapes of these characters are square (4/5) or rectangular (3/2). In Su Shi's work, all the characters are made up of curving and diagonal strokes, so that they tend to describe spirals and ovals (2/2; 2/3). The mixture of curving cursive-script characters and geometric running-script characters in Yan's *Poem for General Pei* creates a sense of organic forms overlaying a static grid. In Su Shi's copy of the *Letter,* the characters are altogether organic and dynamic.

From this comparison it is evident that the styles of Su Shi and Yan Zhenqing are fundamentally different. Yet what model for Su Shi's *haofang*-manner copy of the *Letter* is there but the *haofang* manner of Yan's *Poem?* Both display characters of strikingly contrasting sizes, dynamic composition, and highly modulated brushwork that are not seen in the main body of work left by these two men. The only other work by Su Shi that comes close to his copy of the *Letter* is the famous *Huangzhou Cold Food Poems* of around 1082 (Figure 26). His other

works, exemplified by the *Eulogy for Huang Jidao* of 1087 (Figure 27), are generally much less dramatic. In sum, then, Su Shi rendered his copy of Yan Zhenqing's *Letter on the Controversy* in his version of the *haofang* manner of Yan Zhenqing's *Poem for General Pei*. The irony is that Su Shi reworked one of the most admired monuments of the *pingdan* aesthetic in the manner of a work so dramatic and visually arresting that it has generally been held outside the accepted oeuvre of Yan Zhenqing's calligraphy. In his art, Su Shi employed the unorthodox side of Yan Zhenqing's calligraphy, even as he promoted Yan Zhenqing in his criticism as the orthodox calligraphic model.

Indeed, so opulent and exciting are the brush strokes and the compo-

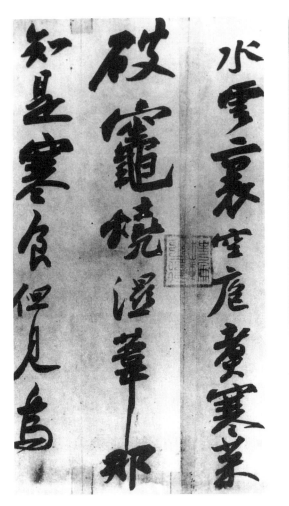

Figure 26. Su Shi, *Huangzhou Cold Food Poems*, detail, 1082, ink on paper. Collection of the National Palace Museum, Taiwan, Republic of China.

Figure 27. Su Shi, *Eulogy for Huang Jidao*, detail, ink on paper. Shanghai Museum.

sitions that one is tempted to accuse Su Shi of the very thing he deplored in "petty men"—that their calligraphy "appears eager to please and flatter." The modulations in his brush line must have been achieved through the ignoble means that he condemned in the calligraphers of the Jin dynasty: the slanted brush tip. Huang Tingjian, Su Shi's devoted student and friend, was compelled to acknowledge this criticism of Su Shi's brush method, even as he tried to demonstrate how Su Shi's weak point did no harm:

> Some say that Dongpo's *ge* [hooked diagonal] strokes show defective brushwork and others say that since he rests his wrist on the paper and lets his brush lean over, the left side of his characters is graceful but the right side is withered. This is to look at a leopard through a tube and fail to see the complete form. Don't they know that when Xi Shi pounded herself on the breast and scowled, even in her imperfect condition she was beautiful?[39]

Although it was a gracious and loyal defense, Huang Tingjian actually conceded the point. If we understand Su Shi's background in calligraphy study, however, his reliance on the means of the Jin calligraphers was only to be expected, quite apart from his espousal of the style of Yan Zhenqing. Huang Tingjian said of Su Shi's study of calligraphy:

> When Dongpo Daoren [Su Shi] was young, he studied the *Orchid Pavilion,* so that his calligraphy had the same "seductive beauty" as that of Xu Jihai [Xu Hao]. . . . In middle age he enjoyed studying the calligraphy of Yan Zhenqing. . . .[40]

Naturally, Su Shi's style was based on the slanted-brush manner of Wang Xizhi, since his childhood model had been Wang's *Orchid Pavilion Preface.* Even extensive study of another calligrapher in middle age would not significantly alter the habits of his hand.

Su Shi promoted Yan Zhenqing as the patriarch of Song Confucian literati calligraphy in his criticism and his choice of models in later life, and he extolled the "centered brush" both as proper calligraphic technique and as a metaphor for moral rectitude. And yet his own calligraphic manner, which unquestionably owes some of its daring use of awkwardness and bluntness to his study of Yan Zhenqing, does not emulate the unmodulated blandness seen in Yan Zhenqing's centered-brush *Letter on the Controversy.* It is instead a triumph of the boldness and drama that can be achieved only through the use of a slanted brush.

This gap between theory and practice is what Huang Tingjian attempted to bridge with the analogy to Xi Shi. Though flawed, it is still beautiful. Thus while a great artist such as Su Shi could be excused for employing the slanted brush in his calligraphy, any acknowledgment in one's critical writings that the slanted brush ought to have a place in the repertoire of the Confucian calligrapher would be apostasy. As a result,

although the styles of the Song calligraphers are varied and individual, the same judgment of Yan Zhenqing and his followers as the proper models and the centered brush as the proper method was handed down unchanged from one generation to the next in their critical writings. The same accolades for the achievements of the admirers of Yan Zhenqing echo down the years, for to recognize a correct choice of calligraphic model in someone else is to identify yourself as one of the elect. For example, Huang Tingjian said of Su Shi what Su Shi had earlier said of Cai Xiang: "His calligraphy is the best of this dynasty."[41] And Huang Tingjian claimed for Su Shi what Ouyang Xiu had once said of Yan Zhenqing: "His loyalty and righteousness shine as brightly as the sun or moon."[42] Sometimes the comparisons were explicit. Huang Tingjian wrote:

> Master Dongpo once compared himself to Yan, Duke of Lu. I pondered it and concluded that, all things considered, these two gentlemen were both heroes to a generation.[43]

Su Shi's relationship to the style of Yan Zhenqing reveals that the most important symbol of political identification was not the faithful reproduction of the ideal style, but the expression of affiliation in one's critical writings with the accepted patriarchs of one's political group. The calligraphic styles of Cai Xiang, Ouyang Xiu, Su Shi, and Huang Tingjian are instantly distinguishable and their uses of the calligraphic style of Yan Zhenqing quite disparate. But their political identification with moderate conservative reform and the advancement of the political and cultural power of the scholar-official class was the same, and so, consequently, was their promotion of Yan Zhenqing and themselves as his Confucian standard-bearers.

From Daoist Inscriptions to Daoist Immortal

YAN ZHENQING's tenure in provincial Jizhou lasted two years. Although he sought diversion in poetry and sight-seeing, his true feelings were revealed in his inscriptions of 766, in which he wrote "through my carelessness and clumsiness, I was degraded to serve in Jizhou" and "as a result of accusations of wrongdoing, I was made to serve in Jizhou."[1] In the summer of 768, Yan Zhenqing was transferred to serve as prefect of Fuzhou (Jiangxi), the prefecture that bordered Jizhou on the east. Fuzhou had been the home of a number of Daoist personages, both real and fantastic, from at least the third century.[2] As Yan Zhenqing toured the cities of Fuzhou over the four years he served there, he visited the sites where these Daoist figures dwelled. There he refurbished their altars and wrote stele inscriptions to record the histories of the sites and biographies of the deities.

The Daoist Inscriptions at Fuzhou

The two earliest Daoist inscriptions, dated to 768 and 769, he wrote to commemorate female Daoists at sites in and around Linchuan, the prefectural seat of Fuzhou. The first of these was the "Stele Inscription for the Altar of the Transcendant Lady Wei of the Jin Dynasty, the Lady of the Southern Peak, Primal Worthy of the Purple Void, Concurrently Supreme True Mistress of Destiny."[3] This text includes a hagiography of the noblewoman Wei Huacun (252–334) and an account of several of her latter-day female followers.[4] As an immortal, Lady Wei revealed a number of the early Shangqing scriptures to Yang Xi (330–ca. 370), the founder of the Maoshan Daoist tradition.[5] One of her Tang-dynasty adherents, Huang Lingwei (ca. 640–721), who rediscovered and restored the shrine of Lady Wei at Linchuan, was the subject of the second dated inscription by Yan Zhenqing, the "Stele Inscription for the Altar of the Transcendant Miss Flower, of Well Mountain, Linchuan District, Fuzhou."[6] Another inscription that concerns historical persons commemo-

rates two Daoists named Wang and Guo. It was engraved on a stele on Mount Huagai, near the town of Chongren, nearly fifty kilometers south-west of Linchuan. Although it is undated, it was likely produced while Yan was prefect of Fuzhou.

His only Daoist inscription extant in calligraphic form is the *Record of the Altar of the Immortal of Mount Magu, Nancheng District, Fuzhou,* dated to 771, which was erected on Mount Magu, southwest of the town of Nancheng (Figure 28). The original stone is long since lost,

Figure 28. Yan Zhenqing, *Record of the Altar of the Immortal of Mount Magu, Nancheng District, Fuzhou,* detail, 771, ink rubbing. From *Song ta Yan Lugong dazi Magu xiantan ji* (Chengdu: Chengdu guji shudian, 1986), p. 9.

and the stele that stands on Mount Magu now is a Ming-dynasty reen-
graving sponsored by Prince Yi (Zhu Youbin, born after 1470). Only a
few old ink rubbings taken from the original stone are extant today, such
as the Song-dynasty ink rubbing in the Shanghai Museum.[7] The first half
of the text is a transcription of the hagiography of the Daoist divinity
Miss Hemp (Magu), drawn from the *Biographies of Divinities and Im-
mortals (Shenxian zhuan)* of the Daoist literatus Ge Hong (284–364).[8]
Miss Hemp was a divine crane-woman. Ge Hong's narrative is set dur-
ing the second century. It tells how Miss Hemp's older brother, the Daoist
immortal Wang Fangping, requested that she manifest herself to the
family of his disciple Cai Jing. Miss Hemp appeared as a beautiful young
woman, lavishly coiffed and dressed. Cai Jing was not yet a perfected
immortal, however, and proved to have insufficient spiritual maturity to
deal correctly with the situation. As her hagiography reports:

> Miss Hemp had hands like the talons of a bird. Cai Jing thought to
> himself that when his back itched, it would be very nice to have these
> talons to scratch it with. Wang Fangping knew what Cai Jing was
> thinking, so he had Cai Jing lashed with a whip and said to him, "Miss
> Hemp is a divinity! How can you thoughtlessly believe her talons are
> for scratching your back?" The whip laid on Cai Jing's back was visi-
> ble, but there appeared to be no one holding the whip. Wang Fangping
> warned Cai Jing, "My whip does not tolerate such impropriety!"[9]

In the second half of the *Record of the Altar of the Immortal of
Mount Magu,* Yan Zhenqing describes the history of Daoist activity at
Mount Magu, including its current residents:

> In the third year of the Great Chronometry era [768], I was made gov-
> ernor of Fuzhou. According to the *Classic of Maps,* Mount Magu is in
> Nancheng district. At the summit is an ancient altar. Tradition says
> this is where Miss Hemp attained to the Way. To the southeast of the
> altar is a pool. In the center was a red lotus, which suddenly turned
> blue recently. Now it has become white. Below the north end of the
> pool, beside the altar, are firs and pines, all bent into a canopy. Occa-
> sionally the bell and chime sounds of [Daoist immortals] pacing the
> void have been heard.
> To the southeast is a waterfall, which cascades more than three hun-
> dred feet. To the northeast there is a monastery on a stone outcrop-
> ping. There are still mussel and conch shells embedded in the high
> rocks, which some believe to be remnants of the transformations of the
> mulberry fields [into the Eastern Sea and back again over aeons]. To
> the northwest is Mayuan. I think this is the site in Xie Lingyun's [385–
> 433] poem, "I Go into the Third Valley of Mayuan Where Huazi Hill
> Stands."[10] There is a divinity residing at the mouth of the spring, by
> whom prayers for rain are speedily answered.
> During the Opened Prime era [713–742], the Daoist Deng Ziyang
> practiced the Way at this spot. He received an imperial summons to

enter the Great Unity Palace, where he exercised his merit and virtue [as a Daoist *fangshi*, or doctor] for twenty-seven years.[11] One day there suddenly appeared in the courtyard a dragon chariot drawn by tigers and two men holding tallies. Deng Ziyang turned and said to his friend Zhu Wuyou, "They have come to receive me. You may report to the throne for me that I wish my corpse to be returned for burial on my mountain." Then he asked that a temple be set up at the side of the altar. Emperor Xuanzong complied with this. In the fifth year of the Heavenly Treasure era [746], a dragon was reported to be in the stone pool of the waterfall, and a yellow dragon was seen. Emperor Xuanzong expressed his gratitude for this [symbol of the Tang emperor]. Then he ordered that repairs be made to the abode of the Transcendant [Deng Ziyang], the one with the true demeanor of a cloud-following crane. Alas!

In the past, Miss Hemp left her traces on this ridge [Mount Magu]. The extant altar of "True Immortal of the South Face" [Lady Wei] is at Guiyuan. Miss Flower [Huang Lingwei] manifested her unusual quality at Jingshan. Her present disciple, the female Daoist Li Qiongxian, is eighty years old, but her complexion is very youthful. After Zeng Miaoxing had a dream that Li Qiongxian so instructed her, she ate only flowers and gave up grain.[12] Deng Ziyang's nephew is named Decheng. He continues the practices of incense and paper money. His disciple Tan Xianyan reveres the writings on Daoist arts, and Shi Yuandong, Zuo Tongxuan, and Zou Yuhua are all pure and vacuous in their service of the Way. If the genius of this locale is no different from the luminous numina of other regions, then why has there been such a splendid succession of worthies here? As I have had the pleasure of knowing the latest of these eminences, I have dared to engrave this record in stone.[13]

In this inscription Yan makes no attempt to divide the historical facts from the miraculous events reported at this site, nor does he make critical comment on Ge Hong's fabulous biography of Miss Hemp. Is this evidence that Yan Zhenqing was a practicing, believing Daoist? Soon after his death, Daoist hagiographers claimed that Yan had ingested an elixir of immortality during his life and had become a Daoist immortal after his martyrdom. Several different accounts appear in late Tang and early Song texts describing how Yan Zhenqing took youth-preserving drugs during his life and how, after his death, his corpse was at first miraculously preserved, only later to disappear, thereby revealing his status as a Daoist immortal. The biography of Yan Zhenqing in the *Xian li zhuan* (Biographies of Immortal Officials), a late Tang Daoist compilation, tells of Yan Zhenqing being cured of an illness at the age of eighteen or nineteen by a cinnabar pill given him by a traveling Daoist doctor and relates the miracles associated with his corpse.[14] The same sort of stories are found in the tenth-century *Xu xian zhuan* (Sequel

to the Biographies of Immortals), the *Taiping guang ji* (Extensive Records of the Grand Tranquility Reign), which is dated to 978, and the *Tang yu lin* (Forest of Tang Legends) by Wang Dang (1050?–ca. 1110).[15]

Yan Zhenqing as Daoist: Biography

Yet another of these accounts, which appears in the early Song-dynasty *Luozhong jiyi* (Record of Prodigies in the Luo Region), became the source for a Daoist hagiography by Mi Fu.[16] His *Record of the Immortal Duke of Lu* was engraved in 1092 onto the reverse of the stele inscribed with the *Record of the New Temple to Yan, Duke of Lu,* by a contemporary scholar-official named Cao Fu (Presented Scholar ca. 1098–1100).[17] This stele stood on the grounds of the temple to Yan Zhenqing in Feixian (Shandong), northwest of Linyi, the ancestral home of the Yan clan.[18] In his *Record of the New Temple,* Cao Fu described how the old temple to Yan Zhenqing had fallen into disrepair and how in 1091 the local magistrate and several members of the Yan clan joined forces to build a new temple for which Cao Fu wrote the dedicatory stele inscription:

> In the sixth year of the Yuanyou era [1091], Yang Yuanyong was in his second year as district magistrate. He issued a proclamation throughout the prefecture that read:
> "According to the 'Sacrificial Regulations,' if there is one who can prevent a great disaster or can ward off a great calamity, then sacrifice to him. If through his toil he stabilizes the state, if by his death he fulfills his duty, then sacrifice to him. When the Duke of Lu governed Pingyuan, An Lushan's plan to revolt was not yet hatched. But my lord was able to detect the clues, and so when the revolt came and all of the northeast had fallen, Pingyuan alone stood prepared. Together with his cousin Gaoqing, the governor of Changshan, he led a great following, and all the commanderies of Hebei relied on Pingyuan for its impregnable walls. This indeed may be called 'warding off a great calamity.' Later, when he was oppressed by a venal minister, he faced the ultimate sacrifice unmoved and unbowed, and in the end he met his death at the hands of the rebel [Li Xilie]. This indeed may be called 'fulfilling his duty by his death.' "
> The stele for the new temple was going to be erected without a text engraved on it. I was afraid it would fail to manifest [Yan Zhenqing's] loyalty and righteousness or to encourage future officials if there were no words upon it.[19]

Here Cao Fu repeats the standard Confucian version of the life and death of Yan Zhenqing, condensed to the two events upon which his reputation as a Confucian martyr rested: his loyal resistance to the rebels An Lushan and Li Xilie. Mi Fu's inscription was originally en-

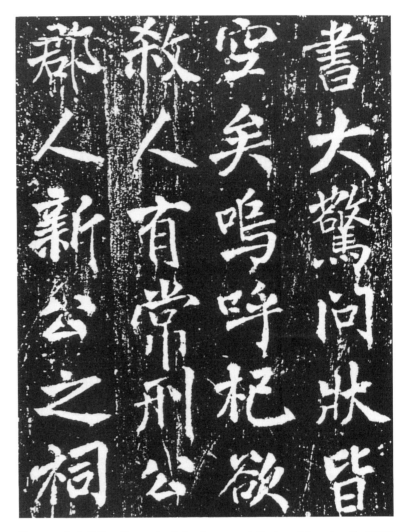

Figure 29. Mi Fu, *Record of the Immortal Duke of Lu*, detail, 1092, ink rubbing. Feixian, Shandong. From *Shodō zenshū*, vol. 18, pl. 205.

graved on a stele at the temple to Yan Zhenqing in Huzhou around 1088, but in 1092 it was engraved again onto the reverse of the Feixian stele (Figure 29).[20]

Mi Fu's inscription is both literally and figuratively "the other side of the record." For while Cao Fu's essay praised Yan Zhenqing as a Confucian exemplar exclusively, Mi Fu offered a standard Daoist version of Yan's life:

The Duke of Lu was hated by [the grand councillor] Lu Qi, so when Li Xilie revolted, Lu Qi was the first to argue for sending Yan [to negotiate with Li Xilie]. Many officials remonstrated against this. Emperor Dezong asked Lu Qi why. He replied: "Zhenqing is an impor-

tant minister at court. His loyalty and righteousness are known throughout the subcelestial realm. Who would not submit in awe? Now if an envoy is sent who cannot strike fear into the rebels, it will be a national disgrace. Pay no heed to this babble of opinions. Your Majesty ought to decide the matter himself, without being swayed by the sentiments of the crowd." But Dezong could not decide, and so he was sent.

Everyone knew that Yan Zhenqing would never return. His relatives and clansmen held a banquet for him at Changlepo [on the western bank of the Chan River, just east of Chang'an]. After Yan had something to drink, he leapt up onto the bridge, where he danced about. He said to the banqueters: "Once when I was in the south, I met the Daoist, Tao Eighty-Eight. He gave me a pinch of Azure Mist, which I took. Since then I have not aged. He once told me that I would face a great danger after the age of seventy and that he would meet me in the Luofu Mountains. Isn't this journey what he was talking about?"

Later Yan Zhenqing died at the hands of the rebels. When the rebels were pacified, his family members opened his grave. His coloring was as fresh and his nails and hair were as long as if he had been living. They returned the body for burial in the ancestral tomb in the hills north of the Yanshi district seat. Later there was a trader who went to the Luofu Mountains, where he encountered two Daoists. When they saw him they asked him, "Where do you come from?" The trader replied, "Luoyang." The first one smiled and said, "Would you be so good as to carry a note back to my family?" The trader agreed, so the Daoist wrote a letter to send with him. The address read, "To the Yan family in the hills north of the Yanshi district seat, Luoyang." But when the trader got there, the place turned out to be a family cemetery. The gray-haired cemetery keeper recognized the calligraphy of the note as Yan Zhenqing's. He was very startled and asked the trader for a description of the man who had written it; the trader described Yan Zhenqing completely. So the cemetery keeper brought the trader to Yan's family, who all wept to hear him. Then they divined the proper day to unseal the tomb and open the coffin. It was already empty!

Alas! Although Lu Qi wanted to destroy Yan Zhenqing as a person, he could not destroy him as an immortal. Li Xilie and Lu Qi were merely murderers, and they received the standard punishment for murder. Though Yan Zhenqing died, his reputation did not decay, all the more so when he became an immortal [and his physical body did not decay].

In the third year of the Yuanyou era [1088], I came to see the new temple to Yan Zhenqing put up by the people of this commandery, and I paid my respects before the image of Yan Zhenqing. So stern and imposing were the heroic spirit and immortal frame of the image that it seemed to be alive. I once read the *Record of Prodigies in the Luo Region*, which records the events of Yan Zhenqing's life. As

recorded in the dynastic histories, Lu Qi's obeisance to Yan Zhenqing in the Secretariat and his speech before Emperor Dezong showed him to be a consummate villain, but as for Yan Zhenqing's immortality, how can it be doubted?

Yan Zhenqing's tremendous virtue has been chronicled a great many times, and in discussions of ranking in the groves of learning he has been deemed accomplished in every sphere of culture. This is undoubtedly what has encouraged this misguided obsession with "loyalty and righteousness." To prevent being haunted by a wronged ghost, this true record of Yan Zhenqing becoming an immortal I have had engraved onto the reverse of this stele, to be handed down along with the account in the *Sequel to the Biographies of Immortals*.[21]

Mi Fu did not intend to contest Yan Zhenqing's reputation for loyalty and righteousness, for it was that reputation which made Yan Zhenqing's name such a valuable object of contention. Mi Fu himself praised Yan's "loyalty and righteousness" in his colophon on the *Letter on the Controversy over Seating Protocol*.[22] His writing of the Daoist record was intended to contest the Confucian appropriation of Yan Zhenqing as one of their own with their narrow characterization of him solely as an exemplar of the Confucian values of loyalty and righteousness. Mi Fu and the Daoist hagiographers believed that a life of Confucian virtue was an excellent qualification for metamorphosis into a Daoist immortal, and they were pleased to describe Yan's bravery and loyalty in the face of persecution as well as his transcendence over death. His Confucian biographers, however, not only avoided any discussion of the belief that Yan had metamorphosed into an immortal at his death, they also deplored any evidence of thought or action on his part associated with Daoism. In his famous record for the temple dedicated to Yan Zhenqing in Fuzhou, for example, the Confucian essayist Zeng Gong (1019–1083) lamented that "my lord's scholarship and writings were frequently tainted with the theories of immortality [Daoism] and Buddhism and consequently not always rational."[23] Ouyang Xiu complained that Yan "could not avoid being affected by the theories of immortality. Buddhism and Daoism are truly the people's sorrow!"[24] Thus the aim of Mi Fu's inscription was to enter a record of Yan Zhenqing's life as a Daoist in a public place in connection with a clan-sponsored, Confucian temple dedicated to the worship of Yan Zhenqing. This contest of hagiographies makes clear how serious were the claims on the posthumous reputation of Yan Zhenqing in the eleventh century.

Yan Zhenqing as Daoist: Calligraphy

In the calligraphy of his *Record of the Immortal Duke of Lu*, Mi Fu mimicked the squared forms and indented final hooks of Yan's regular script (Figure 29). His reproduction of the hallmarks of Yan's style is

somewhat surprising, given Mi Fu's often-quoted disparagements of Yan's regular script. Mi Fu criticized Yan Zhenqing's regular script for lacking the Song-dynasty ideals of "blandness" *(pingdan)* and "natural perfection" *(tiancheng)*. He particularly disliked the use of what he called *tiao* and *ti*:

> Since he became famous as a master for his *tiao* and *ti*, he used that mannerism too much, so his work lacks the flavor of blandness and natural perfection. . . . On the whole, the *tiao* and *ti* of Yan Zhenqing and Liu [Gongquan] were the progenitors of all the strange and bad writing of later generations. Following them, the methods of antiquity dissipated and were no longer handed down. But the style of [Yan's] *Dried Deer Meat Letter*, which belongs to Mr. An, and *Sick Horse Letter*, which belongs to Mr. Su, is generous and purely antique, without any of those *tiao* and *ti*. These were done while he was minister of justice. These letters on paper are exquisitely realized in both intention and spirit, which is why I say they were done then. The brush spirit is dense and tightly structured, not leggy and overgrown.[25]

Mi Fu's use of the terms *"tiao"* and *"ti"* (or possibly *"tiaoti"*) is problematic—both to translate into English and to relate to the features of Yan Zhenqing's calligraphy. Lothar Ledderose has translated *"tiaoti"* together as "stumbling," which he believes refers to the indentations Yan Zhenqing created in the underside of his *na* (upper-left-to-lower-right diagonal) and hooked *shu* (vertical) strokes by lifting the brush just before the end of the stroke (as in Figure 28, 2/3 and 1/2).[26] Wen Fong translated *"tiao"* and *"ti"* as "flicking and kicking."[27] I agree with Ledderose's identification of the mannerism that Mi Fu criticized, but I also agree with Fong that *"tiao"* and *"ti"* refer to two kinds of strokes. I wonder if *tiao* ("flicking") is not a reference to the leftward flick of the brush that creates the hook at the end of the *shu* stroke and *ti* ("kicking") is not a reference to the movement of the *na* stroke, which bends, or "kicks," at the midpoint of the stroke. In the end, whichever translation we choose does not affect Mi Fu's complaint: that Yan's regular script contains distracting brush mannerisms. Why he reproduced them to write out Yan's Daoist biography is not clear. It seems to fly in the face of his strongly stated aesthetic convictions, but perhaps it was done to indicate genuine reverence for the person of Yan Zhenqing.

Although Mi Fu disparaged Yan Zhenqing's regular script, he found much to admire in Yan's running script. While he considered Yan's regular script mannered and artificial ("intentional"), he admired his running script as organic and natural ("unintentional"). Mi Fu promoted Yan Zhenqing's running-script letters because he felt that they manifested his own aesthetic standard, which was based on his extensive study of the calligraphy of Wang Xianzhi, the finest calligrapher in Mi Fu's estimation. I contend that Mi Fu's aesthetic standard was essentially Daoist—not only because the calligraphic style of Wang Xianzhi

was influenced by the practice of Daoism, but also because Mi Fu's own political identification was with the Song court and court Daoism. One aspect of this affiliation, in line with his view of Yan as a Daoist immortal, was the promotion of Yan's running-script calligraphy as Daoist.

The nature of this Daoist aesthetic is revealed in Mi Fu's admiring description of Yan Zhenqing's *Letter on the Controversy over Seating Protocol*:

> Each character from the worn brush is intentionally connected to the next in a flying movement, yet their fantastic shapes and strange forms are unpremeditated.[28]

There are two key concepts in this passage. The first is that the characters are connected to one another. The second is that the calligraphy itself is unpremeditated, or unconscious. Both characteristics were admired by Mi Fu because they are found in the "single-stroke calligraphy" of Wang Xianzhi. Mi Fu was unusual in admiring the calligraphy of Wang Xianzhi over that of his father, Wang Xizhi. Mi once wrote: "Zijing's [Wang Xianzhi's] natural perfection is transcendent and untrammeled. How can his father compare?"[29] Mi Fu described Wang Xianzhi's writing in the same terms he had used for Yan Zhenqing's running script:

> [The characters] are continuous and connected, with no beginning or end, as if there were no willful intent. This is what is known as "single-stroke calligraphy."[30]

The source for Wang Xianzhi's "single-stroke calligraphy," which was considered the novel style of its day, has been discussed in detail by Lothar Ledderose.[31] Ledderose has reported on modern-day sessions of planchette writing, in which a Daoist priest in a trance state "receives" divinely inspired texts, writing out the characters in a tray of sand with a wooden stick. This Daoist practice can be documented back to at least the Tang dynasty. The style of this planchette writing, which is done with great speed and abandon, involves connected characters and unpremeditated forms. From this Ledderose argues that the novelty in Wang Xianzhi's style was borrowed from the unpremeditated, continuous line of Daoist planchette writing.

If the distinguishing feature of Wang Xianzhi's calligraphy lies in what it borrowed from Daoist religious practice—and that feature is the one that Mi Fu considered its paramount virtue—then I would argue that Mi Fu promoted a Daoist aesthetic in calligraphy. One of the few works by Yan Zhenqing that Mi Fu found acceptable stylistically, the *Letter on the Controversy over Seating Protocol,* he praised for having the Daoist aesthetic qualities of "single-stroke calligraphy." Was he not promoting the idea of Yan's running script as "natural" and "Daoist" over his regular script, which he saw as "constructed" and "Confucian"?

Mi Fu was not a self-made man of literature like the Confucian reformers, and he never met Ouyang Xiu. His mother had been a lady-in-waiting to the later empress of Emperor Yingzong (r. 1063–1067), and he had grown up in the imperial palace. He became an artist, collector, and critic who made his way among the court nobility through artistic talent and eccentric charm. In 1105, he served as doctor of calligraphy and painting during the reign of the great patron of Daoism, Emperor Huizong.[32] He was a protégé of Huizong's Grand Councillor Cai Jing (1046–1126), and several anecdotes concerning his whimsical behavior are preserved in *Tieweishan congtan,* the collection of jottings by Cai Jing's youngest son Cai Tao (died after 1147). Among the art collectors and connoisseurs in his circle of friends were several members of the Song imperial family, such as Wang Shen (ca. 1051–ca. 1103), Li Wei, Zhao Zhongyuan (1054–1123), and Zhao Lingkun.[33] Mi Fu has not, to my knowledge, been identified as a practicing Daoist. But it would appear that he was more closely allied to the group of men who promoted Daoism at the imperial court than to the scholar-officials such as Ouyang Xiu and Cai Xiang who opposed Daoism and Buddhism.

Mi Fu's promotion of the "Daoist" qualities in the calligraphy of Yan Zhenqing was of a piece with his recording of the Daoist legends concerning Yan Zhenqing's corpse. He seems to have shared the goal of the promoters of Daoism at the court of Huizong: to enlist the name and reputation of Yan Zhenqing on the Daoist register. Another protégé of Cai Jing, Ye Mengde (1077–1148), once wrote: "The men of the Tang dynasty often said that Yan Zhenqing was a divine immortal."[34] He then added: "In recent times, tradition has it that Ouyang Xiu and Han Qi were both immortals. How can this be doubted?" This is propaganda at its most brazen—since Ouyang Xiu was a staunch Confucianist and Han Qi a pious Buddhist—and serves only to weaken the claim for Daoist activity by Yan Zhenqing.

Was Yan Zhenqing a Daoist?

Leaving aside the question of immortality, certain circumstances in the history of the Yan clan suggest involvement with Daoism long before Yan Zhenqing wrote his Daoist stele inscriptions. During the Western Jin dynasty (265–316), the Wang clan, of which Wang Xizhi and Wang Xianzhi were descendants, lived in the Langye region of Shandong province, where the school of Daoism known as the "Way of the Celestial Master" (Tianshi Dao) had its origins. The Wangs were adherents of this school of Daoism in Langye, and they continued their Daoist practices in the south under the Eastern Jin (317–420). Many of the Wangs had personal names ending in the character *"zhi,"* which was often a sign of a follower of the Way of the Celestial Master.[35] The Yan clan too had resided in Langye, and when the Western Jin dynasty fell,

Yan Zhenqing's thirteenth-generation ancestor Yan Han (265–357) followed the future Emperor Yuan of the Eastern Jin dynasty south to Nanjing.[36] Not only were the members of the Yan clan followers of the former Langye aristocracy, but many of them had names ending in the character *"zhi,"* such as Jingzhi, Tengzhi, Bingzhi, and Yanzhi.[37] Yan Zhenqing's sixth-generation ancestor, Yan Xie (498–539), once wrote a book entitled *Biographies of Jin Dynasty Immortals.* The Yan clan had intermarried for generations with the Shen clan of Wuxing (modern Huzhou), during the Six Dynasties period, and with the Yin clan of Chen commandery (modern Shenqiu, Henan), during the Tang dynasty. These two clans were "Celestial Master" Daoist families. Yan Zhenqing himself was related by marriage to the Wang clan: his mother-in-law was the daughter of one Wang Qiu of Langye.[38] Thus it seems likely that the Yan clan, too, had a tradition of participation in the Way of the Celestial Master.

On the counter side, I have found no evidence that Yan Zhenqing himself was a practicing Daoist. His inscriptions for the Daoist sites in Fuzhou are similar in form to those for other famous sites—such as the one for the temple of Dongfang Shuo, in which he quotes a biography of the figure in question from a well-known literary source and then appends an account of the current circumstances of his career as an official and the names and occupations of the people he encountered at his post. Although Yan Zhenqing stated in the *Magu* inscription that he was personally acquainted with some of the Daoist priests on Mount Magu, the writing of this and the other stele inscriptions for local sites seems to have been simply another official duty. The religious establishment on Mount Magu had been patronized by Emperor Xuanzong, and the cult of Miss Hemp continued to receive imperial attention at least through the Northern Song dynasty.[39] As the emperor's local representative, Yan Zhenqing may have been expected to make a tour of inspection to all local Daoist sites in Fuzhou. Though they seem credulous, there is nothing zealous about the contents of these stele inscriptions. A failure to distinguish between the mythical Miss Hemp and the actual Huang Lingwei is evidence merely of an encyclopedic cast of mind, typical of the syncretic world of the Tang dynasty.[40]

Certainly Yan had Daoist friends, such as the renowned Maoshan master Li Hanguang (683–769), with whom he traveled in 759 and for whom he wrote an epitaph in 777.[41] But no mention is made of adherence to Daoism in any of Yan Zhenqing's many stele inscriptions for his ancestors. His nephew and biographer Yin Liang never suggested that he participated in Daoist activities, nor do we read of it in the anecdotes written about him by his contemporaries, such as those in Feng Yan's *Mr. Feng's Record of Experience.*[42] Nowhere in his own writings does he confess a belief in Daoism or describe participation in Daoist activities.

And yet the year 768, when Yan Zhenqing first arrived in Fuzhou, was in some respects conducive to thoughts of immortality. In the eleventh month, Yan Zhenqing's younger brother Yunzang died at his post in Jiangling. Zhenqing was now the only surviving member of his generation. Furthermore, in 768 he reached the age of sixty *sui*, completing the calendrical cycle. Perhaps the local cults of the immortals Miss Hemp and Miss Flower held a special appeal under the circumstances.

6

Buddhist Companions and Commemoration

YAN ZHENQING'S more mundane activities as prefect of Fuzhou included having the embankments repaired for better irrigation. The people of Fuzhou later erected a shrine in his honor, for which the Song-dynasty writer Zeng Gong composed his famous essay, "The Record of the Shrine of Yan, Duke of Lu, at Fuzhou."[1] His replacement as prefect arrived early in 771, and Yan was free of duties. Sailing across Lake Poyang and down the Yangzi River, he arrived home in Shangyuan district (near modern Nanjing) four months later, where he was reunited with his large household. His family had been evacuated from Chang'an during the An Lushan Rebellion to find refuge in this peaceful southern city, just as Yan Zhenqing's thirteenth-generation ancestor Yan Han had done at the fall of the Western Jin dynasty. Late in 771, Yan Zhenqing made his obeisances at the ancestral tombs in the hills outside the city, where Yan Han and the members of seven succeeding generations were buried, and there he erected a stele inscribed with an exhaustive recitative of the achievements of the Yan clan to date.[2]

Yan Zhenqing remained at home for the better part of a year, until the following autumn, when he traveled to Luoyang. There he was informed of his appointment as prefect of Huzhou (Zhejiang). He left Luoyang to return his mother's coffin for burial in the ancestral tomb outside Chang'an, then traveled to Huzhou. Yan's arrival in Huzhou in 773 was also a homecoming of sorts. As a child, he lived for some years in Wu district, which lies to the east across the Great Lake from Huzhou, where Lady Yin had taken her children to live with her father after the deaths of her husband and brother. At that time Yin Zijing was serving as district magistrate in Wu.

Cultural Activities in Huzhou: 773–777

As prefect of Huzhou, Yan Zhenqing enjoyed considerable social and scholarly activity. Only a year after his arrival, in the spring of 774, he composed an inscription for the site of much of this activity:

On the southern slope of Mount Zhu, southwest of the prefectural seat, there lies Profound Joy Monastery [Miaoxisi]. It was established by Emperor Wu of the Liang dynasty. . . .

In the seventh year of the Great Chronometry era [772], I was appointed prefect to this region. At that time, Assistant Surveillance Commissioner and Palace Censor Yuan Gao [b. 727] reached this prefecture on his tour of inspection, so I met with him on this hill. Subsequently, I had a pavilion built to the southeast. Because it was built on a *guihai* day, the twenty-first, in the tenth month, of which the first day was a *guimao* day, during the winter of a *guichou* year, Retired Scholar Lu [Yu] named it the Three *Gui* Pavilion.

To the northwest, in a stand of cassia trees, I created a cassia canopy. All around for several hundred paces were fragrant groves and luxuriant trees. There were three types of cassia there, which produced red, blue, and purple blossoms. Each had a different type of flower and leaf. Beneath the cassias was a branching path for my lord Yuan to walk among them. For this reason it was called "The Censor's Path."[3]

The name of the Three *Gui (san gui)* Pavilion is a pun twice over, playing on the three types of cassia *(san gui)* on Mount Zhu, a term also used as a metaphor for three high dignitaries. This kind of jest was typical of Lu Yu (733–804). As a young man he fled the Buddhist monastery where he was raised because the abbot beat him for disobeying his prohibition against writing. He joined a troupe of actors and wrote his first work, *On Jokes.*[4] As the leader of the troupe, he was patronized by local officials, who noticed and encouraged his literary talent. When he arrived as a refugee in Huzhou during the An Lushan Rebellion, he went to live at Profound Joy Monastery, where he formed a close bond with the famous poet and Buddhist monk Jiaoran (ca. 724–ca. 799).

By the time Yan Zhenqing arrived in Huzhou, Lu Yu was already a national celebrity called the "Genius of Tea" for his book *Canon of Tea (Chajing)*. Lu Yu had a great range of interests as an author. In addition to his writings with titles such as *Monograph on People and Things of the North and South* and *Prognostications and Dreams,* he also wrote a work called *Sources Explained,* which was probably a dictionary, and two works on local officials entitled *Record of Successive Officials in Wuxing* and *Record of Prefects of Huzhou.* He was eminently qualified to collaborate with Yan Zhenqing in his long-standing lexicographical project.

In the Profound Joy Monastery inscription, Yan Zhenqing gave a thorough history of his dictionary, which survives today only as recollected fragments.[5] As he explains, it was called *Sea of Rhymes, Mirror of Sources (Yunhai jingyuan):*

Since the time I served as an editor in the Palace Library [734], I have presumed to analyze and annotate the *Qieyun* written by Lu Fayan

and my fifth-generation ancestor Yan Zhitui, using such etymological works as *Shuowen* and *Cangya*.[6] [The words in the *Qieyun*] were taken from the classics, histories, philosophers, and collectanea and are arranged with the two characters [for pronunciation] at the top and complete phrases [of explanation and quotations] below. I have expanded and edited it. Thus my work is called *Yunhai* [Sea of Rhymes]. And because it illuminates the original roots of the words, with nothing left unrevealed, my work is further called *jingyuan* [Mirror of Sources].

At the end of the Heavenly Treasure era, when I was sent out to govern Pingyuan, I worked on revising it with some of the local scholars, including Feng Shao of Bohai, Gao Yun, and his younger clansman, the present secretarial receptionist to the heir apparent, Gao Hun. We had put together two hundred chapters, but when An Lushan rebelled, the work stopped when it was only one-quarter done. When I served as prefect of Fuzhou, some of the local scholars there, such as Zuo Fuyuan and Jiang Rubi, helped restore and expand it to five hundred chapters, but it was still quite immature and riddled with problems, and I had not the leisure to edit it.

In the *renzi* year of the Great Chronometry era [772], I was appointed prefect of Huzhou. In leisure from public service, during the summer [of 773] I met daily with the Buddhist monk Fahai from Jinling; the former palace censor, Li E; Lu Yu; the instructor in the School for the Sons of the State, Chu Chong, a native of this prefecture; the case reviewer, Tang Qinghe; the great supplicator, Liu Cha; the vice magistrate of Changcheng, Pan Shu;[7] the district defender, Pei Xun; the assistant magistrate of Changshu, Xiao Cun;[8] the district defender of Jiaxing, Lu Shixiu; and Yang Suichu, Cui Hong, Yang Deyuan, Hu Zhong, Tang She of Nanyang, Yan Ji,[9] Wei Jie, Zuo Xingzong, and Yan Ce to discuss the work, at the prefectural school and at the pond for the release of living creatures. When winter came, we traveled out to the eastern slope of this hill. Then in the spring of the following year [774], the work was completed.

At that time, a virtuous monk lived on Mount Zhu whose name was Jiaoran and who was skilled at literary composition. . . .

The Chan monk Jiaoran was probably the most renowned poet in the southeast in the years following the rebellion, and when Yan Zhenqing arrived in Huzhou, a coterie of scholars and poets gathered around them.[10] Eclectic in their literary and philosophical interests, the members with Buddhist backgrounds, such as Jiaoran and Lu Yu, were also well versed in Lao-Zhuang philosophy and the Confucian Classics, while those with Confucian educations, such as Yan Zhenqing, were knowledgeable about Buddhist and Daoist traditions. The cultural achievements for which this group is known were the compilation of the *Yunhai jingyuan* and the composition of linked verse.

In linked verse, a series of lines or couplets on a given topic, each

composed by a different person, together form a portrait of their subject. Linked verse was a significant genre in the Six Dynasties period, but it had fallen out of popularity until revived by Yan Zhenqing and Jiaoran.[11] Perhaps one reason they chose to employ this antique form was that Jiaoran was a tenth-generation descendant of Xie Lingyun (385–433), while Yan Zhenqing was a tenth-generation descendant of Yan Yanzhi (384–456). These two poets were twin stars of the Six Dynasties period.[12] Only a small percentage of these linked verses still remain, divided between the collected works of Jiaoran and Yan Zhenqing. They were done in various lengths of line, ranging from three-character to seven, and in various humors, from the jocular to the somber. Some are in the old three-character Yuefu form called "Five Mixed Dishes":

> Yan Zhenqing:
> Five mixed dishes: Sweet, salt, sour.
> Departs and returns: Raven and hare.
> You never regain: Springtimes past.
> Jiaoran:
> Five mixed dishes: Five colors of thread.
> Departs and returns: A round of poems.
> You never regain: Happy occasions missed.[13]

Others are *yongwu* poems in which a material object is taken as the subject, as in these five-character couplets on lanterns:

> Yan Zhenqing:
> Shattering the darkness, their brilliance at first white;
> then, floating like clouds, colors convey their clarity.
> Jiaoran:
> Garlands of flowers hang frozen in the trees;
> like torches, they split the courtyard.[14]

And there are the humorous rounds, condemned by later Confucianists as too vulgar to have been written by a man so virtuous and upright, such as the seven-character "Big Talk":[15]

> Jiaoran:
> Loudly I sing on Langfeng, then step across to Yingzhou.
> Yan Zhenqing:
> Broiled roc and fried leviathan, and still my meal goes on.
> Li E:
> I travel the four quadrants, up and down, to where nothing lies
> beyond.
> Zhang Jian:
> One sip and suddenly I have drained the ocean wide.[16]

In 756, before Yan abandoned Pingyuan, he sent his only son, Yan Po, as a guarantee of good faith to the Pinglu military commissioner,

Liu Zhengchen. Liu's troops did set out for Pingyuan, but they failed to arrive before the city surrendered. Liu then engaged the rebel Shi Siming at Youzhou, but he was routed and fled back to Yingzhou (Liaoning) where he was soon murdered by poison.[17] The ten-year-old boy was left without a protector, and when Yan Zhenqing returned to Emperor Suzong's provisional court, Yan Po was awarded posthumous honors (though in fact he was still alive). But twenty years later, in Huzhou, Jiaoran wrote the following poem for Yan Zhenqing:

> Offering congratulations to My Lord Yan Zhenqing on the return of
> his long-lost son from faraway Hebei:
> Once you lost a thing of value in the vapors and mists,
> now you find in your hand those long ago years.
> After so long a separation, how startling to find him grown,
> after so many hardships, how joyful to find him whole.
> To faith, the minister gave weight,
> with fear, the governor felt sympathy.
> In the teeming courtyard, you see the tree of jade,
> and once again, you possess the connecting branch.[18]

The *Ponds* Steles

Another dream realized in Huzhou was Yan Zhenqing's project of erecting a stele inscribed with his "Ponds for the Release of Living Creatures Throughout the Subcelestial Realm." This essay was written to commemorate Emperor Suzong's decision to build eighty-one ponds throughout China to be used for the pious Buddhist practice of releasing captive fish and other aquatic creatures. Although the "Ponds" essay was written originally in 759, Yan was only able to erect a stele inscribed with it in Huzhou in 773. The following year, he set up a companion stele next to it that carried three additional inscriptions. On the obverse was Yan's request to Emperor Suzong for a heading for the *Ponds* stele and the emperor's reply, both done in 760. On the reverse was a complete history of the project from 759 to 773.

Yan Zhenqing's request to the emperor reads as follows:

> Your subject has heard that in emperors and kings there is no virtue greater than assisting living creatures, while the central concern of ministers of state is to venture to lose themselves in words of praise. In winter of last year [759], while your subject was serving as governor of Shengzhou, together with Left Courageous Guard Vice Commandant of the Left Shi Yuancong, Imperial Commissioner Zhang Tingyu, and others, I received the proclamation of the imperial command that ponds for the release of living creatures be constructed in suburban areas near rivers in each of the prefectures and districts in the subcelestial realm. From Xingdao district in Yangzhou to the Tai-

ping Bridge over the Qin Huai River near Shengzhou and Jiangning, there are to be eighty-one in all.

The imperial grace saturates the flora and fauna. The imperial favor extends even to the multitude of insects. Emanating from your august heart, they travel throughout the subcelestial realm. In the entire succession of emperors, such has never been heard of before. Who does not rejoice at it, even to the peoples on the shores of the sea?

At that time, your subject, in his ungoverned folly, hastily composed a draft of a "Ponds for the Release of Living Creatures Throughout the Subcelestial Realm Stele Inscription." Further, he used his official salary to select a stone in that prefecture [Shengzhou] and expended his awkward skills to write it out. Because our desire is to let the populace of the subcelestial realm know the virtue of Your Majesty's love for living things and make your petty officials grasp the significance of the ancient worthies' skill at praise, I subsequently transcribed a copy on silk, which I entrusted to Shi Yuancong to present to the throne, together with this request to the emperor to write a heading for it, in order to make it known and imperishable. As the dots and strokes of my earlier calligraphy [inscribed on the stele in Shengzhou] were rather too fine, I feared it would not endure, and so your subject has now respectfully engraved a stone with a "hollow-thumb" large-script copy, which I submit to the throne in the company of this memorial.[19] Thus does this petty official exhaust his respectful sincerity in a special plea for Your Sage Grace to deign to comply with his prior request. Then the subcelestial realm would be fortunate indeed!

Is this but a whim of your ignorant official? In antiquity, the First August Emperor of Qin [r. 221–210 B.C.E.] was a cruel and tyrannical ruler and Li Si [d. 208 B.C.E.] an evil and fawning minister, yet the bronzes and stones they had engraved have been handed down to later generations. Emperor Wen of Wei [r. 220–226] was a lord who was ceded his throne by another clan and Zhong You [151–230] an official who was partial to one clique, yet they also set up a stele at Fanchang extolling [the emperor's] virtue. How much worse that Your Majesty's towering meritorious achievement should go unrecorded. Thus your subject presumes to bring shame on himself and respectfully risk death in order to make it known. . . .[20]

In his reply Emperor Suzong assented to Yan Zhenqing's request:

We extend "Inner Truth" to all living creatures and take their nurture as our central concern. All that exists between the canopy of heaven and the carriage of earth, we must raise to the realm of virtue and longevity.

Cultivate the creatures of the four directions,
in the single pneuma they harmoniously unite.
Establish the ponds by the rivers Jiang and Han,
that fishes and turtles may together requite.

Our minister has been careful in the minutest particulars with the imperial favor, polishing Our Great Plan, and engraving his admirable text in excellent stone. Its style soars and excites, its rhymes ring like bells. It realizes the "imperishable" of the establishment of wise words and records the ultimate virtue of the love for living things. Such a song must become a duet. Since antiquity it has been so, that the proper sentiments emanate from the center. We commend your idea, and with that which you have requested We shall comply.[21]

On the reverse of the companion stele, Yan told of the years intervening between the genesis of the stele project and its realization:

The August Emperor Suzong graciously gave his assent [to the request that he write a heading] and thus there is this reply. This imperial missive had already been handed down when, through my carelessness and clumsiness, I received a reprimand [from Emperor Suzong]. Then came the first day of the eighth month [of 760] and my dismissal with an appointment as prefectural aide in Pengzhou.

The present emperor [Daizong] ascended the throne in summer, during the fifth month of the inaugural year of the Treasure Response era [762]. I accepted the post of governor of Lizhou, but Qiang bandits were besieging the city and I could not gain entry. By gracious imperial order I returned to the capital. My lord Liu Yan, Duke of Pengcheng, present minister and former grand councilor, ceded his post to me and I became vice minister of revenue in the Department of State Affairs [twelfth month, 762]. In spring, during the third month of the second year [763], I was transferred to the Ministry of Personnel. In the autumn of the inaugural year of the Ample Virtue era [763], during the eighth month, I accepted the post of governor of Jiangling, concurrent with that of censor-in-chief and acting military, surveillance, and supervisory commissioner of Jingnan. I had not departed when a replacement was found. I was transferred to right assistant director of the Department of State Affairs. In spring of the next year [764], during the first month, I was appointed acting minister of justice and concurrent censor-in-chief, to act as Shuofang Mobile Brigade pacification commissioner for six prefectures, including Jin and Fen, to proclaim the imperial will to Grand Preceptor and Secretariat Director Pugu Huaien [who had rebelled against the throne]. I did not depart, but subsequently fulfilled my duties in the central government.

In the spring of the second year of the Eternal Majesty era [766], during the second month, I was dismissed to the post of administrative aide of Xiazhou. Not twenty days later, I was further degraded to [a similar post in] Jizhou. In summer of the third year of the Great Chronometry era [768], during the fifth month, I came to be appointed governor of Fuzhou. In the intercalary third month of the sixth year [771], my replacement arrived. In autumn, during the eighth month, I arrived in Shangyuan [modern Nanjing]. And so for

sixteen years I suffered for my carelessness and stupidity, while I accumulated dismissals and disgrace.

As for the selection of a stele stone, until now I had only been entrusted with places in the foothills and had not had the leisure to erect one on a lofty site. In autumn of the seventh year [772], during the ninth month, I returned to the Eastern Capital, where my fortunes were raised when I was appointed governor of Huzhou. In the spring of the next year [773], during the first month, I arrived at my post.

To the east of the prefectural seat are the two streams Tiao and Zha. South of these streams is one of the Ponds for the Release of Living Creatures established by our Treasure Response Prime Sage Cultured and Martial August Emperor [Daizong]. To the west of the prefectural seat is White Crane Mountain. As the mountain has plenty of excellent stone, I selected some and had it quarried. I ordered my clerks to have it slabbed and polished and my servants to have it engraved. It was set up to the east of Camel Bridge in Huzhou. Now, through this manifestation of my sincerity in commemorating the deceased, will the virtue of the late emperor [Suzong] in assisting living creatures be displayed.

Since the heading had not been set and no one could remember it, some of my retainers suggested that the characters in the reply the late emperor wrote granting permission be edited and then engraved. I complied with this. Restraining my desire to stop with that, since that would not show sufficient respect, I then had this record inscribed on the reverse of the stele. How like was [the late emperor] to the glorious brilliance of the heavenly bodies in their complete course of the universe and the luminous radiance of the constellations in their resplendency equal to the sun and moon![22]

Why did Yan Zhenqing involve himself in this imperial Buddhist project? The original inscription for the ponds that Yan Zhenqing wrote in 759 is curious in that although its purpose is manifestly Buddhist, its language is mainly Confucian.[23] After opening with a salutation to Emperor Suzong, it then describes how the two capitals were heroically regained from the rebels and how Suzong filially welcomed Retired Emperor Xuanzong back from Shu. It notes that even with all his worries, the emperor still had concern left for all other living creatures. Thus in 759 he charged Shi Yuancong and Zhang Tingyu with writing an edict declaring that eighty-one ponds would be built throughout the realm. Next Yan Zhenqing quotes from the Confucian Classics, *Yijing* and *Shujing*, on the subject of the humaneness of the ruler extending to all forms of life. In the emperor's reply, these quotations are echoed in the reference to "Inner Truth" [hexagram 61 in the *Yijing*] and in the quotation "fishes and turtles may together requite" from the *Shujing*.) Yan Zhenqing then cites some examples of earlier benevolent rulers, none of them Buddhist, and congratulates the emperor on his attempt

to emulate the past. In short, except for one or two Buddhist terms, the inscription is thoroughly Confucian.

One theory on Yan's motivation was formed by Su Shi:

> In Huzhou stands the *Ponds for the Release of Living Creatures Stele,* by Yan, Duke of Lu. It records the memorial that he offered Suzong, in which he wrote: "Three audiences [with his parents] every day will greatly illuminate the filial piety of the Son of Heaven. Ask after [your parents'] comfort and watch over their diet, and make no change in the ritual of the family members." The Duke of Lu knew that Suzong was conscience-stricken over this [taking his father's throne] and therefore used this opportunity to remonstrate with him. Who could believe that the Duke of Lu had any real interest in releasing living creatures![24]

Su Shi believed that Yan Zhenqing had seized on this project as an opportunity to state his views on Suzong's treatment of his father. Suzong had taken the throne when Xuanzong fled Chang'an at the beginning of the An Lushan Rebellion, but he failed to return it to his father when the old man returned two years later. In 760, Yan's feelings about Suzong's behavior were shown when Suzong allowed the eunuch Li Fuguo to move the retired emperor unceremoniously out of his former living quarters. Yan led the court officials in memorializing the emperor in protest of this breach of filial piety. Thus Su Shi argued that Confucian morality was the real issue in the *Ponds* inscription, not Buddhist piety.

Su Shi's theory may explain the impetus behind the original *Ponds* inscription, but not the zeal with which Yan Zhenqing completed the project. Why would Yan set up a stele engraved with an admonitory memorial when the emperor to whom it was addressed had been dead for eleven years? Why set up a companion stele engraved with the correspondence between himself and the emperor and a record of all the hardships he had endured in the years since Suzong had dismissed him? Their parting seems to have been acrimonious. Yan wrote in his *Ponds* record: "I received a reprimand from the emperor." This reprimand may have been over the very subject that Su Shi identified—that is, Yan's objection to Suzong's treatment of his father. That Yan was banished to Pengzhou immediately after he led the court officials in protest over the improper relocation of the retired emperor suggests this was so. Emperor Suzong died in 762 while Yan was still in Pengzhou, so there was no reconciliation. Therefore, I suggest that only with the passing of the years was Yan able to distance himself from those events and finally undertake his own monument to the late emperor.

The other motivation for the *Ponds* stele and its companion may have been to offer an expression of gratitude to the current emperor, Daizong, for having brought Yan Zhenqing back out of the wilderness

of exile to his childhood home in the south. Perhaps Yan Zhenqing wished to thank the emperor for his personal renascence in Huzhou, for the good company of Jiaoran and Lu Yu, for the return of his son, for the success of his literary projects. Both Emperors Suzong and Daizong were in thrall to the Tantric Buddhist master Amoghavajra (705–774), and both sponsored a considerable number of Buddhist projects and observances. No doubt it seemed appropriate to Yan Zhenqing to repay the two emperors in a coin they would value. The pond for the release of living creatures in Huzhou was a public construction, conceived by Emperor Suzong and realized by Emperor Daizong, that allowed Yan Zhenqing the opportunity to honor both emperors by publishing a record of his dedication to their project.

Yan Zhenqing in Song-Dynasty Compendia

Though the stone steles disappeared long ago, Yan Zhenqing's request to the emperor and the record on the reverse, both from the companion stele, may still be seen (Figure 30). They are preserved in the *Hall of Loyalty and Righteousness Compendium,* a set of stone engravings of some thirty-eight calligraphic works. The *Compendium* was compiled by the scholar-official Liu Yuangang in 1215—the first engraved compendium devoted to the calligraphy of Yan Zhenqing. Though its stone tablets are no longer extant, a unique surviving Song-dynasty ink rubbing of the *Compendium* is now held by the Zhejiang Provincial Museum in Hangzhou.[25]

To understand the place of the *Hall of Loyalty and Righteousness Compendium* in the history of engraved calligraphic compendia, we should look at their development from their beginnings in the tenth century. Engraved collections of calligraphy are known as *fatie,* or "model letters." The choice of works to be included in these publications is well worth examining, since *fatie* served simultaneously as copybooks, records of important collections, and illustrated histories of calligraphy. Because of these functions, *fatie* became propaganda tools in the contest between imperial and literati choices of calligraphic models. The inclusion or exclusion of Yan Zhenqing's calligraphy in imperial and scholar-sponsored *fatie* of the Song dynasty was one of the most obvious points of contention. Although works by Yan Zhenqing were kept in the palace collection, none of his calligraphy appeared in any imperially sponsored *fatie* until the relatively late date of 1185.

In 992, Song Taizong commissioned the *Chunhua ge tie* (Model Letters in the Imperial Archives in the Chunhua Era [990–995]), the first of the Song *fatie,* which has been the most famous and influential ever since.[26] The court calligrapher Wang Zhu was instructed to select the finest calligraphies from the imperial storehouses, which were then

Figure 30. Yan Zhenqing, *Request to the Emperor to Write a Heading for the Ponds for the Release of Living Creatures Throughout the Subcelestial Realm Stele*, detail, 760, ink rubbing, from the *Hall of Loyalty and Righteousness Compendium*. Zhejiang Provincial Museum.

Figure 31. Yan Zhenqing, *Letter for Cai Mingyuan*, detail, ca. 759, ink rubbing, from the *Jiang tie*. Collection of Liaoning Provincial Museum, Shenyang.

engraved into wooden plates, in a collection of ten volumes. The first five volumes represented the calligraphy of nearly one hundred emperors, officials, and scholars from legendary antiquity through the Tang dynasty, while the last five volumes were devoted exclusively to the calligraphy of Wang Xizhi and Wang Xianzhi. No works by Yan Zhenqing were included. Nor was any of his calligraphy chosen for the supplement, known as the *Yuanyou bige xutie* (Supplementary Model Letters in the Imperial Archives in the Yuanyou Era [1086–1094]), a further selection of calligraphy from the imperial collection that was engraved between 1090 and 1101.[27] Only in 1185 was calligraphy by Yan Zhenqing included in an imperially sponsored engraved compendium, the *Chunxi bige xutie* (Supplementary Model Letters in the Imperial Archives in the Chunxi Era [1174–1190]). This was a ten-volume supplement to the *Chunxi bige tie* (Model Letters in the Imperial Archives in the Chunxi Era), which was itself a reengraving of the original *Chunhua ge tie*.[28] Two running-script works—his *Draft Eulogy for Uncle Yuansun* and *Letter for Liu Taichong*—appear in the third volume, which was dedicated to the calligraphy of "seven worthies" of the Tang dynasty.

By contrast, the engraved compendia sponsored privately by scholars and officials from the 1040s onward contained works by Yan Zhenqing. Pan Shidan's twenty-volume *Jiang tie* was created between 1049 and 1064 in Jiangzhou (Shanxi). It was essentially a reengraving of the *Chunhua ge tie* with minor additions and deletions.[29] The *Jiang tie* added four letters by Yan Zhenqing: the *Letter for Cai Mingyuan* (Figure 31), the *Zouyou Letter,* the *Cold Food Letter* (Figure 32), and the *Fengci Letter.* The ten-volume *Tan tie* was created by the Buddhist monk-calligrapher Xibai in Tanzhou (Changsha, Hunan) in 1042–1043. It contains letters by Jin and Tang masters, including two works by Yan Zhenqing, the *Draft Eulogy for Nephew Jiming* and *Dried Deer Meat Letter,* though it should be noted that they are rather unfaithful copies.[30] Not surprisingly, works by Yan Zhenqing also appeared in the privately sponsored *fatie* that rejected the preponderance of classical-tradition letters in the *Chunhua ge tie* in search of a more balanced and complete history of calligraphy. The *Ru tie,* compiled by Wang Cai as governor of Ruzhou (Henan) in 1109, reproduced some letters from the *Chunhua ge tie* but also included a large amount of epigraphic material (such as inscriptions on stone steles and bronze vessels) and writing by northerners and other calligraphers not represented there. It included one letter by Yan Zhenqing, the previously unrecorded *Jiang Huai Letter* (or *Yihang Letter*).

The Northern Song engraved compendia were all surveys, however, in which Yan was simply one among dozens of calligraphers. The first monographic compendia, those that published the work of a single

calligrapher only, appeared in the Southern Song. A compendium dedicated solely to the calligraphy of Mi Fu was commissioned by Emperor Gaozong in 1141. In 1186, a compendium of Su Shi's writings was published by a private scholar in Chengdu (Sichuan). In the late twelfth century, monographic compendia were also published of writings by Ouyang Xiu, Cai Xiang, and Huang Tingjian. The decision to publicize Ouyang's unbeautiful handwriting demonstrates that the motivation

Figure 32. Yan Zhenqing, *Cold Food Letter*, detail, undated, ink rubbing, from the *Hall of Loyalty and Righteousness Compendium*. Zhejiang Provincial Museum.

behind the production of these compendia was as much political as aesthetic. With individual compendia devoted to each of the Confucian reformers, it seems almost logical that the next calligrapher to be canonized in a monographic compendium would have been their Tang-dynasty touchstone, Yan Zhenqing.

Liu Yuangang, the compiler of the *Hall of Loyalty and Righteousness Compendium*, was a grandson of the grand councillor Liu Zheng (1129–1206), who served Emperors Xiaozong and Guangzong during the years 1189–1194 and was a patron of the controversial Neo-Confucian philosopher Zhu Xi. Liu Yuangang passed the Erudite Literatus examination in 1205 and subsequently served in the capital in a number of prestigious posts: palace library proofreader, drafter for the heir apparent, imperial diarist, and auxiliary Hanlin academician.[31] Around 1215, he was appointed to serve as governor in Wenzhou (Zhejiang), where he had a momentous personal encounter with the descendants of Yan Zhenqing. In a postface to the edition of Yan's collected works that he also sponsored, Liu Yuangang wrote:

> I was born three hundred and ninety-four years after the death of my lord [Yan Zhenqing]. Another thirty-five years after that, I was appointed governor of Yongjia [Wenzhou]. I searched out his descendants, who had moved their residence here during the Five Dynasties period. Six of his descendants are on record as having served as officials between the Huangyou and Shaoxing eras of this dynasty [1049–1162], showing how long the influence of his loyalty and righteousness has continued to filter down.

Liu then determined to have Yan's collected works reprinted:

> I asked after my lord's writings so that I could publish them, in order to encourage scholars and commoners, but his family did not own a copy. [Elsewhere] I was able to obtain the twelve-chapter edition with the preface by Liu Yuanfu [Chang], which is the one compiled by Song Cidao [Minqiu] during the Jiayou era. His engraved writings had been abridged [through ink rubbings cut and pasted into albums?] and the characters [on the stone] had become illegible, so that their meanings became degraded and false.[32]

Liu Chang and Song Minqiu (1019–1079), the son of Song Shou, were both friends of Ouyang Xiu and served in high posts at court. Ouyang Xiu shared an interest in epigraphy with Liu Chang and the study of Tang history with Song Minqiu.[33] During the Jiayou era (1056–1063), Song Minqiu compiled the first collection of the writings of Yan Zhenqing, the preface for which was written by Liu Chang.[34] Liu Yuangang compiled a new edition of Yan's collected works in sixteen chapters, called *Wenzhong ji* after Yan's posthumous epithet, *Wenzhong* ("Cultured and Loyal"). Next he edited a chronology of Yan's life based on

his biographies in the dynastic histories and the copious biographical
material in Yan's stele inscriptions for his various relatives.[35] Lastly, Liu
produced the *Hall of Loyalty and Righteousness Compendium*.

The *Hall of Loyalty and Righteousness Compendium*

The contents of the *Compendium*, to put it kindly, are miscellaneous.
Volumes 1 and 2 most resemble a typical model-letters compendium.
They contain twenty-five letters and other brief writings, including the
draft of the *Letter on the Controversy over Seating Protocol*. I suspect
that all these letters had already been engraved long ago and that Liu
used ink rubbings as the basis for his compendium. We know, for exam-
ple, that An Shiwen had already had the *Letter on the Controversy over
Seating Protocol* engraved in stone around 1086, and he owned other
letters by Yan Zhenqing that we may assume he also had engraved.[36] In
the twelfth century, Ye Mengde testified to seeing engraved copies of the
Dried Deer Meat Letter, the *Request for Rice Letter*, the *Cold Food
Letter*, the *Letter for Cai Mingyuan*, the *Letter to Administrator Lu Ba*,
and the *Letter for Liu Taichong*, all of which are found in the *Compen-
dium*.[37] In addition, other letters in the *Compendium* are found in
earlier *fatie*. The *Fengci Letter* was included in the mid-eleventh-century
Jiang tie, for example, and the *Yihang Letter* appeared first in the *Ru tie*
of 1109.

Volume 3 consists of three problematic pieces: the *Poem for General
Pei*, the *Engraved Poem of the Daoist Qingyuan*, and a unique version
of the *Record of the Altar of the Immortal of Mount Magu*. The anom-
alous stylistic qualities of the *Poem for General Pei* were discussed in
Chapter 4. The *Engraved Poem of the Daoist Qingyuan* purports to be
a copy by Yan Zhenqing of a poem written by a certain Daoist Qing-
yuan and his friend Shen Gongzi at Tiger Hill Monastery in Wu. Ap-
pended is a poem in response by Yan himself, signed as minister of jus-
tice in the year 770. Unhappily for the authenticity of this piece, Yan
did not serve as minister of justice in 770. Moreover, as the Qing-
dynasty scholar Huang Benji has noted, none of the Tang taboo charac-
ters are altered in this piece as they are routinely modified in Yan's gen-
uine writings.[38] The version of the *Record of the Altar of the Immortal
of Mount Magu* that Liu included in Volume 3 of the *Compendium* is
known as the "medium-character version" because its characters are
between one and two centimeters in height. This is to distinguish it
from the "large-character version," the original stele on Mount Magu,
which had characters of about five centimeters in height, and the
"small-character version," in characters of less than one centimeter, on
a stele that also stands in Nancheng county.[39] The medium-character
version is found only in the *Compendium*. It is not recorded in any of
the standard epigraphic sources and is generally dismissed as a fake.

Volume 4 consists of the *Record on the Reverse of the Encomium on a Portrait of Dongfang Shuo* of 754. Volumes 5 and 6 consist of the *Guo Family Temple Stele,* which was set up in Chang'an in 764. The remaining material is not clearly divided into volumes. It consists of the *Request to the Emperor to Write a Heading for the Ponds for the Release of Living Creatures Throughout the Subcelestial Realm Stele,* in Yan Zhenqing's hand, and the *Imperial Response,* which is in a large, florid running script that is probably Emperor Suzong's hand. Both pieces were written in 760 and were engraved on the same stele in Huzhou.

Following this are several edicts granting posthumous offices to Yan's grandfather Yan Zhaofu, his uncle Yan Yuansun, his father Yan Weizhen, and his mother Lady Yin, as well as two announcements of office for Yan Zhenqing himself, one granting him the position of minister of justice in 777 and the other granting him the post of junior preceptor to the heir apparent in 780. It was a common practice for officials in the Tang dynasty to copy out their official notices of appointment.[40] These copies were rarely signed, however, since they were not the original compositions of the copyist. In traditional times, critics often assumed that the person who received the announcement of appointment was also the calligrapher, but such is not always necessarily or demonstrably the case.

Liu Yuangang made a number of interesting comments regarding these edicts in a colophon following them that was also engraved in the *Compendium.* Liu did not claim the edicts were all written by Yan Zhenqing himself. He honestly states that they were traditionally said to be either Yan's own handwriting or that of his son Jun, his brother Yunzang's son Yu, or someone else in that generation.[41] Almost as if to apologize for their lack of attractiveness, Liu remarks that the edicts are valuable for their inspirational quality and should not be discussed solely in terms of the quality of the calligraphy. Lastly, he asserts that although stone engravings of the edicts existed already, he was able to bring together the ink originals to have them engraved for the *Compendium.* This is a difficult statement for us to prove by measuring the edicts in the *Compendium* against the originals. Only one of the edicts is extant in an ink-written form. It is the one granting Yan Zhenqing the post of junior preceptor to the heir apparent, known to posterity as the *Self-Written Announcement of Office (Zishu gaoshen)* (Figure 33), now in the collection of the Shodō hakubutsukan, Tokyo.

As is true of many other works in the *Compendium,* none of these edicts was recorded in the Northern Song dynasty. Ouyang Xiu once saw a group of announcements of office that were displayed in the Secretariat by members of the Yan family, but they were entirely different documents.[42] The *Self-Written Announcement of Office,* however, does bear a colophon written by Ouyang's close friend Cai Xiang in 1055

(Figure 42). This colophon was also engraved into the *Compendium* by Liu Yuangang. That presents no particular problem. The real difficulty lies in the conflict between Liu's statement that he borrowed the ink originals to copy for the *Compendium* and the later documentation on the ink-written version in the Shodō hakubutsukan. It includes a colo-

Figure 33. Yan Zhenqing (attrib.), *Self-Written Announcement of Office,* detail, 780, ink on paper. Shodō hakubutsukan, Tokyo.

phon of authentication for the imperial collection by the well-known connoisseur Mi Youren (1074–1151) and a label said to have been written by Emperor Lizong (r. 1225–1265).⁴³ Thus the Shodō hakubutsukan's *Announcement* would appear to have been in the imperial collection throughout the Southern Song dynasty. If the work in the Shodō hakubutsukan is the same one that Liu Yuangang copied into his *Compendium,* how could he have obtained it in Wenzhou in 1215? A comparison between the Shodō hakubutsukan version and the version in the *Compendium* (Figure 34) shows that the calligraphy in the Shodō hakubutsukan version is quite weak, as I discuss further in Chapter 7.⁴⁴ Moreover, the tentativeness and lack of skill are the same in the ink-written version of the *Announcement* and the colophon by Cai Xiang appended to it. I suspect they are both by the same copyist. As in the case of the ink-written version of the *Poem for General Pei,* it may have been produced by copying an ink rubbing from the *Compendium.* I believe that Liu Yuangang probably did obtain the original of the *Self-Written Announcement of Office* for the *Compendium* in 1215. All in all, though, the *Compendium* is a very mixed collection. It contains both early fakes and originals that are the source of today's fakes. Nevertheless, it is the *Compendium* as a whole that is of the greatest significance.

I have argued elsewhere for the importance of examining the contents of Song-dynasty *fatie* for their political significance.⁴⁵ It may be shown that the course of their development, in terms of content and sponsorship, reveals how the compendia embodied the political tensions between the scholar-official class and the throne during the Song. As we have seen, the earliest compendia display the universal acceptance of the classical tradition of Six Dynasties calligraphy championed by the throne in the late tenth and early eleventh centuries. In the mid-eleventh century begins the promotion of epigraphy and other nonclassical calligraphy by scholar-officials. By the late twelfth century we see the endorsement of the idea of cultural figures, especially Confucian personalities, as important to the history of calligraphy by both imperial and private sponsors.

In the case of the *Compendium,* compiled in 1215, what was its political significance? Did it lie simply in the nature of the project itself —that is, canonizing Yan Zhenqing in a monographic compendium? Were there compelling reasons for Liu's choice of pieces, or did he merely collect and reengrave what was available to him in Wenzhou? Let us summarize the contents of the *Compendium.* It contains two volumes of personal letters and drafts in running script, one volume of previously unrecorded poems and inscriptions, three regular-script stele inscriptions that predate 770, and six edicts from Yan's official career. What do these thirty-eight very disparate works have in common? Only

four were recorded by Ouyang Xiu (the *Request for Rice Letter, Cold Food Letter, Letter for Cai Mingyuan*, and *Encomium on a Portrait of Dongfang Shuo*). As we shall see in the following chapter, the majority of pieces by Yan Zhenqing cited in Ouyang's *Collected Records of Antiquity* were regular-script steles dated between 770 and 780. The calligraphic manner displayed in these stele inscriptions was canonized

Figure 34. Yan Zhenqing (attrib.), *Self-Written Announcement of Office*, detail, 780, ink rubbing, from the *Hall of Loyalty and Righteousness Compendium*. Zhejiang Provincial Museum.

as the "Yan style." My sense is that Liu's purpose in creating the *Hall of Loyalty and Righteousness Compendium* was twofold. He wished not only to mark Yan Zhenqing's importance in the history of calligraphy with a monographic compendium, but also to fill in the lacunae in Ouyang Xiu's influential record. By publishing the letters-tradition part of Yan Zhenqing's oeuvre as a complement to the stele-tradition part published by Ouyang Xiu, Liu Yuangang would make the full range of Yan Zhenqing's genius known.

7

The Late Style
of Yan Zhenqing

PERHAPS YAN ZHENQING would have been content to spin out the rest of his days in Huzhou constructing pavilions and composing poetry, but early in 777 his nemesis at court was removed from the scene. Yuan Zai, who had kept him in the provinces for eleven years, was executed in the third month of 777, and Yang Yan was sent into exile. In the fourth month, Yang Wan (d. 777) was elevated to the rank of grand councillor, and the following month he recommended Yan Zhenqing for a position at court.[1] The two even collaborated on a stele inscription for the temple of the renowned general and statesman Li Baoyu (704–777) in Chang'an, which Yang Wan wrote and Yan transcribed.[2] That autumn Yan was appointed minister of justice, and at the end of the year he presented his dictionary *Yunhai jingyuan*, in 360 chapters, to the court.

High Honors from the Throne

When he reached the age of seventy *sui* in 778, Yan petitioned the throne to allow him to retire. Instead he was transferred to serve as minister of personnel. Then, early in the summer of 779, Emperor Daizong passed away and his son ascended the throne. It so happened the new emperor's mother was a daughter of the Shen clan of Wuxing. During the Six Dynasties period, the Shen and Yan clans had intermarried.[3] As a result, Yan Zhenqing's sons were honored by Emperor Dezong (r. 780–805) as relatives. Yan Jun, who was serving in the establishment of the heir apparent, was given the title of Baron of Yishui (Shandong), and Yan Shuo, a proofreader in the Palace Library, was made Baron of Xintai (Shandong).

At this time Yan Zhenqing was appointed commissioner for rites and ceremonies, a special post in which his long-standing and well-known expertise in the ritual of the dynastic ancestral cult could be consulted

by the emperor. Yan Zhenqing's biographer-nephew Yin Liang described this post:

> The present emperor [Dezong], on the occasion of his imperial mourning, appointed my lord commissioner for rites and ceremonies. Since the time of Emperor Xuanzong, this post has noted omissions and remissions in ceremonial propriety. My lord was well versed in the decisions of antiquity and modern times and did not involve himself in court intrigue. He simply researched the canons of ritual and followed the straight path. The present emperor entrusted him with [the rituals for] the tomb of the late emperor, and when it was completed he was granted the prestige title of grand master for splendid happiness.[4]

Of course, Yan Zhenqing's strict views on state ritual had indeed involved him in court intrigue—as when he criticized Yuan Zai for failure to arrange for sacrifices at the imperial tombs before the court returned to Chang'an after the Tibetan scare of 763. Yan's zeal for rectitude continued unabated in this new post. David McMullen has described him as "particularly significant in the post-rebellion history of the dynastic ancestral cult."[5] In addition to the *Yuanling Rituals*, which he wrote to guide the rites performed at the tomb of Emperor Daizong, Yan Zhenqing also researched and wrote memorials on the great controversies then facing the practice of state ritual.[6] One of these concerned the proper rearrangement of the ancestors' spirit tablets in the imperial temple. The arguments in Yan's memorial were accepted. Another of his opinions focused on the controversy surrounding the advisability of maintaining the imperial ancestral temple in Luoyang, the Eastern Capital. The temple in Luoyang had been abandoned after the An Lushan Rebellion, but some of the spirit tablets had been saved. Yan presented a memorial requesting that they be replaced. Emperor Dezong did not rule against him, but simply left it open for discussion.[7] Other ritual issues Yan addressed involved the complexity of the posthumous names for emperors and the abolition of the taboo on marriage in *ziwu* and *maoyou* years.[8]

In similar fashion, Yan Zhenqing soon after undertook to restore his own family temple and erect a grand stele monument to his own long-deceased father, Yan Weizhen. In the early autumn of 780, he composed and transcribed the *Temple Stele Inscription for Lord Yan, the Late Tang Grand Master for Thorough Counsel, Companion to the Prince of Xue, Pillar of State, Posthumously Entitled Vice Director of the Palace Library, Chancellor of the Directorate of Education, and Junior Guardian of the Heir Apparent*. Although this stele inscription was dedicated to Yan Weizhen, whose exalted posthumous titles were gained for him by his well-placed sons, it is a genealogical record of the

achievements of the entire Yan clan and is known familiarly as the *Yan Family Temple Stele.*

Development of the "Yan Style"

As a work of art, the *Yan Family Temple Stele* constitutes the apogee of Yan Zhenqing's regular-script calligraphy. As his latest surviving monumental stele inscription, it represents the furthest development of his style, and because it was intended as a permanent monument to his father and his clan, it was executed at his highest level of craftsmanship. The characters are solid and weighty, yet expansive and even; the effect is as much sculptural as calligraphic (Figure 35). The manner shown in the *Yan Family Temple Stele* is what came to be known and imitated as the "Yan style." There are two points I wish to pursue with regard to the "Yan style." The first is technical: how did Yan himself, in terms of the development of his calligraphic technique, arrive at this manner? The second concerns the politics of calligraphic style: why was his "old-age style" regular script promoted as the "Yan style"?

The periodization of the stylistic development of Yan's regular script has been the subject of a number of studies by modern Chinese art historians in the last twenty years.[9] The one observation they all make in common concerns the transition from his early use of the "square," slanted-brush, clerical-script brush method to the "round," centered-brush, seal-script brush method as his distinctive style evolved. We have seen the sharp-edged stroke endings and highly modulated strokes of the "square" brush method in his *Prabhutaratna Pagoda Stele* of 752. This early manner accorded with the kind of calligraphy that was expected of officials at the court of Emperor Xuanzong: tight compositions and attractive exposed brush-tip work, yet substantial and weighty, like the style of the emperor himself.[10]

Yan Zhenqing's transition away from the "square" brush method and the tight compositions of his "metropolitan" calligraphy coincided with his departure from Chang'an, the destruction of the court of Emperor Xuanzong soon after, and the subsequent decline in imperial patronage and control in the arts. As early as the *Encomium on a Portrait of Dongfang Shuo* of 754, Yan Zhenqing's characters began to expand internally and the strokes became less modulated, while the entry point of the strokes began to disappear, disguised by the use of the *cang feng,* or "concealed brush-tip" technique. The decreasing modulation in the brush stroke and the increasing use of the "concealed brush tip" indicate the greater use of the centered brush, the brush method characteristic of seal script.

Seal script enjoyed a renaissance during the Tang dynasty. Its greatest practitioner was Li Yangbing, a calligrapher with whom Yan Zhenqing

worked on several inscriptions.[11] Yan himself was competent at seal script, as the heading to his *Record on the Reverse of the Encomium on a Portrait of Dongfang Shuo Stele* shows.[12] Not only did he change his brush method to that used in seal script, but the compositions of his characters became increasingly taller, more evenly distributed, and more spacious inside, in imitation of seal-script character forms. This transition period extends, from the evidence of extant works, from the *Encomium* inscription of 754 and the similar *Inscribed Record of a Visit to the Shrine of Shaohao* of 758 (Figure 36) through the inscriptions of the early and mid-760s, such as the *Lidui Record of Mr. Xianyu* of 762 (Figure 16) and the *Guo Family Temple Stele* of 764 (Figure 37). The fully realized "Yan style" is seen in the works of Yan's final decade

Figure 35. (left) Yan Zhenqing, *Yan Family Temple Stele,* detail, 780, ink rubbing. Shaanxi Provincial Museum. From *Shoseki meihin sōkan,* vol. 90.

Figure 36. (above) Yan Zhenqing, *Inscribed Record of a Visit to the Shrine of Shaohao,* detail, 758, ink rubbing. Shaanxi Provincial Museum. From *Zhongguo shufa: Yan Zhenqing,* vol. 1, p. 159.

as a calligrapher—from the *Immortal of Mount Magu* stele of 771 (Figure 28), through the *Stele for Li Hanguang* of 777 (Figure 38), to the *Yan Family Temple Stele* of 780 (Figure 35).

What the Song literati found so admirable about the "Yan style" was, of course, the contrast it provided to the style of Wang Xizhi. The compositional structure of Wang-style characters is described as "left tight, right loose," meaning that the shapes of the characters tend to cluster on the left side and fan out to the right. By comparison, Yan Zhenqing's characters are even and rectangular. There is no sense of movement in one direction over another; rather, a weighty stability is evident, as in seal script. Seal script has traditionally been characterized as "level, upright, round, and straight," and these are the qualities that Yan Zhenqing applied to his regular script. "Level" refers to the *heng* (horizontal) strokes, which are virtually even from top to bottom and side to side; "upright," the right angles at which the intersecting strokes meet; "round," the brushwork, with its blunt stroke ends and unmodulated strokes; and "straight," the absolute verticality of the *shu* strokes. Yan Zhenqing's application of seal-script technique to the writing of regular script is what the Song literati saw as his revolutionary contribution to the history of calligraphy.

Promotion of the "Yan Style"

The revival of Yan Zhenqing's style among the Song scholar-officials appears to have begun in the 1030s in the circle of Han Qi. According to Mi Fu, Han's predecessor Song Shou had his own style, which became fashionable, whereas "Han Qi loved the calligraphy of Yan Zhenqing."[13] Han's practice of Yan's style is evident in his calligraphy, and though he was no artist he could convey some of the four-square qualities of Yan's style in his personal handwriting, as in his *Two-Night-Stay Letter* (Figure 39). Fan Zhongyan, another of the Qingli reformers, coined the famous phrase "sinews of Yan, bones of Liu [Gongquan]" to identify the stylistic references in the calligraphy of his friend, the poet Shi Manqing (994–1041).[14] Though the reformers practiced Yan's style, these men were neither great artists nor critics. They copied his style, but they did not transform it. They were connoisseurs of calligraphy, but so far as we know they did not collect it or write about it systematically.

The member of their circle who did collect calligraphy and write criticism systematically was Ouyang Xiu. He was a zealous propagandist for the regular-script calligraphy of Yan Zhenqing's final decade which he promoted as the "Yan style." Ouyang used his collecting and criticism in the *Collected Records of Antiquity* to focus his contemporaries' feelings of dissatisfaction with the court-sponsored Wang style and their admiration for the "Yan style" into a competition between the two as

Figure 37. Yan Zhenqing, *Guo Family Temple Stele Inscription*, detail, 764, ink rubbing. Shaanxi Provincial Museum. From *Shodō zenshū*, 3rd ed., vol. 10, pl. 35.

Figure 38. Yan Zhenqing, *Stele for Li Xuanjing [Li Hanguang]*, detail, 777, ink rubbing. From *Zhongguo shufa: Yan Zhenqing*, vol. 4, p. 170.

Figure 39. Han Qi, *Two-Night-Stay Letter*, detail, undated, ink on paper. Collection unknown. From *Zhongguo lidai fashu moji daguan*, vol. 5, p. 28.

representatives of an imperial style and a scholar style. He seems to have taken his cue from the caustic appraisal of the Wang style by his much-beloved model in literature, Han Yu, who wrote that "[Wang] Xizhi's vulgar calligraphy took advantage of its seductive beauty."[15] Apparently Han Yu did not record his opinion of the calligraphy of Yan Zhenqing, but he was connected to some of Yan's followers and descendants. As a young man, Han Yu knew Xiao Cun, the son of Xiao Yingshi, who worked with Yan Zhenqing on his dictionary project in Huzhou, and in later life Han was a friend of Wei Dan, one of Yan's grandsons.[16] In literature, Han was a great admirer of the writings of Yan Zhenqing's close friend Dugu Ji (725–777). Furthermore, Meng Jiao (751–814), Han's partner in writing linked verse, had been an associate of Jiaoran, Yan Zhenqing's partner in linked verse.[17] To Ouyang Xiu, whose youthful discovery of the literary works of Han Yu shaped his life as a man of letters, Han's disapproval of the style of Wang Xizhi and his association with the circle of Yan Zhenqing may have suggested the rough outline for the conflict between imperial and scholar-sponsored styles that Ouyang Xiu fostered.

Collecting the "Yan Style"

Ouyang Xiu's instrument of propaganda for the "Yan style" was his collection of ink rubbings of stone inscriptions by Yan Zhenqing and the colophons he wrote for those ink rubbings, which were published in Ouyang's *Collected Records of Antiquity.* Which works did Ouyang Xiu collect and discuss? Chapter 7 of *Collected Records of Antiquity* lists the following.

Encomium on a Portrait of Dongfang Shuo and *Record on the Reverse of the Encomium on a Portrait of Dongfang Shuo Stele* (Figure 4). These are the two sides of the *Encomium* stele of 754. Xiahou Zhan's essay is found on the obverse. On the reverse is Yan's record of the outing to the temple of Dongfang Shuo with An Lushan's spies. The stele that stands in Lingxian (Shandong) today is said to have been reengraved during the Jin dynasty.

Inscription at Quiet Dwelling Monastery. Written to record a visit to the Quiet Dwelling Monastery (Jingjusi) in Jizhou with friends in 766, it is apparently no longer extant. The text is preserved in Yan's collected writings.[18]

Record of the Altar of the Immortal of Mount Magu (Figure 28). Ouyang collected an ink rubbing of the original stele of 771, called the large-character version, and one of the small-character version. The original large-character stele no longer exists. The stele now in Nan-

cheng (Jiangxi) was reengraved during the Ming dynasty by Prince Yi. The small-character version is in Nancheng also. The medium-character version does not appear in the documentary record until Liu Yuan-gang's *Hall of Loyalty and Righteousness Compendium* of 1215.

Paean to the Resurgence of the Great Tang Dynasty (Figure 14). Yuan Jie's tribute to Emperor Suzong was written in 761 and inscribed on the cliff face at Wu Creek, near Qiyang (Hunan), by Yan in 771.

Lexicon for Gaining Employment (Ganlu zishu). This manual of orthography was written by Zhenqing's uncle Yan Yuansun to be studied in preparation for the government examinations.[19] In 771, as prefect of Huzhou, Yan transcribed it onto a stele that was set up in the courtyard of the prefectural office for the edification of local scholars. Ouyang Xiu collected two versions: the original by Yan Zhenqing and the re-engraving ordered by Yang Hangong, prefect of Huzhou, at the request of Yan's nephew Yan Yu in 839. These are no longer extant. The few ink rubbings known today are from the "Shu version," a reengraving of 1142.[20]

Stele for Ouyang Wei. In 775, Yan composed and transcribed this regular-script stele, which was set up in Zhengxian (Henan).[21]

Spirit Way Stele for Du Ji. Yan wrote this epitaph for the Spirit Road stele at the Chang'an tomb of his friend and son-in-law Du Ji upon his death in 777.[22]

Record of the Archery Hall. This stele, dated to 777, was written in Huzhou. It was already shattered in Ouyang Xiu's day, and the text does not survive in Yan's collected works.

Stele for Zhang Jingyin.[23] Ouyang assigned the date of 779 to this stele, although it was already ruined and he admits very little of it was legible. According to him, the stele was destroyed deliberately:

> The stele for Zhang Jingyin was written and transcribed by Yan Zhen-qing. It stood in the middle of peasant fields in Linying district in Xuzhou. Early in the Qingli era, those who knew about this stele came one by one to make copies from it. The local people grew concerned that they would trample the crops in the field, so they smashed up the stele. When I was in Chuyang, I heard about it and sent some-one to search it out. I was able to obtain the smashed remnants, of which there were seven pieces. The text could not be put back in order. Only his name was left. It said: "My lord's taboo name was Jingyin, and he was a man of Nanyang. His grandfather was Cheng

and his father Lian." The strokes of the characters are particularly unusual. What a terrible pity![24]

Spirit Way Stele for Yan Qinli (Figure 40). This stele for Yan Zhenqing's great-grandfather disappeared at the end of the Northern Song and was excavated in Xi'an in 1922.[25] It is now in the third hall of the Forest of Steles, Shaanxi Provincial Museum, Xi'an. As a consequence

Figure 40. Yan Zhenqing, *Spirit Way Stele for Yan Qinli,* detail, undated, ink rubbing. Shaanxi Provincial Museum. From *Shoseki meihin sōkan,* vol. 6.

of being spared eight hundred years of abrasion from the taking of ink rubbings, it is in an excellent state of preservation. Although the stele bears no date, Ouyang Xiu arbitrarily recorded it as a work of 779. Based on internal evidence, Huang Benji argued it was written in 759.[26]

Yan Family Temple Stele (Figure 35). As described earlier, this stele was produced in 780 to honor Yan's long-deceased father, Yan Weizhen. It is his latest surviving inscription, and there is a seal-script heading by Li Yangbing. Standing approximately three meters high on a tortoise base, the stele is now prominently placed in the center of the front row in the second stele hall at the Forest of Steles.

Stele for Yan Yunnan. The stele inscription of 762 for Zhenqing's older brother Yunnan is apparently no longer extant.[27]

Huzhou Stone Record. This list of tombs, temples, residences, mountains, bodies of water, and other interesting sights in the districts of Huzhou prefecture is now lost. It was probably written during Yan's tenure as prefect between 773 and 777.[28]

Letter for Cai Mingyuan (Figure 31). This running-script letter of recommendation describes the dedicated service of the clerk Cai Mingyuan, who worked for Yan when he was prefect of Raozhou. It probably was written in 759. First engraved in the mid-eleventh century, in the *Jiang tie*, it has been included in later compendia as well. No ink-written original exists, but a poor tracing copy once in the collection of Luo Zhenyu (1866–1940) has been reproduced.[29]

Cold Food Letter (Figure 32). In this brief undated letter in running script, Yan reports on the chilly weather at the time of the Cold Food Festival in early spring. In the eleventh century there was an ink-written version and various engraved versions.[30]

Twenty-Two Character Letter. This may be an alternate title for the *Writing a Letter Letter* (Figure 23), which is twenty-two characters long exclusive of the signature. It is extant only in the *Hall of Loyalty and Righteousness Compendium.*

Request for Rice Letter. This brief running-script letter was written to ask for financial assistance from one Grand Guardian Li, who was probably Li Guangjin, younger brother of Li Guangbi, the great loyalist general of the An Lushan Rebellion. It was probably written around 765.[31]

Epitaph for Yuan Cishan (Figure 41). Cishan is the style name of Yuan Jie, author of the "Paean to the Resurgence of the Great Tang Dynasty." The stele is in Lushan district (Henan). As the inscription is partially effaced, the date is either 772 or 775. In his colophon Ouyang says nothing about calligraphic style. Instead he discusses the history of literature, declaring Yuan Jie a member of the ancient-style prose lineage:

Figure 41. Yan Zhenqing, *Epitaph for Yuan Cishan*, detail, 772, ink rubbing. Lushanxian, Henan. From *Tang Yan Zhenqing shu Yuan Cishan mu bei* (Kaifeng: Henan renmin chubanshe, 1979), p. 15.

The epitaph for Yuan Cishan was written and transcribed by Yan Zhenqing. During the Tang the height of government was reached with Emperor Taizong, perhaps equaling the Three Dynasties of antiquity, yet only in literature were they unable to break with the degeneracy of the Chen [557–589] and Sui dynasties. Only a long time later did Han [Yu] and Liu [Zongyuan (773–819)] and their followers emerge. It is difficult to change common practices, and changing the style of literary writing is also difficult. During the Opened Prime and Heavenly Treasure eras, Cishan was the only one to practice ancient-style prose. The force of his brush was heroic and his expression extraordinary. He was no less than a follower of Han Yu. He may be called a scholar of brave independence.[32]

Defining the "Yan Style"

With the exception of the four letters, the works Ouyang collected are large public monuments in regular script. Of these fourteen regular-script stele inscriptions, eleven date from the decade of 770–780. Thus when Ouyang Xiu extolled the calligraphic style of Yan Zhenqing, the style in question was that of his engraved regular script of the 770s. This focus on his "old-age style" was furthered by Ouyang's habit of assigning the date of 779 to works on which the date could no longer be read. Through sheer weight of numbers, then, Ouyang defined the "Yan style" as the regular script of Yan's last decade.

The content of these inscriptions consists mostly of information of historical interest. This was, in fact, the aspect of Yan Zhenqing's writing that Ouyang Xiu dealt with principally in his colophons. In his introduction to the *Collected Records of Antiquity,* he said of his purpose in collecting ink rubbings that "I have recorded those that may correct the omissions and errors in the histories and biographies."[33] On ten of the eighteen works listed, Ouyang Xiu discussed only historical information. Of the remainder, on five of them he considered Yan's calligraphy from the connoisseur's point of view; on the other four he took the moralist's point of view, expressing his admiration for Yan's regular-script style as a manifestation of his personality.

These panegyrics for Yan Zhenqing as a paradigm of Confucian morality find their equal only in Ouyang's praises for Yuan Jie and Han Yu. He promoted Yan as the Confucian standard in calligraphy, just as he championed Yuan Jie and Han Yu in literature:

I consider my lord Yan's calligraphy to be like the loyal minister, exemplary officer, or the gentleman of morals in its uprightness, gravity, and reverence. When a person first sees it, he is in awe of it. And it follows that the longer he looks at it, the more admirable it becomes.[34]

The virtue of my lord's loyalty and righteousness was bright as the sun and moon and steadfast as metal and stone. Thus was he able to illumine the generations that followed.[35]

> This man's loyalty and righteousness emanated from his heaven-sent nature. Thus his brush strokes are firm, strong, and individual and do not follow in earlier footsteps. Outstanding, unusual, and imposing, they resemble his personality.[36]

Only one flaw marked his hero, and that was Yan's obvious tolerance for Buddhism and Daoism:

> The purity of my lord Yan's loyalty and righteousness shone like the sun and the moon. His personality was dignified and stern, firm and strong, just like the strokes of his brush. And yet he could not avoid being affected by the theories of immortality. Buddhism and Daoism are truly the people's sorrow![37]

The very nature of Ouyang Xiu's collection tended to favor the works of Yan Zhenqing over Wang Xizhi. Ouyang's real interest lay in epigraphy as a source for history, and when he discussed calligraphy in his colophons, he was talking largely about works engraved in stone. The great majority of the thousand pieces listed in the *Collected Records of Antiquity* are ink rubbings from engraved stone monuments and bronzes. With the exception of three copies of Wang Xizhi's *Orchid Pavilion Preface*, an ink rubbing of Wang's regular-script transcription of the essay "On General Yue Yi," and what are probably some of the Jin-dynasty volumes of the *Chunhua ge tie*, his collection lacked any works of the classical tradition to discuss.[38] By collecting works with historical and epigraphic interest, he restricted himself to a certain range in which the large number of extant engraved stone steles by Yan Zhenqing would be virtually certain to predominate. On the foundation of his scholarly preference for epigraphy and the moralistic premise that models should be chosen by reputation, he built the "Yan style" as an aesthetic standard. Yet the simple fact of Yan's oeuvre and reputation does not explain why Ouyang so vigorously promoted Yan Zhenqing as the patriarch of Confucian calligraphy. Yan's calligraphic style and the symbolic value of his reputation were both flexible implements: Ouyang used Yan's style as a sword in his attack on court styles in the arts; he used Yan's reputation as a shield in his defense against charges of disloyalty.

In the arts, Ouyang's Confucian activism led him to oppose court-sponsored styles because of their focus on style and effect over expressive and didactic purpose. In poetry, he opposed the Xikun court style; in prose, parallel prose and the imperial academy style; in painting, professional and court painting; and in calligraphy, the court-sponsored Wang style.[39] In their place he advocated informal poetry, the ancient-style prose of Han Yu, literati amateur painting, and the calligraphic style of Yan Zhenqing. All were promoted for their capacity to permit personal expression, not as vehicles for displays of skill.

In politics, however, there is no such thing as "loyal opposition" under an absolute monarchy. Confucian tradition allows for a single individual to take his stand against improper government action, make his remonstrance to the throne, and stand willing to suffer banishment or execution for it. It specifically forbids the formation of cliques or factions to further the aims of groups opposed to certain government policies.[40] The minor reform of 1043–1044 was undone by the charge of factionalism. Indeed, Ouyang's essay "On Factions" is his famous, unsuccessful defense of the formation of parties by "loyal and righteous gentlemen," which he quickly repudiated.[41] His unhappy experiences with the problem of factionalism may help to explain his promotion of Yan Zhenqing—the celebrated paragon of "loyalty and righteousness" who was universally praised as a loyalist martyr, a man with a reputation for having stood as an individual against certain notorious grand councillors but never against the emperor or government policies. Perhaps one reason Ouyang Xiu hoisted the standard of Yan Zhenqing was to fight the charge of factionalism.

Cai Xiang's Interpretation of the "Yan Style"

When Emperor Dezong ascended the throne in 779, he installed as his most powerful grand councillor Yang Yan, the archenemy of Liu Yan, whose clique Yan Zhenqing had been associated with for nearly twenty years. In 780, Yang Yan destroyed Liu Yan, driving him into exile and death. To deal with the venerable Yan Zhenqing, he decided merely to promote him out of the way into a nonpolicymaking position. Yang had Yan Zhenqing transferred from minister of personnel to the more prestigious but less powerful position of junior preceptor to the heir apparent. The announcement of appointment was composed by Secretariat Drafter Yu Shao (712–792):

> By Imperial Command: As the heir apparent is the root of the sub-celestial realm, so his preceptor is the teacher of the greatly good [future emperor]. To make this root firm, we must first establish the teacher. Had we not sought out loyal worthies, how should we judge and proclaim this teacher to be the Grand Master for Splendid Happiness, Acting Minister of Personnel, Commissioner for Rites and Ceremonies, Supreme Pillar of State, and Dynasty-Founding Duke of Lu Commandery, Yan Zhenqing?
>
> His establishment of virtue and pursuit of its practice put him in the first of the four classes, and his admirable literary works and great learning make him kindred to all the philosophers. His faithful admonitions exhaust a minister's virtue and his loyal warnings preserve the official's custom. He has appeared at court for service both domestic and foreign and has borne the burden of service to the national altars

of soil and grain. In repose, he is distinguished by his upright recti-
tude. In action, he has transcended the joys and sorrows of life and
death. As Lord Shan made appointments, so he purifies the ranks of
the officials. As Shusun determined ritual, so he illuminates Our
Royal Measure.[42] Only when the emperor is greatly good will the
whole empire in fact be upright. To understand "what comes of devo-
tion to antiquity," think on this man.[43]

Furthermore, the dowager empress venerates and honors our matri-
lineal connections. We regard his previous meritorious achievements
of long standing as the kindness of a worthy person of near relation,
and we invoke his protection in order to fledge our wings fully. This
imperial order of the Unique Sovereign states further that we permit
the appointment as junior preceptor to the heir apparent, with the
retention of service as commissioner for rites and ceremonies and pres-
tige titles, merit titles, and titles of nobility as before.[44]

When Yan Zhenqing received the announcement of his appointment,
he copied it over in his own hand. This is the work, discussed in Chap-
ter 6, known as the *Self-Written Announcement of Office*, which is
extant in ink-rubbing form in the *Hall of Loyalty and Righteousness
Compendium* and as a copy in ink on paper in the collection of the
Shodō hakubutsukan in Tokyo (Figure 33). I call it a copy because the
strokes of the calligraphy are faltering and weak and there is an overall
lack of strength and balance in the characters—flaws shared by the
edict attributed to Yan Zhenqing and the colophon attributed to Cai
Xiang. Moreover, I do not think this is a copy of an original by Yan
Zhenqing. Certain elements in particular do not accord with Yan's
method of writing. In comparing it to the *Yan Family Temple Stele* of
the same year, two examples stand out. First: in characters that have a
bei element, in the *Announcement* the right-hand dot at the bottom
often covers the bottom of the right-hand *shu* (vertical) stroke (see Fig-
ure 33, 1/5, 2/5). In the *Yan Family Temple Stele*, the right-hand dot in
this type of element does not cover the bottom of the right-hand *shu*
stroke (see Figure 35, 1/4, 2/2). Second: the lower left-hand dot at the
bottom of every character *"qi"* in the *Announcement* is a *ti* stroke,
which moves from lower left to upper right (see Figure 33, 2/7). But the
lower left-hand dot in all the *"qi"* characters in the *Yan Family Temple
Stele* is a *pie* stroke, which moves from upper right to lower left (see
Figure 35, 3/1). These differences do not represent the kind of variety
seen when a calligrapher writes under separate circumstances; they are
errors in reproduction that reveal another hand. As Liu Yuangang
remarked in his colophon to the *Hall of Loyalty and Righteousness
Compendium*, some of the edicts were said to have been written over by
Yan's sons and nephews. The *Self-Written Announcement* is probably
not by Yan Zhenqing, although it may represent a Tang-dynasty artifact.

No matter what we may think of this piece, it was considered a genuine work of Yan Zhenqing during the Song dynasty. The brief formal colophon of 1055 by Cai Xiang, which is appended to the *Announcement* (Figure 42), reads as follows:

> This announcement from the Duke of Lu's final years reveals a loyalty and worthiness such as we have never seen. Cai Xiang of Puyang

Figure 42. Cai Xiang, *Colophon to Yan Zhenqing's Self-Written Announcement of Office*, detail, 1055, ink on paper. Shodō hakubutsukan, Tokyo.

fasted and purified himself in order to examine it, this twenty-third day of the tenth month of the second year of the Zhihe era.

At a glance one can see that Cai Xiang's colophon was done after the style of Yan Zhenqing. It has the seal-script qualities admired by the Song literati: the round, centered-brush brushwork, the open, balanced character forms, and the stable vertical axis; and it has the faults of the "Yan style," proudly displayed, such as "silkworm heads and swallow tails"—the knobby beginnings of strokes and the indented ends of strokes. The formal devices are all evident, but an extraordinary change in spirit has taken place. Where Yan Zhenqing's characters are weighty, four-square, and monumental, Cai Xiang's are graceful, lively, and decorous. No heavy, blunt *shu* strokes are seen and no insistence on absolutely level *heng* strokes.

Much the same transformation is seen in Cai Xiang's large regular-script engraved inscriptions in the style of Yan Zhenqing. Comparing Cai Xiang's *Record of the Wan'an Bridge* of 1060 (Figure 43) to Yan Zhenqing's *Lidui Record of Mr. Xianyu* (Figure 16), we see that Cai Xiang's technical skill in imitating the brushwork and character forms of Yan Zhenqing's cliff inscription is quite good, yet a kind of neatening and quickening has also taken place. The lively slanting horizontal strokes seen in the colophon to the *Announcement* are employed here also, and the awkward and grave demeanor of the model has been given a lighter, more graceful look. This transformation of the "Yan style" is undoubtedly due to Cai's early and continuous study of the style of Wang Xizhi.

As a young man Cai Xiang studied calligraphy with Zhou Yue (fl. ca. 1023–1048), the head of the Calligraphy School of the Directorate of Education. Although, to my knowledge, no works by Zhou Yue are extant, undoubtedly he practiced the court-sponsored Wang style.[45] In his running-script and cursive letters, Cai Xiang employed the exposed-tip brushwork, delicate ligatures, and "left tight, right loose" compositional structure of the Wangs (Figure 44). Cai Xiang and Emperor Renzong exchanged examples of their handwriting, and the emperor requested him to transcribe epitaph stele inscriptions for members of the imperial family. The emperor's acceptance of his style also indicates that Cai Xiang's calligraphy was based on the court-sponsored style.

Cai himself testified to his lifelong interest in the Wang style—especially to his interest in copies of the *Orchid Pavilion Preface,* the premier work of Wang Xizhi. He saw the copy in the imperial archives, another copy attributed to Chu Suiliang owned by the eminent collector Su Shunyuan (1006–1054), and a third in the possession of his teacher Zhou Yue. He was also familiar with several engraved versions.[46] In 1063, he examined and signed the scroll containing Tang copies of three

Figure 43. Cai Xiang, *Record of the Wan'an Bridge*, detail, 1060, ink rubbing. Jinjiang, Fujian. From *Song Cai Xiang shu Luoyang qiao ji* (Fuzhou: Fujian renmin chubanshe, 1982), p. 20.

Figure 44. Cai Xiang, *Letter to Yanyou*, detail, 1064, ink on paper. Collection of the National Palace Museum, Taiwan, Republic of China.

letters by Wang Xizhi called *Ping'an, Heru,* and *Fengju* (National Palace Museum, Taipei). This scroll belonged to the imperial son-in-law Li Wei, who evidently invited a party of the Qingli reformers and their followers to view it. The scroll was signed by sixteen men, including Ouyang Xiu, Han Qi, Liu Chang, and Song Minqiu.[47]

Cai Xiang met Ouyang Xiu in 1030, when the eighteen-year-old prodigy from Fujian came to the capital and passed the examinations in the same class as Ouyang. Cai Xiang was an important member of Ouyang Xiu and Mei Yaochen's circle of poets and antiquarians, and he spent more than thirty years discussing and studying the works in Ouyang's collection of ink rubbings, including the many pieces by Yan Zhenqing.

We cannot say that Cai Xiang would never have practiced the style of Yan Zhenqing had he not been an intimate of Ouyang Xiu. But his extant comments about Yan sound as if they could have come from Ouyang. Cai Xiang promoted Yan Zhenqing as a moral exemplar in the Confucian fashion, as well, advocating his calligraphy on the basis of the correspondence of personality and handwriting:

> Yan, Duke of Lu, had natural ability and was a loyal and filial man. People greatly love his calligraphy, for is not the calligraphy the expression of the man?[48]

It can scarcely be a coincidence that Cai Xiang's rendition of Yan Zhenqing was limited to that aspect of it represented in Ouyang Xiu's collection—that is, the monumental regular script of Yan Zhenqing's last decade.

Cai Xiang was the one artist among Ouyang's contemporaries capable of a creative transformation of the style of Yan Zhenqing. This transformation was a combination of the styles of Wang Xizhi and Yan Zhenqing, in which he draped the upright frame of the Tang loyalist in the elegant robes of the Eastern Jin aristocrat. By offering the possibility of interpretation of Yan's style, he was as responsible as Ouyang for making the study of the "Yan style" part of the standard curriculum of future generations of scholars. Where Ouyang promoted Yan Zhenqing in his calligraphy collection and the accompanying colophons, Cai Xiang was the one who studied and copied from that collection, using his considerable artistic ability and his status as a favorite calligrapher of Emperor Renzong to make the style of Yan Zhenqing a workable tool in the Song context. Without him, Su Shi would not have created his *Record of Enjoying Rich Harvests Pavilion* or *Copy of the Letter on the Controversy over Seating Protocol.*

Critical Influence

The attitudes expressed by Ouyang Xiu concerning Yan Zhenqing were well known in his day and quite influential on the succeeding gen-

eration of critics. Han Yu's judgment on Wang Xizhi was familiar to them, as well, and they used the term *"zi mei,"* "seductive beauty," as a metonym for the Wang style. It could be used neutrally—as Huang Tingjian used it to describe the result of Su Shi's study of the *Orchid Pavilion Preface*—or it could be used pejoratively as Zhu Changwen did. Zhu Changwen was a friend and contemporary of Su Shi who passed the Presented Scholar examination as a teenager but was prevented from holding office due to a birth defect.[49] Living in his hometown of Suzhou, he wrote works of history, including a history of calligraphy that began with the artists of the mid-Tang, where Zhang Huaiguan's (fl. ca. 714–760) *Calligraphy Judgments (Shu duan)* had left off. In his *Sequel to Calligraphy Judgments (Xu Shu duan)* of 1074, Zhu Changwen wrote:

> Some say that the calligraphy of Yan Zhenqing is quite lacking in "seductive beauty" and that it seems to overexpose its sinews and bones, so how can it surpass that of Yu Shinan and Chu Suiliang or match that of Wang Xizhi and Wang Xianzhi? I answer that it is not that Yan Zhenqing was unable to be seductive, but that a sense of shame kept him from it. Tuizhi [Han Yu] once said: "[Wang] Xizhi's vulgar calligraphy took advantage of its seductive beauty," which he considered its flaw. Seeking to accord with popular custom was not Yan Zhenqing's ambition.[50]

The idea of Yan Zhenqing's final decade as the ultimate expression of his style was also advocated by Zhu Changwen:

> The *Qianfusi Stele* [*Prabhutaratna Pagoda Stele*] that has been handed down to today, which dates from when Yan Zhenqing was a young vice director in the Ministry of War [752], has a vigorous strength and an elegant maturity, comparable to the old-age style of Ouyang Xun, Yu Shinan, Xu Hao, and Shen Chuanshi, but the Duke of Lu's calligraphic works following the *Paean to the Resurgence* [771] are very different from his earlier ones, for would not the increase in his years and the loftiness of his study refine his calligraphy to its essence?[51]

In Zhu Changwen's discussion of individual works by Yan Zhenqing, they all date from his last decade:

> In those who have skill in calligraphy, it will reflect the affairs to which they respond and the inspirations they encounter, which can then be perceived by looking at their calligraphy. Therefore, by looking at the *Paean to the Resurgence* [771] with its vast and imposing expansiveness, we can picture the fullness of his merit and virtue; by looking at the *Family Temple Stele* [780], with its grave and reverent sincerity, we can see his respect for the legacy of his clan; by looking at the *Record of the Altar of the Immortal* [771], with its refined and clever excellence, we can imagine the marvels of his will and spirit;

and by looking at the *Epitaph for Yuan Cishan* [772], with its honest and magnanimous generosity, we can see the purity of his conduct as an official.[52]

Now that we are familiar with the view of Yan Zhenqing put forward by the reform officials and their friends, we should look at the response by the throne. Although no works by Yan were included in any imperial engraved calligraphy compendia until 1185, twenty-eight pieces of his calligraphy were held in the palace collection at the end of the Northern Song. These works were not ink rubbings from regular-script steles of Yan's last decade, such as Ouyang Xiu and Zhu Chang-wen promoted, but ink-written letters, poems, drafts, and announcements of office. Around 1120, the *Calligraphy Catalog of the Xuanhe Era* was compiled. The entry on Yan Zhenqing reads as follows:

> Yan Zhenqing, whose style name was Qingchen [Incorrupt Official], was a fifth-generation descendant of [Yan] Shigu and a man of Langye. In his career as an official, he reached grand preceptor to the heir apparent, and he was enfeoffed as Duke of Lu Commandery. Early on he passed the Presented Scholar examination, then was selected for other special examinations, and as a censor was sent out to Hexi-Longyou. The Wuyuan area was experiencing a great drought, but when he settled the case of someone who had been wrongly jailed, rain commenced to fall, until the entire prefecture was soaked, and so the people called it "the censor's rain." While he was governing Ping-yuan, twenty-three commanderies of Hedong-Shuofang [*sic*] were sacked by the rebels, and Pingyuan alone was prepared. When his memorial arrived, Emperor Minghuang exclaimed over it, seeing what kind of man he was. Later he was harmed by evil elements, and Lu Qi particularly disliked him. When Li Xilie sacked Ruzhou, Lu Qi was determined to send Zhenqing to proclaim the imperial order to surrender. Though all the officials commented on how lamentable it was, Zhenqing had to go. When he saw Xilie, he understood that he could not be instructed, so he cursed him and died.
>
> As his loyalty was bright as day and his ability the loftiest in the realm, so the essential spirit revealed in the manifestations of his brush and ink is independent yet comprehensive. His large seal script, small seal script, *bafen* script, clerical script, and so on all are formed by a single rule. To call this the "Greater Odes" of calligraphy would not be inappropriate! A critic [Zhu Changwen] said of his calligraphy: "Dots like falling stones, strokes like summer clouds, hooked verticals like bent metal, hooked horizontals as if shot from a crossbow." These were his cardinal principles. As for their myriad transformations, each has its own manner, such as the vast and imposing *Paean to the Resurgence,* the grave and reverent *Family Temple Stele,* the refined and clever *Record of the Altar of the Immortal,* and the magnanimous generosity of the *Epitaph for Yuan Cishan,* and all the

others are different, too. The *Qianfosi Stele* [*sic*] written in his youth was already comparable to the old-age style of Ouyang Xun, Yu Shinan, Xu Hao, and Shen Chuanshi, while the works following the *Resurgence* are very different from the earlier ones—and what was gained was due to his increasing age.

Ouyang Xiu obtained [an ink rubbing of] the broken stele [for Yan Yunnan] and wrote a colophon for it, which said: "Like a loyal minister, exemplary officer, or a gentleman of morals, its uprightness, gravity, and reverence inspire awe yet are admirable. Though this [ink rubbing] is not whole, I could not bear to throw it away."[53] This is how high his fame and popularity were. Later vulgar followers sought only to imitate his little idiosyncrasies, and of them it was said, "they only obtained the silkworm heads and swallow tails." Having failed to understand the marvels of [writing with a seal-script method] "like an awl drawing in sand," what their minds comprehend and their natures grasp is not worth discussing. Yan once wrote "The Twelve Concepts of Brush Method," which provides all the instructions of his teacher [Zhang Xu]. Hence his regular script is truly good enough to hand down to posterity.

The imperial archives contain at present twenty-eight pieces:

Regular script: *Imperial Order on Wayside Banners; Announcement Granting Posthumous Honors to Yan Yunnan's Father Weizhen; Announcement Granting Posthumous Honors to Yan Yunnan's Mother Lady Shang* [*sic*]; *Poems Written at Magistrate Pan's Bamboo Hill Library; Announcement of Office for Zhu Juchuan; Shuzhuo Letter.*

Running script: *Preceding Letter on the Seating Controversy; Succeeding Letter on the Seating Controversy; Sending Off a Manjusri Stele Text Letter; Bow to My Wife Letter; Letter to Grand Guardian Li Guangyan* [*sic*]; *Letter of Recommendation for Cai Mingyuan of Poyang; Letter of Recommendation for Liu Taichong; Imperial Commissioner Liu Letter; Kaifu Letter; Luhou Letter; Yaotai Letter; Large Seal and Small Seal Script Letter; Midsummer Letter; Huzhou Letter; Sending Off Writing Letter; Request for Rice Letter; Request for Dried Meat Letter; Fine Writing Letter; Sick Horse Letter; Letter of Recommendation for Xin Huang; Eulogy for Uncle Yan Yuansun; Eulogy for Nephew Jiming.*[54]

Two important observations may be drawn here. The first is that this entry on Yan Zhenqing in the imperial *Calligraphy Catalog of the Xuanhe Era* is an amalgam of the reformers' opinions. The first two-thirds of the entry is largely a paraphrase of Zhu Changwen's entry in his *Sequel to Calligraphy Judgments*. The last third quotes one of Ouyang Xiu's colophons in which he promoted Yan's calligraphy on the basis of his character. The only dissonant note is the remark that Yan's followers "only obtained the silkworm heads and swallow tails." This remark seems to echo Mi Fu's opinion that "none of Yan's authentic

Figure 45. Yan Zhenqing, *Imperial Commissioner Liu Letter,* ca. 775, ink on paper. Collection of the National Palace Museum, Taiwan, Republic of China.

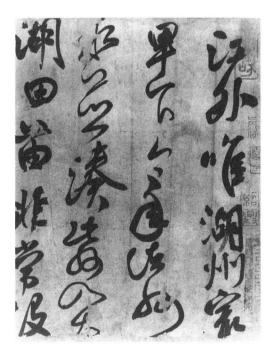

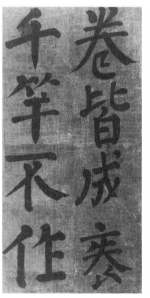

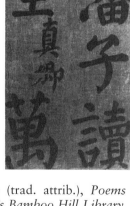

Figure 46. Yan Zhenqing (trad. attrib.), *Huzhou Letter,* detail, undated, ink on paper. Beijing Palace Museum.

Figure 47. Yan Zhenqing (trad. attrib.), *Poems Written at Magistrate Pan's Bamboo Hill Library,* detail, undated, ink on paper. Beijing Palace Museum.

works have strokes with silkworm heads and swallow tails" and that his follower Liu Gongquan "was the progenitor of later ugly and weird writing."[55] This criticism is very tame, however, compared to Mi Fu's general dismissal of Yan's regular script for being mannered and unnatural.[56] Anything that might connect Yan to imperial traditions is also omitted. No mention is made of any relationship to Wang Xizhi, single-stroke cursive script, or Daoism. In short, there is no sign of a competing imperial position on Yan Zhenqing in his entry in the imperial catalog.

The second thing to note, from the list of works, is how few pieces collected by the throne have survived. Only four out of twenty-eight are extant in ink-written form. The *Imperial Commissioner Liu Letter* (Figure 45) and *Draft Eulogy for Nephew Jiming* (Figure 12) are in the National Palace Museum, Taipei. The *Huzhou Letter* (Figure 46) and the *Poems Written at Magistrate Pan's Bamboo Hill Library* (Figure 47) are in the Beijing Palace Museum. The first two are generally considered authentic; the latter two are not. The other nineteen works that survive are found only in ink-rubbing form, and that is due largely to the efforts of scholar-officials such as An Shiwen and Liu Yuangang. Compare this to the fact that eight of the fourteen regular-script works collected by Ouyang Xiu have survived in the same form to the present day, and all are authentic. The visual record of the throne's idea of Yan Zhenqing's style has mostly disappeared, while Ouyang's has endured.

The entry in the *Calligraphy Catalog of the Xuanhe Era* indicates how the throne conformed to the Qingli reformers' valuation of Yan Zhenqing over the course of the twelfth century. At the beginning of the Northern Song, Yan was officially ignored in the imperial compendium *Chunhua ge tie*. Then in the 1030s and 1040s, the reformers and their friends began to study his style and to collect and publish his works. Soon the imperial archives contained letters and drafts previously owned by An Shiwen in the 1080s. In 1120 Yan was described in the reformers' words in the catalog of the imperial collection, and in 1185 he was represented for the first time in an imperial engraved calligraphy compendium. After the fall of the Northern Song, his ink-written letters continued to disappear, but his regular-script stele inscriptions endured. By the end of the Southern Song, one view of Yan Zhenqing prevailed. The visual and critical record is dominated by the image of the upright Confucian martyr who wrote an upright regular script. This image is the one that has come down to us.

8

Confucian
Martyrdom

EARLY IN 781, Censor-in-Chief Lu Qi (died ca. 785) was elevated to serve as a grand councillor. Like so many before him, Lu Qi had no tolerance for the outspokenness of Yan Zhenqing, and so he had Yan promoted to grand preceptor to the heir apparent but dismissed from his post as commissioner for rites and ceremonies. Though this was seemingly a routine maneuver, it was particularly villainous coming from Lu Qi, for he owed Yan Zhenqing an unusual consideration. One of the severed heads of the chief officials of Luoyang that Duan Ziguang had dragged through the gates of Pingyuan twenty-five years earlier had belonged to Lu Qi's father, and it was Yan Zhenqing who had buried him and performed the ritual mourning. When Yan heard that Lu Qi was also considering sending him out to a military post, he went to see Lu at the Secretariat and gently rebuked him:

> I have been hated by small men because of their pettiness. I have fled into exile more than once. Now I am emaciated and aged. Fortunately, I have you to protect me. When the head of your father, the former vice censor-in-chief, was sent to me in Pingyuan, I dared not wipe the bloodstains from his face with my robe, but instead I licked them off with my tongue. Can you not bear to tolerate me?[1]

In the first month of 783, Li Xilie, the military commissioner of Huaixi, revolted against the Tang and sacked the city of Ruzhou. Lu Qi immediately recommended that Yan Zhenqing be sent out to induce Li Xilie to surrender. The court was aghast, but none of the officials' memorials could persuade the emperor to refuse Lu Qi's plan. And so Yan Zhenqing was issued a team of four horses from the government courier station, and he set off for Luoyang. From there he traveled a short distance south to the rebel camp at Xuzhou. Immediately Yan proceeded to read Li Xilie the imperial instructions to surrender, but he was rushed by the rebel troops before he could finish. Li prevented his men from killing Yan, and for a time treated him as a guest, all the

while sending memorials filled with false information to the throne, forged in Yan Zhenqing's name.

Li Xilie apparently enjoyed looking on Yan as a cultured ornament to his fraudulent court, and he ordered him to attend a number of his official banquets. At one of these, in Yan's presence, Li was asked by another of the rebel leaders why he did not set up his own dynasty and reign title and employ the venerated grand preceptor as his own grand councillor. Yan Zhenqing replied for him:

> What grand councillor would this be! Have you gentlemen never heard of Yan Gaoqing? He was my elder brother. When An Lushan revolted, he was the first to raise loyalist volunteers, and as he was being killed, he never ceased to curse them. Now I am nearing eighty. In my official career, I have reached the post of grand preceptor. I will preserve the virtue of my elder brother in death and beyond. How could I be coerced by the likes of you?[2]

Soon after, Li gave up the pretense of civility and had Yan Zhenqing imprisoned. Yan's sons, his nephew Xian, and his friend Zhang Jian (ca. 745–ca. 805) repeatedly sent memorials begging the court to ransom him, but Lu Qi intercepted them all.[3]

In 784, Li Xilie sent his troops to attack the imperial army under Geshu Yao, who had retaken Ruzhou. Li's generals, however, were plotting among themselves to turn and attack Li himself and make Yan Zhenqing the new military commissioner. When news of the plot was leaked, Li had the generals killed and Yan sent to be held in Longxing Monastery in Caizhou. In his cell, Yan composed his own tomb epitaph and funeral eulogy.

Late in the year, Li Xilie sacked Bianzhou and declared himself "August Emperor of the Great Chu Dynasty" with the inaugural reign title of "Martial Success." He sent a messenger to Yan Zhenqing to find out from the former commissioner for rites and ceremonies the ritual for ascending the throne. Yan remained unwilling to collaborate in any way. He chided the rebellious official, saying: "I am an old man now, but once I did know state ritual. Now all I can remember is the ritual for a feudal lord's audience of submission to the emperor."

During the time of Yan's captivity, Emperor Dezong and the court were forced to flee the capital by mutinous frontier troops led by Zhu Ci (742–784), the brother of one of Li Xilie's rebel confederates. Only in the autumn of 784, after the death of Zhu Ci, was the court able to return to Chang'an, where justice was meted out to Zhu's cohorts. Among those executed by imperial order was Li Xiqian, a younger brother of Li Xilie. Eventually this news made its way to Li Xilie. In response he dispatched some of his men to Longxing Monastery in Caizhou, and there, on the thirteenth day of the eighth month

of the inaugural year of the Honorable Prime era, they hanged Yan Zhenqing.

The following year, Li Xilie was murdered by poison and Huaixi was pacified. The new Huaixi military commissioner sent Yan Zhenqing's coffin off under escort, and it was met at Ruzhou by his sons, Jun and Shuo. They conducted funerary services at Ruzhou, then accompanied their father's coffin home to Chang'an, where Yan Zhenqing was buried in the family tomb south of the city walls. Emperor Dezong suspended court audience for five days and ordered a record compiled of Yan Zhenqing's achievements. He was granted the posthumous title of minister of education and the posthumous epithet of "Cultured and Loyal."

As Sima Qian's famous dictum has it: "Men die but one death, and this death may be as weighty as Mount Tai or as light as a goose feather." Yan Zhenqing's martyrdom was as weighty, as meaningful, as any has ever been in Confucian China. There is no more exalted sacrifice at the altar of Confucian filial piety than to lay down one's life for loyalty to the emperor. Mencius said: "I desire life, but I also desire righteousness. If I cannot have both, I will let life go and choose righteousness." Yan Zhenqing's fate as a martyr set the seal on his life as a moral exemplar. Thanks to the belief in characterology, a calligrapher who is a moral exemplar may become an artistic model. In their search for a standard of calligraphy to raise in the struggle against the power and culture of the court, the Song literati found in Yan Zhenqing a man whose life as scholar, statesman, and amateur artist resembled theirs. The supreme difference in his life was the manner of his death. Many of the important Song literati suffered hardships and exile, but they were persecuted for insufficient allegiance to the throne, not martyred for loyalty. The unassailable rectitude of Yan Zhenqing's martyrdom ennobled everything about him. For the Song literati to imitate his style of writing was to borrow for themselves the sword and shield of this heroic artist, "cultured and loyal."

Notes

Chapter 1: The Politics of Calligraphy

1. Yang Xiong, *Fayan, Sibu beiyao* ed., chap. 5, p. 3b.
2. Sima Qian, *Shiji* (Beijing: Zhonghua shuju, 1959), chap. 47, p. 1947.
3. *Xin Tang shu*, by Ouyang Xiu, Song Qi, et al. (Beijing: Zhonghua shuju, 1975), chap. 45, p. 1171.
4. See Lothar Ledderose, *Mi Fu and the Classical Tradition of Chinese Calligraphy* (Princeton: Princeton University Press, 1979), p. 30.
5. Alfred Forke, trans., *Lunheng*, pt. II, 2nd ed. (rpt. New York: Paragon Book Gallery, 1962), 2:229.
6. Liu Xun et al., *Jiu Tang shu* (Beijing: Zhonghua shuju, 1975), chap. 165, p. 4310.
7. Translation by William R. B. Acker, *Some T'ang and Pre-T'ang Texts on Chinese Painting* (Leiden: Brill, 1954 and 1974), p. lvi.
8. *Biyizan,* in *Lidai shufa lunwenxuan,* ed. Huang Jian (Shanghai: Shanghai shu hua chubanshe, 1979), 1:62.
9. From *Zhu Wengong yu,* quoted in Huang Benji, ed., *Yan Lugong ji* (Taipei: Zhonghua shuju, 1970), chap. 21, p. 4a.
10. Fang Xuanling et al., *Jin shu,* (Beijing: Zhonghua shuju, 1974), chap. 80, pp. 2107–2108.
11. *Song shi,* ed. Tuotuo et al. (Beijing: Zhonghua shuju, 1977), chap. 296, pp. 9872–9873.
12. E. A. Kracke Jr., *Civil Service in Early Sung China, 960–1067* (Cambridge, Mass.: Harvard University Press, 1953), p. 59.
13. E. A. Kracke Jr., "Region, Family, and Individual in the Chinese Examinations System," in *Chinese Thought and Institutions,* ed. John K. Fairbank (Chicago: University of Chicago Press, 1957), p. 253.
14. E. A. Kracke Jr., "The Expansion of Educational Opportunity in the Reign of Hui-tsung of Sung and Its Implications," *Sung Studies Newsletter* 13 (1977): 6–30.
15. James T. C. Liu, *Ou-yang Hsiu: An Eleventh-Century Neo-Confucianist* (Stanford: Stanford University Press, 1967), pp. 86–87.
16. *Mencius,* II B:2; II A:7; I B:9.
17. This summary of the Qingli reform is based on "The Minor Reform," in Liu, *Ou-yang Hsiu,* pp. 40–51.
18. Mi Fu, *Shu shi* (Taipei: Shijie shuju, 1962), p. 57.
19. Charles Hartman, *Han Yü and the T'ang Search for Unity* (Princeton: Princeton University Press, 1986), pp. 84–86.

20. Gaylord Kai Loh Leung and C. Bradford Langley, *"Hsi-k'un ch'ou-ch'ang chi,"* in *The Indiana Companion to Traditional Chinese Literature,* ed. William H. Nienhauser Jr. (Bloomington: Indiana University Press, 1986), p. 412.

21. Liu, *Ou-yang Hsiu;* Ronald C. Egan, *The Literary Works of Ou-yang Hsiu (1007–1072)* (Cambridge: Cambridge University Press, 1984); Lien-sheng Yang, "The Organization of Official Historiography: Principles and Methods of the Standard Histories from the T'ang Through the Ming Dynasty," in *Historians of China and Japan,* ed. W. G. Beasley and E. G. Pulleyblank (London: Oxford University Press, 1961), pp. 44–59.

22. See Ronald C. Egan, "Ou-yang Hsiu and Su Shih on Calligraphy," *Harvard Journal of Asiatic Studies* 49 (2) (Dec. 1989):382.

23. Cai Xiang, *Cai Zhonghuigong ji,* Xunminzhai ed. (1734), chap. 24, p. 21a.

24. Stephen Owen, *Remembrances: The Experience of the Past in Classical Chinese Literature* (Cambridge, Mass: Harvard University Press, 1986), p. 26.

25. "Tang Yan Lugong ershier zi tie," *Jigulu,* chap. 7, p. 1177, in Ouyang Xiu, *Ouyang Xiu quanji,* 2 vols. (Beijing: Zhongguo shudian, 1986).

26. "Song Wendi shendao bei," *Jigulu,* chap. 4, p. 1140; translation by Egan, "Ou-yang Hsiu and Su Shih," p. 383.

27. See Amy McNair, "The Engraved Model-Letters Compendia of the Song Dynasty," *Journal of the American Oriental Society* 114 (2) (April–June 1994): 214.

28. Zhu Jianxin, *Jinshixue* (rpt. Beijing: Wenwu chubanshe, 1981), p. 21.

29. In a letter to Cai Xiang, Ouyang Xiu states that he collected the one thousand scrolls in his collection in the years from 1045 to 1062 (*Ouyang Xiu quanji,* chap. 69, p. 506), whereas the dates that appear in the colophons on the works of Yan Zhenqing range between 1063 and 1066.

30. Han Yu, "The Song of the Stone Drums," *Han Changli ji* (Shanghai: Commercial Press, 1936), chap. 2, p. 44.

31. According to Jorgensen, the Chan scheme itself was modeled on the Confucian idea of "legitimate internal dynastic succession." See John Jorgensen, "The 'Imperial' Lineage of Ch'an Buddhism: The Role of Confucian Ritual and Ancestor Worship in Ch'an's Search for Legitimation in the Mid-T'ang Dynasty," *Papers on Far Eastern History* 35 (March 1987): 89–133.

Chapter 2: Yan Zhenqing's Illustrious Background and Early Career

1. See the preface Cen Shen wrote for his poem on Yan's departure for Pingyuan, *Cen Shen ji jiao zhu,* ed. Chen Tiemin and Hou Zhongyi (Shanghai: Shanghai guji chubanshe, 1981), p. 107.

2. The principal biographical sources for the life of Yan Zhenqing are *Xin Tang shu,* chap. 153; *Jiu Tang shu,* chap. 128; and Yin Liang, *Yan Lugong xing zhuang,* in *Quan Tang wen,* ed. Dong Gao (Tainan: Jingwei shuju, 1965), chap. 514, pp. 9a–26a. Yin Liang was the grandson of Yan Zhenqing's uncle Yin Jianyou and served as an official under Yan Zhenqing. His account, the earliest and most detailed, was written for the court when the emperor learned of Yan Zhenqing's death in 786.

3. This stele is not extant. See Feng Yan (Presented Scholar, 756), *Feng shi wen jian ji jiao zhu* (Beijing: Zhonghua shuju, 1958), chap. 10, p. 87.

4. In *Wen xuan,* ed. Xiao Tong (Shanghai: Commercial Press, 1937), chap. 10, pp. 15–18.

5. Huang Benji, ed., *Yan Lugong ji* (rpt. Taipei: Zhonghua shuju, 1970), chap. 5, p. 6b.

6. Zhang Huaiguan, *Shu duan,* in *Lidai shufa lunwenxuan,* 1:198.

7. Tao Hongjing and Emperor Wu of Liang, *Lun shu qi,* in *Fashu yaolu,* ed. Zhang Yanyuan (Beijing: Renmin meishu chubanshe, 1984), p. 50.

8. Chu Suiliang, *Jin Youjun Wang Xizhi shu mu,* in *Fashu yaolu,* p. 88; Sun Guoting, *Shupu,* in *Lidai shufa lunwenxuan,* 1:128.

9. See *Tang Wei Shu xu shu lu,* in *Fashu yaolu,* pp. 165–166.

10. Emperor Xuanzong composed and transcribed the text for a stele on Mount Hua. In 750, he had one hundred copies (ink rubbings?) given to the court officials. Yan Zhenqing and Yan Yunnan, who was serving as a remonstrance official, each received one copy (*Yan Lugong ji,* chap. 8, pp. 6b–7a).

11. Su Shi, *Dongpo tiba* (Taipei: Shijie shuju, 1962), chap. 4, p. 76a.

12. See Rong Geng, *Cong tie mu* (Hong Kong: Zhonghua shuju, 1980–1986), 1:49–66. There is also an anonymous copy of the *Encomium,* attributed to the Tang dynasty, now in the National Palace Museum in Taipei, that carries the forged signature of Mi Fu. In ink on silk, in small regular-script characters, it is quite similar to the ink-rubbing version. For a reproduction see *Gugong lidai fashu quanji* (Taipei: National Palace Museum, 1977), 2:38–39.

13. *Zhongguo shufa quanji,* vol. 25: *Sui Tang Wudai bian, Yan Zhenqing* 1 (Beijing: Rongbaozhai, 1993), p. 416.

14. See Charles Hartman, *Han Yü and the T'ang Search for Unity* (Princeton: Princeton University Press, 1986), p. 238.

15. *Tuian jinshi shuhua ba* (1845), chap. 4, p. 32b.

16. *Shodō zenshū,* 3rd ed. (Tokyo: Heibonsha, 1966–1969), 4:155.

17. See Dou Ji, *Shu shu fu,* in *Fashu yaolu,* chap. 6; Xu Hao, *Lun shu,* in *Fashu yaolu,* pp. 116–118.

18. See Yan Zhenqing's epitaph for his father, *Yan Lugong ji,* chap. 7, p. 12b. See also *Jiu Tang shu,* chap. 190 *zhong,* p. 5034; *Xin Tang shu,* chap. 199, p. 5683.

19. *Yan Lugong ji,* chap. 4, p. 7a.

20. *Quan Tang shi* (Taipei: Fuxing shuju, 1961), p. 1223.

21. Ibid., p. 745; translation adapted from Stephen Owen, *The Great Age of Chinese Poetry: The High T'ang* (New Haven: Yale University Press, 1981), pp. 107–108.

22. Li Zhao (fl. ca. 806–825), *Tang guo shi bu* (Shanghai: Gudian wenxue chubanshe, 1979), p. 17. For biographies of Zhang Xu see *Jiu Tang shu,* chap. 190 *zhong,* p. 5034, and *Xin Tang shu,* chap. 202, p. 5764.

23. Lu Xie (d. 880), *Lin chi jue,* in *Lidai shufa lunwenxuan,* 1:293.

24. Yan Zhenqing, *Wenzhong ji* (Shanghai: Commercial Press, 1936), chap. 12, p. 88.

25. First seen in *Mo chi bian* (1066), ed. Zhu Changwen (rpt. Taipei: National Central Library, 1970).

26. See Yu Shaosong, *Shuhua shulu jieti* (rpt. Taipei: Zhonghua shuju, 1980), chap. 9, p. 5b.

27. The *Cangzhen Letter,* in *Tang Huaisu san tie* (Xi'an: Shaanxi renmin chubanshe, 1982), p. 31.

28. For reproductions see *Tangdai caoshujia,* ed. Zhou Ti (Beijing: Beijing Yanshan chubanshe, 1989), pp. 80–84.

29. For a reproduction see *Zhang Xu fashu ji* (Shanghai: Shanghai shuhua chubanshe, 1992), pp. 45–53.

30. See *Tangdai caoshujia,* p. 57; *Liaoning sheng bowuguan cang fashu xuanji* (Shenyang: Wenwu chubanshe, 1962), vol. 5; and *Zhongguo meishu quanji: Shufa zhuanke bian 3: Sui Tang Wudai shufa,* ed. Yang Renkai (Beijing: Renmin meishu chubanshe, 1989), p. 29; a color reproduction is on pp. 112–119. See also Xu Bangda, *Gu shu hua wei'e kaobian* (Nanjing: Jiangsu guji chubanshe,

1984), 1:94–97, and Xiong Bingming, "Yi 'Zhang Xu caoshu sitie' shi yi lin-
ben," *Shupu* 44:18–25.
31. See *Shodō zenshū*, 8:180 and pl. 98–99 for a reproduction.
32. *Beibei nantie lun,* in *Lidai shufa lunwenxuan*, 2:637.
33. *Shodō zenshū*, 8:187 and 7:fig. 41g.
34. *Yan Lugong ji,* chap. 7, p. 12a.
35. Ibid., p. 13a.
36. Sun Chengze, *Gengzi xiaoxia ji* (1660) (Zhibuzu zhai ed.), chap. 6, p. 14a.
37. Zhu Guantian, *Zhongguo shufa quanji*, 25:6.
38. Ibid., 25:5.
39. *Shodō zenshū*, 6:191.
40. See, for example, Stephen J. Goldberg, "Court Calligraphy of the Early T'ang
 Dynasty," *Artibus Asiae* 49 (3–4) (1988–1989):189–237.
41. See Amy McNair, "Engraved Calligraphy in China: Recension and Reception,"
 Art Bulletin 77(1) (March 1995):106–114.
42. Translated in David Lattimore, "Allusion and T'ang Poetry," in *Perspectives on
 the T'ang,* ed. Arthur F. Wright and Denis Twitchett (New Haven: Yale Uni-
 versity Press, 1973), p. 412.
43. See the genealogical chart in Jiang Xingyu, *Yan Lugong zhi shu xue* (Taipei:
 Shijie shuju, 1962), p. 7. For Zhenqing's brothers see *Yan Lugong nianpu,* in
 Yan Lugong ji, p. 15a.
44. *Yan Lugong ji,* chap. 8, p. 7b.
45. See David McMullen, "Historical and Literary Theory in the Mid-Eighth Cen-
 tury," in *Perspectives on the T'ang,* p. 310.
46. Dated to 765; in *Yan Lugong ji,* chap. 5, pp. 1a–2a.
47. On Yan Zhenqing's marriage see *Yan Lugong nianpu,* in *Yan Lugong ji,* p. 3b;
 on the friendship of Wei Shu, Yan Yuansun, Yin Jianyou, and Sun Di see Yan
 Zhenqing's epitaph for Yin Jianyou in *Wenzhong ji,* chap. 10, p. 77, and Yan
 Zhenqing's preface to Sun Di's collected works in *Wenzhong ji,* chap. 12, p. 88.
48. Owen, *The High T'ang,* p. 243.
49. *Cen Shen ji jiao zhu,* p. 108.

Chapter 3: "The Nest Tipped and the Eggs Overturned"

1. The biographical sources used for Yan Gaoqing and Yan Zhenqing in this chap-
 ter are Sima Guang, *Zizhi tongjian,* chap. 217; Yin Liang, *Yan Lugong xing
 zhuang,* pp. 11b–20a; Yan Zhenqing's epitaph for Yan Gaoqing, *Wenzhong
 ji,* suppl. chap. 2, pp. 37–40; the biographies of Yan Gaoqing in *Jiu Tang shu,*
 chap. 187 *xia,* pp. 4896–4899, and Ouyang Xiu, Song Qi, et al., *Xin Tang
 shu,* chap. 192, pp. 5529–5532; and the biographies of Yan Zhenqing in *Jiu
 Tang shu,* chap. 128, pp. 3589–3592, and *Xin Tang shu,* chap. 153, pp.
 4854–4857.
2. From Yan Zhenqing's epitaph for Yan Gaoqing, *Wenzhong ji,* suppl. chap. 2,
 p. 39.
3. See Edwin Pulleyblank, "The An Lu-shan Rebellion and the Origins of Chronic
 Militarism in Late T'ang China," in *Essays on T'ang Society,* ed. John Curtis
 Perry and Bardwell C. Smith (Leiden: Brill, 1976), p. 41 and n. 11.
4. *Wenzhong ji,* chap. 2, pp. 8–9.
5. Ibid., chap. 2, p. 9.
6. Yan alluded to his patrilineal connection to the eight disciples of Confucius sur-
 named Yan in his epitaph for Yan Han and in the *Yan Family Temple Stele*
 (*Wenzhong ji,* suppl. chap. 2, p. 30, and chap. 16, p. 117).

7. *Jiu Tang shu,* chap. 128, p. 3592; *Xin Tang shu,* chap. 153, p. 4856; *Yan Lugong xing zhuang,* p. 19b.

8. Adapted from James Legge, *The Chinese Classics* (rpt. Hong Kong: Hong Kong University Press, 1960), 2:411.

9. *Wenzhong ji,* suppl. chap. 2, p. 40.

10. *Jiu Tang shu,* chap. 128, p. 3596.

11. *Wenzhong ji,* chap. 10, p. 80.

12. See *Gugong fashu,* vol. 5: *Tang Yan Zhenqing shu ji ji wen gao* (Taipei: National Palace Museum, 1964), pp. 13a–15a.

13. Mi Fu, *Baozhang daifang lu* (Taipei: Shijie shuju, 1962), p. 7a.

14. Huang Tingjian, *Shangu tiba* (Taipei: Shijie shuju, 1962), chap. 4, p. 40.

15. *Zhuangzi* (Shanghai: Shanghai guji Press, 1988), chap. 29, p. 150; translation by Burton Watson, *The Complete Works of Chuang Tzu* (New York: Columbia University Press, 1968), p. 324.

16. *Nan shi,* ed. Li Yanshou (Beijing: Zhonghua shuju, 1975), chap. 71, p. 1739.

17. The calligraphers were Handan Chun and Cao Xi. See Yu Shinan, *Shu zhi shu,* in *Fashu yaolu,* p. 87.

18. *Fashu yaolu,* p. 217.

19. See Fu Shen, "Huang T'ing-chien's Calligraphy and His *Scroll for Chang Ta-t'ung:* A Masterpiece Written in Exile" (Ph.D. dissertation, Princeton University, 1976), p. 65.

20. *Quan Tang wen,* chap. 380, pp. 7a–7b.

21. *Shu moya bei hou* (Written on the cliff after the stele), in Huang Tingjian, *Huang Shangu shi,* ed. Huang Gongzhu (Shanghai: Commercial Press, 1934), pp. 105–106.

22. Stephen Owen, *The Great Age of Chinese Poetry: The High T'ang* (New Haven: Yale University Press, 1981), pp. 214–217; translated in David R. McCraw, *Du Fu's Laments from the South* (Honolulu: University of Hawai'i Press, 1992), pp. 201–204.

23. Fu Shen, "Huang T'ing-chien's Calligraphy," p. 194.

24. *Shangu tiba,* chap. 7, p. 64.

25. Ibid., chap. 5, p. 45.

26. Ibid., chap. 5, p. 44.

Chapter 4: Partisan Politics at the Postrebellion Court

1. See *Shodō zenshū,* 10:154–155 and pl. 22–23. For a complete reproduction see *Shoseki meihin sōkan* (Tokyo: Nigensha, 1958–1981), vol. 34.

2. See *Zhongguo shufa: Yan Zhenqing,* 1:287–289. The stele was excavated in the Jiaqing period (1796–1820) in pieces; only a dozen characters can still be read. The complete text is found in Yan's collected works (*Yan Lugong ji,* chap. 5, pp. 6b–7b).

3. *Cambridge History,* p. 490–491.

4. *Yan Lugong xing zhuang,* p. 20b; *Jiu Tang shu,* chap. 128, p. 3592; *Xin Tang shu,* chap. 153, p. 4857.

5. *Xin Tang shu,* chap. 207, p. 5863; *Cambridge History,* pp. 573–574; David McMullen, *State and Scholars in T'ang China* (Cambridge: Cambridge University Press, 1988), pp. 53 and 60.

6. *Jiu Tang shu,* chap. 117, pp. 3396–3397, and *Xin Tang shu,* chap. 133, p. 4546.

7. *Zuo zhuan,* Duke Xiang, year 24; see Legge, *Chinese Classics,* 5:507.

8. "You drove back Shi Siming's recalcitrant army" is a reference to Guo Yingyi's appointment as military commissioner of Huainan to prevent Shi Siming from

moving south after the sack of Luoyang in the autumn of 759. "Resisted the Uighurs' insatiable demands" is apparently a sarcastic reference to Guo Yingyi's failure, while serving as regent of Luoyang, to prevent the pillaging of Luoyang by both Tang and Uighur troops after it was retaken from the rebels in 762. See Guo Yingyi's biography in *Xin Tang shu,* chap. 133, p. 4546.

9. The probable date of this honor was the proclamation of the new reign title Ample Virtue in 763, when "the meritorious officials were granted iron staffs, their names were reposited in the Imperial Ancestral Temple, and their portraits were fashioned in the Hall of Ascending to the Clouds." See *Xin Tang shu,* chap. 6, p. 169.

10. *Yu shu, Da Yu mo,* chap. 14; see Legge, *Chinese Classics,* 3:60.

11. The Bodhi Monastery was located in the Pingkang ward of Chang'an. This ceremony, which commemorated the anniversary of the death of an emperor, was performed in all official Buddhist temples and Daoist monasteries throughout the land. The anniversary closest to the date on which Yan's letter was written was that of Tang Taizu, which fell on the eighteenth day of the ninth month. See Peng Yuanrui, *Zhengzuoweitie kaocheng,* in *Enyutang jingjin xugao* (n.p., ca. 1735–1796), chap. 6, p. 11b.

12. Earlier in the same month the letter was written, Guo Ziyi came to court to announce his victory over Pugu Huaien and the Tibetan–Uighur forces at Fenzhou the month before. A banquet was held for him by the court officials. His son, Guo Xi, was a vanguard commander in the Shuofang Army, under his father's command. See Sima Guang, *Zizhi tongjian,* chap. 223, pp. 7167–7169.

13. *Lunyu,* bk. xvi, chap. 4; see Legge, *Chinese Classics,* 1:311.

14. *Zizhi tongjian,* chap. 224, pp. 7189–7190; *Jiu Tang shu,* chap. 128, pp. 3592–3594; *Xin Tang shu,* chap. 153, pp. 4857–4859.

15. According to Huang Tingjian, *Shangu tiba,* chap. 4, p. 40.

16. Ibid.

17. *Xuanhe shupu* (Taipei: Shijie shuju, 1962), chap. 3, p. 93.

18. According to Mi Fu, *Baozhang daifang lu,* p. 7a.

19. *Shangu tiba,* chap. 4, p. 40.

20. *Baozhang daifang lu,* p. 7a.

21. Su Shi, *Dongpo tiba,* chap. 4, p. 76.

22. For discussions of the various versions see Wen Yan, "Yan Zhenqing de 'Zhengzuowei tie,'" *Shupu* 17:34–36, and Wang Zhuanghong, *Tiexue juyao* (Shanghai: Shanghai shuhua chubanshe, 1987), pp. 143–145.

23. According to the Yuan-dynasty connoisseur Yuan Jue (1267–1327) in a colophon dated to 1315; from *Qingrong jushi ji,* quoted in *Yan Lugong ji,* chap. 24, p. 2b.

24. *Shu shi,* p. 20.

25. *Dongpo tiba,* chap. 4, p. 76; translation by Ronald Egan, *Word, Image, and Deed in the Life of Su Shi* (Cambridge, Mass.: Council on East Asian Studies, Harvard University, 1994), p. 278.

26. Translation by Burton Watson, *The Complete Works of Chuang Tzu* (New York: Columbia University Press, 1968), p. 201.

27. Egan, *Word, Image, and Deed,* pp. 82–83.

28. *Baozhang daifang lu,* p. 7a.

29. *Shu shi,* p. 20.

30. *Shangu tiba,* chap. 4, p. 39.

31. See Susan Bush, *The Chinese Literati on Painting: Su Shih (1037–1101) to Tung Ch'i-ch'ang (1555–1636)* (Cambridge, Mass.: Harvard University Press, 1971); Ronald C. Egan, *The Literary Works of Ou-yang Hsiu (1007–1072)* (Cambridge: Cambridge University Press, 1984); and Jonathan Chaves, *Mei Yao-*

ch'en and the Development of Early Sung Poetry (New York: Columbia University Press, 1976).

32. *Jiu Tang shu,* chap. 165, p. 4310.
33. *Dongpo tiba,* chap. 4, pp. 92b–93a.
34. Quoted in Bian Yongyu, *Shigutang shuhua huikao* (Taipei: n.p., 1958), 2:122–123.
35. The ink rubbing I studied is in the Field Museum of Natural History (file no. 244489 a–d). See Hartmut Walravens, ed., *Catalogue of Chinese Rubbings in Field Museum of Natural History, Fieldiana Anthropology,* n.s., no. 3 (Chicago: Field Museum, 1981), no. 804.
36. In his *Gongkui ji,* quoted in *Yan Lugong ji,* chap. 30, p. 8a–b.
37. An ink-written version of the *Poem for General Pei* is in the collection of the Beijing Palace Museum. Xu Bangda considers it a probable Yuan-dynasty copy after the engraving in the *Hall of Loyalty and Righteousness Compendium.* He believes the *Poem for General Pei,* both as a poem and a work of calligraphy, was originally fabricated sometime during the Song, and so he terms the Palace Museum scroll "a fake within a fake." See Xu Bangda, *Gu shu hua wei'e kaobian,* 1:123–125; reproductions in 2:165–168.
38. *Yan Lugong ji,* chap. 12, p. 1a–b. For Pei Min see *Xin Tang shu,* chap. 71 *shang,* p. 2184, chap. 202, p. 5764, and chap. 216 *shang,* p. 6084.
39. *Shangu tiba,* chap. 5, p. 44; Egan, *Word, Image, and Deed,* p. 273. In the traditional story, Xi Shi, a beauty of the fifth century b.c.e., pounded her breast and scowled because of heartburn. Seeing her lovely face with knitted brows, her homely neighbor imitated her expression, vainly hoping to achieve the same effect. She had mistaken Xi Shi's illness for the source of her beauty. See Herbert Giles, *A Chinese Biographical Dictionary* (rpt. Taipei: Ch'eng wen, 1975), p. 271.
40. *Shangu tiba,* chap. 5, p. 45.
41. *Shangu tiba,* chap. 5, p. 45; *Dongpo tiba,* chap. 4, p. 85.
42. *Shangu tiba,* chap. 5, p. 45; *Jigulu,* chap. 7, p. 1173.
43. *Shangu tiba,* chap. 5, p. 45.

Chapter 5: From Daoist Inscriptions to Daoist Immortal

1. "Inscription at West Grove Monastery" and "Inscription at Quiet Dwelling Monastery," *Yan Lugong ji,* chap. 6, p. 2b.
2. "Stele Inscription for the Two True Lords, Wang and Guo, of Mount Huagai," *Yan Lugong ji,* chap. 6, p. 11a.
3. *Yan Lugong ji,* chap. 6, pp. 6b–9b.
4. See Edward H. Schafer, "The Restoration of the Shrine of Wei Hua-ts'un at Lin-ch'uan in the Eighth Century," *Journal of Oriental Studies* 15(2) (1977):124–137.
5. On the transmission of the Shangqing scriptures see Michel Strickmann, "The Mao Shan Revelations, Taoism and the Aristocracy," *T'oung Pao* 63 (1977): 1–64, and *Le taoisme du Mao Chan, Chronique d'un Révélation* (Paris: Collège de France, 1981).
6. *Yan Lugong ji,* chap. 6, pp. 9b–10b. On Huang Lingwei see Russell Kirkland, "Huang Ling-wei: A Taoist Priestess in T'ang China," *Journal of Chinese Religions* 19 (Fall 1991):47–73.
7. See *Shodō zenshū,* 10:159–160, and Yang Zhenfang, *Beitie xulu* (Chengdu: Sichuan wenyi chubanshe, 1982), p. 160.
8. *Yan Lugong ji,* chap. 5, pp. 10a–11b. On Miss Hemp see also Edward H. Schafer, *Mirages on the Sea of Time: The Taoist Poetry of Ts'ao T'ang* (Berkeley: Uni-

versity of California Press, 1985), pp. 90–102, and Henri Doré, "Recherches sur les Superstitions en Chine," *Variétés Sinologiques* 12 (48) (1918): 1118–1124.

9. Ge Hong, *Shen xian zhuan* (Taipei: Xinxing shuju, 1974), pp. 18b–19a.

10. For a translation see J. D. Frodsham, *The Murmuring Stream: The Life and Works of the Chinese Nature Poet Hsieh Ling-yun (385–433), Duke of K'ang-lo* (Kuala Lumpur: University of Malaya Press, 1967), 1:155.

11. Deng Ziyang may have been invited to the capital by Emperor Xuanzong to participate in the grand project of collating and editing the Daoist canon in the Great Unity Palace, which was initiated around 748. This project is mentioned in Yan Zhenqing's epitaph for the Maoshan Daoist master Li Han-guang (683–769), *Yan Lugong ji,* chap. 7, p. 6a–b. The Nancheng District Gazetteer, however, states that he was called to court during the Opened Prime era to serve as a *fangshi.* See *Nancheng xian zhi* (n.p., 1672), chap. 11, p. 75b.

12. These Daoist women are more fully described in Yan's *Miss Flower* stele inscription. See *Yan Lugong ji,* chap. 6, pp. 9b–10b.

13. *Yan Lugong ji,* chap. 5, pp. 11a–b.

14. Schafer, "Wei Hua-ts'un," p. 126.

15. Shen Fen (tenth century), *Xu xian zhuan,* quoted in *Gujin tushu jicheng* (rpt. Beijing: Zhonghua shuju, 1934), 509:3b; Li Fang, *Taiping guang ji* (Beijing: Zhonghua shuju, 1961), chap. 32, pp. 205–208; Wang Dang, *Tang yu lin* (Changsha: Commercial Press, 1939), p. 154.

16. *Record of Prodigies in the Luo Region* was written by Qin Zaisi of the Song dynasty. His entry on Yan Zhenqing is quoted in the Song-dynasty Daoist Chen Baoguang's *Sandong qunxian lu,* in *Dao zang,* vol. 994, chap. 14, p. 15b.

17. For his biography see *Song shi,* ed. Tuotuo et al. (Beijing: Zhonghua shuju, 1977), chap. 352, pp. 11128–11130.

18. See Nakata Yujiro, *Bei Futsu* (Tokyo: Nigensha, 1982), pp. 194–195.

19. Cao Fu, "Feixian Yan Lugong xin miao ji" (Record of the New Temple to Yan, Duke of Lu, in Feixian), in *Yan Lugong ji,* chap. 17, pp. 8b–9b.

20. *Shodō zenshū* (Tokyo: Heibonsha, 1930–1932), 18:203–205.

21. Mi Fu, "Yan Lugong bei yin ji [or Lugong xian ji ji]," in *Bao Jin yingguang ji,* chap. 7, pp. 54–55.

22. *Shu shi,* p. 19.

23. Zeng Gong, "Fuzhou Yan Lugong ci tang ji" (Record of the Temple of Yan, Duke of Lu, in Fuzhou), in *Yan Lugong ji,* chap. 17, p. 8a.

24. *Jigulu,* chap. 7, p. 1173.

25. *Bao Jin yingguang ji, buyi,* p. 75.

26. Lothar Ledderose, *Mi Fu and the Classical Tradition of Chinese Calligraphy* (Princeton: Princeton University Press, 1979), p. 58.

27. Wen C. Fong, *Images of the Mind* (Princeton: Princeton Art Museum, 1984), p. 90.

28. Mi Fu, *Baozhang daifang lu,* p. 7a.

29. *Shu shi,* p. 11.

30. Ibid., p. 8.

31. Lothar Ledderose, "Some Taoist Elements in the Calligraphy of the Six Dynasties," *T'oung Pao* 70 (1984):246–278.

32. On Daoism at the court of Emperor Huizong see Sun Kekuan, *Song Yuan daojiao zhi fazhan* (Taizhong: Donghai daxue, 1965), chap. 4, pp. 93–165; Jin Zhongshu, "Lun Bei Song monien zhi chongshang daojiao" (On the Promotion of Daoism at the End of the Northern Song), *Xin Ya xuebao* 7(2) (1966):

323–414 and 8(1) (1967):187–296; and Michel Strickmann, "The Longest Taoist Scripture," *History of Religions* 17(3–4) (1978):331–354.

33. See Ledderose, *Mi Fu*, p. 47.

34. Ye Mengde, *Bi shu lu hua* (n.p., Qing dynasty), chap. *xia*, p. 70b.

35. See Chen Yinke, "Tianshi dao yu binhai diyu zhi guanxi" (The Way of the Celestial Master and the coastal regions), *Bulletin of the National Research Institute of History and Philology, Academia Sinica* 3, pt. 4 (1933):439–466.

36. See Yan Han's biography, *Jin shu*, chap. 88, pp. 2285–2287.

37. Yao Cha and Yao Silian, *Liang shu* (Beijing: Zhonghua shuju, 1973), chap. 50, p. 727.

38. See the *Spirit Way Stele* inscription for Yan Zhenqing's brother-in-law Du Ji, *Wenzhong ji*, chap. 8, p. 63. On the interaction between the Wangs and the Yans during the Six Dynasties period see Su Shaoxing, *Liang Jin Nan Chao de shi zu* (Taipei: Lianjing, 1987), pp. 179–180.

39. According to Zhou Bida: "During the Yuanfeng era [1078–1085], Miss Hemp was enfeoffed as Lady of Purity and Truth. During the Yuanyou era [1086–1094], her title was changed to Marvelous and Solitary Perfected One, and during the Xuanhe era [1119–1125], another title was added: Superior Perfected Solitary Primal Worthy of Magnanimous Response. Emperor Huizong also wrote out the four characters for 'Palace of the Primal Worthy.' " From *Lushan riji*, quoted in *Yan Lugong ji*, chap. 25, p. 10b.

40. For example, Yan Zhenqing drew on Daoist books for material for his dictionary, *Yunhai jingyuan*. Feng Yan wrote: "When he was prefect of Huzhou, he supplemented and edited [the manuscript of *Yunhai jingyuan*], and aside from the standard classics he also took from the philosophers, the histories, and Buddhist and Daoist books" (*Feng shi wen jian ji jiao zhu*, p. 12).

41. *Zhongguo shufa quanji*, 25:10.

42. See *Feng shi wen jian ji jiao zhu*, pp. 3, 12, 25, 30, 39, 87, and 98.

Chapter 6: Buddhist Companions and Commemoration

1. "Fuzhou Yan Lugong citang ji," in *Yan Lugong ji*, chap. 17, pp. 7b–8b.

2. No longer extant. See *Yan Lugong ji*, chap. 7, pp. 2a–5b. Four tombs of Yan Han's descendants were excavated in 1958. See "Nanjing Laohushan Jin mu" (Jin Tombs at Laohushan, Nanjing), *Kaogu* 6 (1959):288–295.

3. "Stele Inscription for Profound Joy Monastery, Mount Zhu, Wucheng District, Huzhou," *Wenzhong ji*, chap. 4, pp. 18–20.

4. See Lu Yu's biography in *Xin Tang shu*, chap. 196, p. 5611, and *Lu Wenxue zizhuan* (Autobiography of Instructor Lu), quoted in Fu Shuqin and Ouyang Xun, *Lu Yu Chajing yizhu* (Wuhan: Hubei renmin chubanshe, 1983), pp. 82–90.

5. In *Hanxuetang congshu*, ed. Huang Shi (1893), *tao* 5.

6. The *Qieyun* is still extant. Originally compiled in 601 by Lu Fayan and a group of scholars including Yan Zhitui, it was republished in 751 under the title *Tang yun* and then revised and enlarged in 1011 and published under its present title, *Guang yun*. On the *Qieyun* see Ch'en Yuan, "The Ch'ieh-Yun and Its Hsien-pei Authorship," *Monumenta Serica* 1(2) (1935):245–252.

7. Pan Shu was the man to whom the set of linked verse called "Poems Written at Magistrate Pan's Bamboo Hill Library" was dedicated (*Yan Lugong ji*, chap. 12, p. 9b). In the Beijing Palace Museum is an ink-written version of these couplets (likely a fake). See Xu Wuwen, " 'Yan Zhenqing shu Zhushan lienju' bianwei" (Yan Zhenqing's calligraphy of the Bamboo Hill couplets as fake),

Wenwu 6 (1981):82–86. For a color reproduction see "Yan Zhenqing beitie xulu," *Gugong wenwu yuekan,* no. 17, p. 37.

8. Xiao Cun was the son of Yan Zhenqing's friend, Xiao Yingshi.

9. Should be Yan Cai, a relative of Zhenqing's cited in his "Inscription at Quiet Dwelling Monastery," according to Huang Benji (*Yan Lugong ji, Shixibiao,* p. 6).

10. On Jiaoran see Thomas P. Nielson, *The T'ang Poet-Monk Chiao-jan,* Occasional Paper 3 (Tempe: Center for Asian Studies, Arizona State University, 1972).

11. See Stephen Owen, *The Poetry of Meng Chiao and Han Yü* (New Haven: Yale University Press, 1975), pp. 116–117, and Craig Fisk, "Chiao-jan," in *The Indiana Companion to Traditional Chinese Literature,* ed. William H. Nienhauser Jr. (Bloomington: Indiana University Press, 1986), pp. 270–273.

12. See *Nan shi,* chap. 34, p. 881, and J. D. Frodsham, *The Murmuring Stream,* (Kuala Lumpur: University of Malaya Press, 1967), 1:28.

13. *Yan Lugong ji,* chap. 12, p. 5b.

14. Ibid., chap. 12, p. 8b.

15. See, for example, Hong Mai (1123–1202), *Rong zhai sui bi* (Shanghai: Shanghai guji chubanshe, 1978), *san ji,* chap. 16, pp. 600–601.

16. *Yan Lugong ji,* chap. 12, p. 10a; translation by Elling Eide, personal communication. See also Stephen Owen, *The Great Age of Chinese Poetry: The High T'ang* (New Haven: Yale University Press, 1981), p. 296.

17. See Liu Zhengchen's biography in *Xin Tang shu,* chap. 151, p. 4823.

18. *Yan Lugong ji,* chap. 16, p. 2b.

19. In the brush grip that is used to write large characters, the thumb is bent outward, making a "hollow." See Jiang Xingyu, *Yan Lugong zhi shu xue* (Taipei: Shujie shuju, 1962), pp. 43–46.

20. *Yan Lugong ji,* chap. 1, p. 6a.

21. Ibid., chap. 1, p. 6b.

22. Ibid., chap. 5, p. 13a–b.

23. Ibid., chap. 6, pp. 3b–4b.

24. Ibid., chap. 27, p. 4b.

25. Reproduced as *Song taben Yan Zhenqing shu Zhongyitang tie,* 2 vols. (Hangzhou: Xiling yinshe chubanshe, 1994). See also Zhu Guantian, "Zhejiang bowuguan cang Song ta Yan Zhenqing 'Zhongyitang tie'" (A Song ink rubbing of Yan Zhenqing's "Hall of Loyalty and Righteousness Compendium" in the Zhejiang Museum), *Shupu* 43:18–24. On the history of the *Compendium* see Lin Zhijun, *Tie kao* (Hong Kong: n.p., ca. 1962), pp. 141–151, and Rong Geng, *Cong tie mu* (Hong Kong: Zhonghua shuju, 1980–1986), 3:1137–1146.

26. See Zeng Hongfu (d. after 1248), *Shike buxu* (Changsha: Commercial Press, 1939), pp. 7–15; Lin, *Tie kao,* pp. 15–48; Roger Goepper, *Shu-p'u: Der Traktat zur Schriftkunst des Sun Kuo-t'ing* (Wiesbaden: Franz Steiner, 1974), pp. 408–410; Rong, *Cong tie mu,* 1:1–49; and Amy McNair, "The Engraved Model-Letters Compendia of the Song Dynasty," *Journal of the American Oriental Society* 114(2) (April–June 1994):210–213.

27. Zeng, *Shike buxu,* pp. 22–23.

28. Ibid., p. 24; Rong, *Cong tie mu,* 1:127–133.

29. Cao Shimian, *Fatie puxi* (1245) (Changsha: Commercial Press, 1939), p. 3, and Zeng, *Shike buxu,* pp. 15 and 21.

30. For reproductions see *Song ta Tan tie* (Chengdu: Sichuan cishu chubanshe, 1994), pp. 281–290. The *Tan tie,* or *Changsha tie,* is said by the traditional sources to have been compiled by the eminent official Liu Hang (995–1060) in 1045–1048 while serving as governor of Tanzhou (*Song ta Tan tie,* p. 2).

The original steles were lost in the fall of the Northern Song, and ink rubbings of it were always extremely rare, so this information was handed down without corroboration. The recent publication of a rare rubbing in the Sichuan Provincial Museum shows that the signature inscription mentions only Xibai, not Liu Hang, and the dates given are 1042–1043. It is not clear what role Liu Hang played; perhaps Xibai presented the *Tan tie* to Liu as the local governor.

31. *Quan Song ci,* ed. Tang Guizhang (Beijing: Zhonghua shuju, 1965), pp. 2423–2424; Lu Xinyuan (1834–1894), *Song shi yi* (n.p.: Shi wan juan lou, 1906), chap. 29, pp. 9a–10a; *Song zhong xing xue shi yuan ti ming* (n.p.: Ou xiang ling shi, n.d.), p. 12; and *Song zhong xing dong gong guan liao ti ming* (n.p.: Ou xiang ling shi, n.d.), p. 16.

32. *Yan Lugong wenji houxu, Yan Lugong ji,* chap. 18, p. 2a–b.

33. On the mutual interest in epigraphy of Liu Chang and Ouyang Xiu see Chen Guangchong, "Ouyang Xiu jinshixue shulue" (Ouyang Xiu's epigraphy), *Liaoning daxue xuebao* 6 (1981):54–57. With his father, Song Shou, Song Minqiu compiled the *Tang da zhao ling ji* (Proclamations issued under the Tang) in 1070 and the first gazetteer on Chang'an, the *Chang'an zhi,* in 1076. See *A Sung Bibliography,* ed. Yves Hervouet (Hong Kong: Chinese University Press, 1978), pp. 116 and 137.

34. For Liu Chang's preface see *Yan Lugong ji,* chap. 18, p. 1a–b.

35. For Liu's chronology *(Nianpu)* see *Wenzhong ji,* suppl. chap. 4.

36. See Mi Fu, *Baozhang daifang lu,* p. 7a.

37. Quoted in *Yan Lugong ji,* chap. 30, p. 16a.

38. Ibid., chap. 12, p. 3b and chap. 26, p. 10a.

39. See *Shodō zenshū,* 10:159–160, and Yang Zhenfang, *Beitie xulu* (Chengdu: Sichuan wenyi chubanshe, 1982), p. 160.

40. See Bai Huawen and Ni Ping, "Tangdai de gaoshen," *Wenwu* 11 (1977):77–80.

41. *Yan Lugong ji,* chap. 18, p. 2b.

42. *Jigulu,* chap. 7, p. 1176.

43. *Shodō zenshū,* 10:164.

44. For full reproductions of the two see *Song taben Yan Zhenqing shu Zhongyitang tie,* 2:437–439, 465, 466, and 468 (the lines of the text have gotten separated), and *Shodō zenshū,* 10:pl. 60–65 and the final section illustrated on p. 165.

45. McNair, "The Engraved Model-Letters Compendia."

Chapter 7: The Late Style of Yan Zhenqing

1. *Xin Tang shu,* chap. 62, p. 1699.

2. No longer extant. See *Yan Lugong ji,* chap. 28, pp. 10b–11a.

3. See Yan Zhenqing's record of the achievements of the Shen clan of Wuxing, *Wuxing Shen shi shu zu de ji,* in *Wen zhong ji,* chap. 13, pp. 97–98.

4. *Yan Lugong xing zhuang,* p. 22a–b.

5. David McMullen, *State and Scholars in T'ang China* (Cambridge: Cambridge University Press, 1988), p. 142.

6. The *Yuanling Rituals* is found in *Yan Lugong ji,* chap. 3.

7. McMullen, *State and Scholars,* pp. 142–146.

8. *Yan Lugong nianpu,* pp. 14b–16a; *Yan Lugong wenji,* chap. 2.

9. See Guo Fenghui, "Yan zi de tedian he ta de shuxie fangfa" (The special characteristics of the Yan style and its method of writing), *Shufa* 5 (1982):31–32; Jin Kaicheng, "Yan Zhenqing de shufa" (The calligraphy of Yan Zhenqing), *Wenwu* 10 (1977):81–86; Hu Wensui, "Shitan Yan shu yishu chengjiu" (On the

artistic achievement of the Yan style), *Shufa* 2 (1978):15–18; Chen Ruisong, "Cong 'Yuan Cishan bei' hua Yan zi" (Discussing the Yan style from the "Yuan Cishan stele"), *Shupu* 63:45; and Ouyang Hengzhong, "Yan shu de tedian he linxi" (The special characteristics of the Yan style and how to copy it), *Shupu* 17:34–37.

10. See, for example, the stele inscription by Han Zemu dated 752, reproduced in *Shaanxi lidai beishi xuanji* (Xi'an: Shaanxi renmin chubanshe, 1979), pl. 126. For the calligraphic style of Emperor Xuanzong see his *Ode on Pied Wagtails,* now in the National Palace Museum, Taipei, reproduced in *Masterpieces of Chinese Calligraphy in the National Palace Museum: Supplement,* (Taipei: National Palace Museum, 1973), pl. 2.

11. On Tang-dynasty seal script and Li Yangbing see Shi Anchang, *Tangdai shike zhuanwen* (Beijing: Zijincheng chubanshe, 1987).

12. Reproduced in *Zhongguo shufa: Yan Zhenqing,* 1:49.

13. *Shu shi,* p. 57.

14. From Fan Zhongyan's eulogy for Shi Manqing, quoted in Ma Zonghuo, *Shulin zaojian,* (Taipei: Shijie shuju, 1962), chap. 9, p. 197b. For a reproduction of Shi Manqing's *Baoguang deng timing* see *Zhongguo meishu quanji: Shufa zhuanke bian* 4: *Song Jin Yuan shufa* (Beijing: Renmin meishu chubanshe, 1986), p. 3.

15. Han Yu, "The Song of the Stone Drums," *Han Changli ji* (Shanghai: Commercial Press, 1936), chap. 2, p. 44.

16. On Xiao Cun see *Xin Tang shu,* chap. 202, p. 5770. Han Yu wrote Wei Dan's epitaph; see *Yan Lugong ji,* chap. 20, p. 3b.

17. See David L. McMullen, "Tu-ku Chi," in *The Indiana Companion,* pp. 820–821, and Stephen Owen, *The Poetry of Meng Chiao and Han Yü,* (New Haven: Yale University Press, 1975), p. 116.

18. *Yan Lugong ji,* chap. 6, pp. 2b–3a.

19. See Amy McNair, "Public Values in Calligraphy and Orthography in the Tang Dynasty," *Monumenta Serica* 43 (1995):263–278.

20. *Yan Zhenqing shu Ganlu zishu,* ed. Shi Anchang (Beijing: Zijincheng chubanshe, 1990), p. 96.

21. The stele is not extant, but the text is recorded in *Yan Lugong ji,* chap. 10, pp. 7a–8b.

22. The stele is not extant, but the text is recorded in *Yan Lugong ji,* chap. 10, pp. 10b–12a.

23. For a reproduction of an extant fragment see *The International Seminar on Chinese Calligraphy in Memory of Yen Chen-ch'ing's 1200th Posthumous Anniversary (Jinian Yan Zhenqing shishi yiqian erbai nian Zhongguo shufa guoji xueshu yantaohui)* (Taipei: Council for Cultural Planning and Development, Executive Yuan, R.O.C., 1987), p. 41.

24. *Jigulu,* chap. 7, p. 1175.

25. See *Saian hirin,* ed. Nishikawa Yasashi (Tokyo: Kodansha, 1966), pl. 85–88. The text is recorded in *Yan Lugong ji,* chap. 8, pp. 2a–4a.

26. *Yan Lugong ji,* chap. 23, p. 7a.

27. The text is recorded in *Yan Lugong ji,* chap. 8, pp. 6b–8a.

28. The text is recorded in *Yan Lugong ji,* chap. 5, p. 14a–b.

29. *Shodō zenshū,* 10:pl. 66–67, and Ta Tao, "Luo Zhenyu suocang Yan Zhenqing moji sizhong," *Shupu* 43:46–49.

30. Mi Fu, *Baozhang daifang lu,* p. 12a.

31. Lu Jinzhu, *Zhongguo shufa quanji,* vol. 26, p. 424.

32. *Jigulu,* chap. 7, p. 1178.

33. Preface to the *Jigulu,* p. 1087.

34. *Jigulu,* chap. 7, p. 1177.

35. Ibid.

36. Ibid.

37. Ibid., p. 1173.

38. Ibid., chap. 4, pp. 1138–1139.

39. See Ronald C. Egan, *The Literary Works of Ouyang Xiu (1007–1072)* (Cambridge: Cambridge University Press, 1984), pp. 12–14, 80–82, and 198–200.

40. *Lunyu,* bk. 7, chap. 30. See Legge, *Chinese Classics,* 1:205.

41. See James T. C. Liu, *Ou-yang Hsiu,* (Stanford: Stanford University Press, 1967), pp. 47–64.

42. "Lord Shan" refers to Shan Tao (d. 283), one of the "Seven Sages of the Bamboo Grove," who was famous as a minister of personnel for choosing the right men for office. "Shusun" refers to Shusun Tong, a Qin-Han-period official who established the Han-dynasty rituals. These are complimentary comparisons to Yan Zhenqing as minister of personnel and commissioner for ceremonial propriety.

43. The Han scholar and teacher Huan Rong (21 B.C.E.–59 C.E.) attained very high office at the end of his career. Displaying the many gifts he had received from the throne, he exclaimed "This comes from devotion to antiquity." See Herbert Giles, *A Chinese Biographical Dictionary* (rpt. Taipei: Ch'eng wen, 1975), p. 327.

44. *Yan Lugong ji,* chap. 17, p. 2a–b.

45. Huang Tingjian once referred to Zhou Yue's style as possessing "seductive beauty," Han Yu's derogatory term that served as a metonym for the Wang style. See *Shangu tiba,* chap. 9, p. 97.

46. See Shui Laiyou, *Cai Xiang shufa shiliao ji* (Shanghai: Shanghai shuhua chubanshe, 1983), pp. 12–14.

47. Reproduced in *Gugong fashu,* vol. 1: *Jin Wang Xizhi moji* (Taipei: National Palace Museum, 1962), p. 21a–b.

48. *Cai Zhonghuigong ji,* chap. 34, p. 16b.

49. *A Sung Bibliography,* ed. Yves Hervouet (Hong Kong: Chinese University Press, 1978), p. 131. Zhu Changwen was born with a crippled foot.

50. *Xu Shuduan,* in *Lidai shufa lunwenxuan,* 1:324.

51. Ibid.

52. Ibid.

53. See *Jigulu,* chap. 7, p. 1177.

54. *Xuanhe shupu* (Taipei: Shijie shuju, 1962), chap. 3, pp. 89–94.

55. Mi Fu, *Haiyue mingyan* (Taipei: Shijie shuju, 1962), p. 2.

56. Mi Fu, *Bao Jin yingguang ji, buyi,* p. 75.

Chapter 8: Confucian Martyrdom

1. *Jiu Tang shu,* chap. 128, p. 3595.

2. Ibid., p. 3596.

3. *Yan Lugong ji,* chap. 17, pp. 3b–4a.

Glossary

An Lushan　安錄山
An Shiwen　安師文
Baozhang daifang lu　寶章待訪錄
bei　貝
Boping　博平
"Broken Stele" Thousand Character
　　Classic　殘碑千字文
Cai Jing　蔡京
Cai Jing　蔡經
Cai Mingyuan　蔡明遠
Cai Tao　蔡條
Cai Xiang　蔡襄
Cai Xide　蔡希德
cang feng　藏鋒
Cang Jie　倉頡
Cao Cao　曹操
Cao Fu　曹輔
ce bi　側筆
Cen Shen　岑參
Cen Xun　岑勛
Chang'an　長安
Changsha tie　長沙帖
Changshan　常山
Chen Zun　陳遵
Cheng Hao　程浩
Chu Suiliang　褚遂良
Chunhua ge tie　淳化閣帖
Chunxi bige tie　淳熙秘閣帖
Chunxi bige xutie　淳熙秘閣續帖
Cishutang tie　賜書堂帖
Cold Food Letter　寒食帖

Colophon to the Han Inscription for
　　the Temple on the Western Peak
　　of Mount Hua　漢西嶽華山廟碑
　　題跋
Cui Ling'en　崔靈恩
Cui Yuan　崔瑗
Cui Yuan　崔圓
Cursive and Seal Script Letter　草篆帖
Cursive-Script Thousand Character
　　Classic　草書千字文
de yu yi wai　得于意外
Defending Government Letter　守政帖
Deng Ziyang　鄧紫陽
Dezhou　德州
Dong Qichang　董其昌
Dongfang Shuo　東方朔
Dou Ji　竇臮
Dou Meng　竇蒙
Draft of the Eulogy for Nephew
　　Jiming　祭姪季明文稿
Dried Deer Meat Letter　鹿脯帖
Du Du　杜度
Du Fu　杜甫
Du Hongjian　杜鴻漸
Du Ji　杜濟
Duan Ziguang　段子光
Dugu Ji　獨孤及
Duke of Lu　魯公
Emperor Daizong of Tang　唐代宗
Emperor Dezong of Tang　唐德宗
Emperor Gaozong of Song　宋高宗

Emperor Huizong of Song　宋徽宗

Emperor Ming of Liu Song　宋明帝

Emperor Muzong of Tang　唐穆宗

Emperor Renzong of Song　宋仁宗

Emperor Suzong of Tang　唐肅宗

Emperor Taizong of Song　宋太宗

Emperor Taizong of Tang　唐太宗

Emperor Wu of Han　漢武帝

Emperor Wu of Liang　梁武帝

Emperor Xuanzong of Tang　唐玄宗

Emperor Yang of Sui　隋煬帝

*Encomium on a Portrait of Dongfang
　　Shuo*　東方先生畫贊

*Engraved Poem of the Daoist
　　Qingyuan*　刻清遠道士詩

Epitaph for Amoghavajra　不空和
　　尚碑

Epitaph for Yuan Cishan　元次山銘

Eulogy for Huang Jidao　祭黃幾道文

Eulogy for Uncle Yuansun　祭伯父豪
　　州刺史文

Fa shu yao lu　法書要錄

Fan Zhongyan　范仲淹

fangshi　方士

fatie　法帖

Feng Yan　封演

Fengci Letter　奉辭帖

Fengxiang　鳳翔

Forest of Steles　碑林

Four Ancient-Style Poems　古詩四帖

Fufeng　扶風

fugu　復古

Fuzhou　撫州

Ganlu zishu　干祿字書

Gao Miao　高邈

Gao Ruonuo　高若訥

ge　戈

Ge Hong　葛洪

Geshu Han　哥舒汗

Geshu Yao　哥舒曜

Guangping Letter　廣平帖

Guo Family Temple Stele　郭氏家廟碑

Guo Kui　郭揆

Guo Xi　郭晞

Guo Xuji　郭虛己

Guo Yingyi　郭英乂

Guo Ziyi　郭子儀

Guokou　嘓口

guwen　古文

Han Qi　韓琦

Han Si　韓思

Han Yu　韓愈

haofang　豪放

He Qiannian　何千年

He Zhizhang　賀知章

Helan Jinming　賀蘭進明

heng　橫

Huaisu　懷素

Huang Ba　黃霸

Huang Lingwei　黃靈微

Huang Tingjian　黃庭堅

Huangzhou Cold Food Poems　黃州
　　寒食詩

Huzhou　湖州

Huzhou Letter　湖州帖

Huzhou Stone Record　湖州石記

Imperial Commissioner Liu Letter
　　劉中使帖

Imperial Response　肅宗批答

*Inscribed Record of a Visit to the
　　Shrine of Shaohao*　謁金天王祠
　　題記

*Inscription at Quiet Dwelling
　　Monastery*　靖居寺題名

Inscription at West Grove Monastery
　　西林寺題名

Ji Wen　吉溫

Jiang Huai Letter　江淮帖

Jiang tie　絳帖

Jiaoran　皎然

Jiashan　嘉山

Jigulu　集古錄

Jing Yu　敬羽

Jinshilu　金石錄

Jizhou　吉州

kuang cao　狂草

Kuangseng　狂僧

Lantingxu　蘭亭序

Letter for Cai Mingyuan　與蔡明遠帖
Letter for Liu Taichong　送劉太冲序
Letter on the Controversy over Seating Protocol　爭座位帖
Letter to Administrator Lu Ba　盧八倉曹帖
Letter to Yanyou　致彥猷尺牘
Lexicon for Gaining Employment. See *Ganlu zishu*
Li Bai　李白
Li Baoyu　李抱玉
Li Fuguo　李輔國
Li Guangbi　李光弼
Li Guangjin　李光進
Li Hanguang　李含光
Li Hua　李華
Li Jianzhong　李建中
Li Lin　李麟
Li Qi　李頎
Li Qincou　李欽湊
Li Qiongxian　黎瓊仙
Li Wei　李瑋
Li Xilie　李希烈
Li Xiqian　李希倩
Li Yangbing　李陽冰
Liang Zhangju　梁章鉅
Lidui Record of Mr. Xianyu　鮮于氏離堆記
Linchuan　臨州
Lingwu　靈武
Liquan　醴泉
Liu Chang　劉敞
Liu Gong　劉共
Liu Gongquan　柳公勸
Liu Niangzi　劉娘子
Liu Yan　劉晏
Liu Yuangang　留元剛
Liu Zhan　劉展
Liu Zheng　留正
Liu Zhengchen　留正臣
Lizhou　利州
Lou Yue　樓鑰
Lu Jianzhi　陸柬之
Lu Qi　盧杞

Lu Yanyuan　陸彥遠
Lu Yu　陸羽
Lü Yijian　呂夷簡
Luo Zhenyu　羅振玉
Luoyang　洛陽
Luozhong jiyi　洛中記異
Manjusri Letter　文殊帖
Mei Yaochen　梅堯臣
Meng Jiao　孟郊
Mi Fu　米芾
Mi Youren　米友仁
Miao Jinqing　苗晉卿
Miss Hemp　麻姑
moya　摩崖
na　捺
On General Yue Yi　樂毅論
Ouyang Xiu　歐陽修
Ouyang Xun　歐陽詢
Paean to the Resurgence of the Great Tang Dynasty　大唐中興頌
Pan Shu　潘述
Pei Min　裴旻
Pengzhou　蓬州
pie　撇
Ping Lie　平洌
Ping'an Letter　平安帖
pingdan　平淡
Pingyuan　平原
Poem for General Pei　贈裴將軍
Poems Written at Magistrate Pan's Bamboo Hill Library　竹山聯句題潘氏書堂
Ponds for the Release of Living Creatures Throughout the Subcelestial Realm Stele　天下放生池碑
Prabhutaratna Pagoda Gratitude for Prayers Answered Stele　多寶塔感應碑
Pugu Huaien　僕固懷恩
Puzhou　蒲州
qi　其
Qianfusi　千福寺
qiao　巧

Qinghe　清河

Raozhou　饒州

Record of Enjoying Rich Harvests Pavilion　豐樂亭記

Record of the Altar of the Immortal of Mount Magu, Nancheng District, Fuzhou　撫州南城縣麻姑山仙壇記

Record of the Archery Hall　射堂記

Record of the Immortal Duke of Lu　魯公仙蹟記

Record of the Wan'an Bridge　萬安橋記

Record on the Reverse of the Encomium on a Portrait of Dongfang Shuo　東方先生畫贊碑陰記

Request for Rice Letter　乞米帖

Request to the Emperor to Write a Heading for the Ponds for the Release of Living Creatures Throughout the Subcelestial Realm Stele　乞御書天下放生池碑額表

Ru tie　汝帖

Ruan Yuan　阮元

Shen Chuanshi　沈傳師

Shenxian zhuan　神仙傳

Shi Manqing　石曼卿

Shi Siming　史思明

Shi Yuancong　史元琮

Shiguge　石鼓歌

Shiqu baoji　石渠寶笈

Shiqu baoji xubian　石渠寶笈續編

shiwen　時文

shu　豎

Shu duan　書斷

Shu shi　書史

shu xin hua ye　書心畫也

Shuitou huoming　水頭鑊銘

Shuowen jiezi　說文解字

Sick Horse Letter　馬病帖

Sima Guang　司馬光

Sima Qian　司馬遷

Song Jing　宋璟

Song Minqiu　宋敏求

Song Shou　宋綬

Spirit Way Stele for Du Ji　杜濟神道碑

Spirit Way Stele for Yan Qinli　顏勤禮神道碑

Stele for Li Shenfu　李神符碑

Stele for Li Xuanjing [Li Hanguang]　李玄靖碑

Stele for Ouyang Wei　歐陽琟

Stele for the Temple of Confucius in Fufeng　扶風夫子廟堂碑

Stele for Yan Yunnan　顏允南碑

Stele for Zhang Jingyin　張敬因碑

Stomachache Letter　肚痛帖

Su Shi　蘇軾

Su Shunyuan　蘇舜元

Su Yijian　蘇易簡

Sun Chengze　孫承澤

Sun Di　孫逖

Sun Guoting　孫過庭

Taiping guangji　太平廣記

Tan tie　潭帖

Tang yu lin　唐語林

Tao Hongjing　陶弘景

ti　剔

tiancheng　天成

Tianshi Dao　天師道

Tianshui　天水

tiaoti　挑踢

Tieweishan congtan　鐵圍山叢談

Tong Pass　潼關

Tongzhou　同州

Tumen Pass　土門關

Twelve Concepts of the Brush Method of Administrator Zhang　張長史十二意筆法記

Two-Night-Stay Letter　信宿帖

Wang Anshi　王安石

Wang Cai　王寀

Wang Chengye　王承業

Wang Chong　王充

Wang Dang　王讜

Wang Fangping　王方平

Wang Gongchen　王拱辰

Wang Qiu　王邱

Wang Sengqian　王僧虔

Wang Shen　王詵

Wang Su　王素

Wang Wei　王維

Wang Xianzhi　王獻之

Wang Xiu　王修

Wang Xizhi　王羲之

Wang Zhu　王著

Wei Dan　韋丹

Wei Di　韋迪

Wei Huacun　魏華存

Wei Shu　韋述

Wen xuan　文選

Wenzhong ji　文忠集

Writing a Letter Letter　修書帖

Written on the Cliff After the Stele　書摩崖碑後

Wu　吳

Wu Creek　浯溪

Wu Daozi　吳道子

Wu Zetian　武則天

wuxin　無心

Wuxing　吳興

wuyi　無意

Xi Shi　西施

Xi Xia　西夏

Xiahou Zhan　夏候湛

Xian li zhuan　仙吏傳

Xian Qin guqi ji　先秦古器記

Xianyu Shu　鮮于樞

Xianyu Zhongtong　鮮于仲通

Xiao Cun　蕭存

Xiao Yingshi　蕭穎士

Xiazhou　硤州

Xibai　希白

Xie Lingyun　謝靈運

Xikun chouchang ji　西崑酬唱集

Xu Hao　徐浩

Xu Shu duan　續書斷

Xu Xian zhuan　續仙傳

Xu Xuan　徐鉉

Xuanhe shupu　宣和書譜

Xue Ji　薛稷

Yan Bingzhi　顏炳之

Yan Family Temple Stele　顏氏家廟碑

Yan Gaoqing　顏杲卿

Yan Han　顏含

Yan Jiming　顏季明

Yan Jingzhi　顏靖之

Yan Jun　顏頵

Yan Pei　顏裴

Yan Po　顏頗

Yan Quanming　顏泉明

Yan Shigu　顏師古

Yan Shuo　顏碩

Yan Tengzhi　顏騰之

Yan Weizhen　顏惟貞

Yan Xie　顏協

Yan Yanzhi　顏延之

Yan Yu　顏禺

Yan Yuansun　顏元孫

Yan Yunnan　顏允南

Yan Yunzang　顏允藏

Yan Zhaofu　顏昭甫

Yan Zhending　顏真定

Yan Zhenqing　顏真卿

Yan Zhitui　顏之推

Yang Guifei　楊貴妃

Yang Guozhong　楊國忠

Yang Hangong　楊漢公

Yang Renkai　楊仁愷

Yang Wan　楊綰

Yang Xi　楊羲

Yang Xiong　揚雄

Yang Yan　楊炎

Ye Mengde　葉夢得

yi　意

yi bu zai zi　意不在字

Yihang Letter　一行帖

Yin Jianyou　殷踐猷

Yin Liang　殷亮

Yin Lüzhi 殷履直
Yin Shu 尹洙
Yin Zhongrong 殷仲容
Yin Zijing 殷子敬
Yin Ziqi 尹子奇
yongwu 詠物
youyi 有意
Youzhou 幽州
Yu Chaoen 魚朝恩
Yu Jing 余靖
Yu Shao 于邵
Yu Shinan 虞世南
Yuan Dexiu 元德秀
Yuan Gao 袁高
Yuan Jie 元結
Yuan Lüqian 袁履謙
Yuan Zai 元載
Yuanyou bige xutie 元祐秘閣續帖
Yuanyou era 元祐
Yuefu 樂府
Yunhai jingyuan 韻海鏡源
Zeng Gong 曾鞏
Zeng Miaoxing 曾妙行
Zhang Huaiguan 張懷瓘
Zhang Jian 張薦
Zhang Tingyu 張庭玉
Zhang Xu 張旭

Zhang Yan 張晏
Zhang Yanyuan 張彥遠
Zhang Zhi 張芝
Zhao Kuangyin 趙匡胤
Zhao Lingkun 趙令昆
Zhao Mengfu 趙孟頫
Zhao Mingcheng 趙明誠
Zhao Yi 趙壹
Zhaoling 昭陵
zheng bi 正筆
zhi 之
Zhiyong 智永
zhong bi 中筆
Zhong You 鍾繇
Zhongyitang tie 忠義堂帖
Zhou Mi 周密
Zhou Yue 周越
Zhu Changwen 朱長文
Zhu Ci 朱泚
Zhu Wuyou 竹務猷
Zhu Xi 朱熹
Zhuangzi 莊子
zhuo 拙
zi mei 姿媚
Zishu gaoshen 自書告身
Ziyan Letter 自言帖
Zouyou Letter 鄒游帖

Bibliography

Premodern Texts

Acker, William R. B., trans. *Some T'ang and Pre-T'ang Texts on Chinese Painting.* Leiden: Brill, 1954 and 1974.

Bian Yongyu. *Shigutang shuhua huikao.* 4 vols. Taipei: n.p., 1958.

Cai Tao. *Tieweishan congtan.* N.p.: Gu shu liu tong chu, 1921.

Cai Xiang. *Cai Zhonghuigong ji.* N.p.: Xun min zhai, 1734.

Cao Shimian. *Fatie puxi.* Changsha: Commercial Press, 1939.

Cen Shen. *Cen Shen ji jiao zhu.* Edited by Chen Tiemin and Hou Zhongyi. Shanghai: Shanghai guji chubanshe, 1981.

Chu Suiliang. *Jin Youjun Wang Xizhi shu mu.* In *Fashu yaolu.*

Dao zang. Shanghai: Commercial Press, 1924–1926.

Dou Ji. *Shu shu fu.* In *Fashu yaolu.*

Fang Xuanling et al. *Jin shu.* Beijing: Zhonghua shuju, 1974.

Fashu yaolu. Edited by Zhang Yanyuan. Beijing: Renmin meishu chubanshe, 1984.

Feng Yan. *Feng shi wen jian ji jiao zhu.* Beijing: Zhonghua shuju, 1958.

Forke, Alfred, trans. *Lunheng.* Reprint. New York: Paragon Book Gallery, 1962.

Ge Hong. *Shen xian zhuan.* Taipei: Xinxing shuju, 1974.

Gujin tushu jicheng. Reprint. Beijing: Zhonghua shuju, 1934.

Han Yu. *Han Changli ji.* Shanghai: Commercial Press, 1936.

Hanxuetang congshu. Edited by Huang Shi. N.p., 1893.

Hong Mai. *Rong zhai sui bi.* Shanghai: Shanghai guji chubanshe, 1978.

Huang Benji. *Yan Lugong nianpu.* In Yan Zhenqing, *Yan Lugong ji.*

Huang Tingjian. *Huang Shangu shi.* Edited by Huang Gongzhu. Shanghai: Commercial Press, 1934.

———. *Shangu tiba.* Taipei: Shijie shuju, 1962.

Ji Yougong. *Tang shi ji shi.* Beijing: Zhonghua shuju, 1965.

Li Fang. *Taiping guang ji.* Beijing: Zhonghua shuju, 1961.

Li Zhao. *Tang guo shi bu.* Shanghai: Gudian wenxue chubanshe, 1979.

Liang Zhangju. *Tuian jinshi shuhua ba.* N.p., 1845.

Lidai shufa lunwenxuan. 2 vols. Edited by Huang Jian. Shanghai: Shanghai shu hua chubanshe, 1979.

Liu Xun et al. *Jiu Tang shu.* Beijing: Zhonghua shuju, 1975.

Liu Yuangang. *Yan Lugong nianpu.* In Yan Zhenqing, *Wen zhong ji,* suppl. chap. 4, and *Yan Lugong ji,* chap. 15.

Lu Xie. *Lin chi jue.* In *Lidai shufa lunwenxuan.*

Lu Xinyuan. *Song shi yi*. N.p.: Shi wan juan lou, 1906.

Mi Fu. *Bao Jin yingguang ji*. Changsha: Commercial Press, 1939.

———. *Baozhang daifang lu*. Taipei: Shijie shuju, 1962.

———. *Haiyue mingyan*. Taipei: Shijie shuju, 1962.

———. *Haiyue tiba*. Taipei: Shijie shuju, 1962.

———. *Shu shi*. Taipei: Shijie shuju, 1962.

Nan shi. Edited by Li Yanshou. Beijing: Zhonghua shuju, 1975.

Nancheng xian zhi. N.p., 1672.

Ouyang Xiu. *Ouyang Xiu quanji*. 2 vols. Beijing: Zhongguo shudian, 1986.

Ouyang Xiu, Song Qi, et al. *Xin Tang shu*. Beijing: Zhonghua shuju, 1975.

Peng Yuanrui. *Zhengzuoweitie kaocheng*. In *Enyutang jingjin xugao*. N.p., ca. 1735–1796, chap. 6, pp. 9a–15a.

Quan Song ci. Edited by Tang Guizhang. Beijing: Zhonghua shuju, 1965.

Quan Tang shi. Taipei: Fuxing shuju, 1961.

Quan Tang wen. Edited by Dong Gao. Reprint. Tainan: Jingwei shuju, 1965.

Ruan Yuan. *Beibei nantie lun*. In *Lidai shufa lunwenxuan*.

Sima Guang. *Zizhi tongjian*. Beijing: Zhonghua shuju, 1956.

Sima Qian. *Shiji*. Beijing: Zhonghua shuju, 1959.

Song shi. Edited by Tuotuo et al. Beijing: Zhonghua shuju, 1977.

Song zhong xing dong gong guan liao ti ming. N.p.: Ou xiang ling shi, n.d.

Song zhong xing xue shi yuan ti ming. N.p.: Ou xiang ling shi, n.d.

Su Shi. *Dongpo tiba*. Taipei: Shijie shuju, 1962.

Sun Chengze. *Gengzi xiaoxia ji*. In *Zhibuzu zhai congshu*. Edited by Bao Tingbo. Reprint. Shanghai: Gu shu liu tong chu, 1921.

Sun Guoting. *Shupu*. In *Lidai shufa lunwenxuan*.

Tang hui yao. Taipei: Shijie shuju, 1960.

Tao Hongjing and Emperor Wu of Liang. *Lun shu qi*. In *Fashu yaolu*.

Wang Dang. *Tang yu lin*. Changsha: Commercial Press, 1939.

Wei Shu. *Tang Wei Shu xu shu lu*. In *Fashu yaolu*.

Wen xuan. Edited by Xiao Tong. Shanghai: Commercial Press, 1937.

Xu Hao. *Lun shu*. In *Fashu yaolu*.

Xuanhe shupu. Taipei: Shijie shuju, 1962.

Yan Zhenqing. *Wenzhong ji*. Introduction by Liu Chang. Edited by Liu Yuangang. Shanghai: Commercial Press, 1936.

———. *Wenzhong ji shi yi*. Edited by Huang Benji. Shanghai: Commercial Press, 1936.

———. *Yan Lugong ji*. Edited by Huang Benji. Reprint. Taipei: Zhonghua shuju, 1970.

———. *Yan Zhenqing ji*. Edited by Ling Jiamin. Harbin: Heilongjiang renmin chubanshe, 1993.

Yang Xiong. *Fayan*. Sibu beiyao ed.

Yao Cha and Yao Silian. *Liang shu*. Beijing: Zhonghua shuju, 1973.

Ye Mengde. *Bi shu lu hua*. Reprint. N.p., Qing dynasty.

Yin Liang. *Yan Lugong xing zhuang*. In *Quan Tang wen,* chap. 514, pp. 9a–26a.

Yu Shinan. *Shu zhi shu*. In *Fashu yaolu*.

Zeng Hongfu. *Shike buxu*. Changsha: Commercial Press, 1939.

Zhang Huaiguan. *Shu duan*. In *Lidai shufa lunwenxuan*.

Zhu Changwen. *Mo chi bian*. Reprint. Taipei: National Central Library, 1970.

———. *Xu Shu duan*. In *Lidai shufa lunwenxuan*.

Zhuangzi. Shanghai: Shanghai Guji Press, 1988.

Modern Sources and Reproductions

Aiura Tomoo. *Gan Rokō no kenkyū*. Tokyo: Yūsan kaku, 1942.

Bai Huawen and Ni Ping. "Tangdai de gaoshen." *Wenwu* 11 (1977):77–80.

Barnhart, Richard. "Wei Fu-jen's *Pi Chen t'u* and the Early Texts on Calligraphy." *Archives of the Chinese Art Society of America* 18 (1964):13–25.

Bush, Susan. *The Chinese Literati on Painting: Su Shih (1037–1101) to Tung Ch'i-ch'ang (1555–1636).* Cambridge, Mass.: Harvard University Press, 1971.

Cai Chongming. *Song si jia shufa xi lun.* Taipei: Hua zheng shuju, 1986.

The Cambridge History of China. Vol. 3: *Sui and T'ang China, 589–906, Pt. I.* Edited by Denis Twitchett. Cambridge: Cambridge University Press, 1979.

Catalogue of Chinese Rubbings in Field Museum of Natural History. Edited by Hartmut Walravens. *Fieldiana Anthropology,* n.s., no. 3. Chicago: Field Museum, 1981.

Chaves, Jonathan. "The Legacy of Ts'ang Chieh: The Written Word as Magic." *Oriental Art* 23 (2) (1977):200–215.

———. *Mei Yao-ch'en and the Development of Early Sung Poetry.* New York: Columbia University Press, 1976.

Chen Guangchong. "Ouyang Xiu jinshixue shulue." *Liaoning daxue xuebao* 6 (1981):54–57.

Chen Ruisong. "Cong 'Yuan Cishan bei' hua Yan zi." *Shupu* 63:45.

Chen Yaodong. "Yan Zhenqing 'Huzhou tie' xinian kaoshi." *Shufa* 5 (1983):33–35.

Chen Yinke. "Tianshi dao yu binhai diyu zhi guanxi." *Bulletin of the National Research Institute of History and Philology, Academia Sinica* 3, pt. 4 (1933): 439–466.

Ch'en Yuan. "The Ch'ieh-Yun and Its Hsien-pei Authorship." *Monumenta Serica* 1, (2) (1935):245–252.

Da Shi. "Yan Zhenqing 'Liu Zhongshi tie.' " *Shupu* 43:50–51.

Doré, Henri. "Recherches sur les Superstitions en Chine." *Variétés sinologiques* 12 (1918): 48.

Egan, Ronald C. *The Literary Works of Ou-yang Hsiu (1007–1072).* Cambridge: Cambridge University Press, 1984.

———. "Ou-yang Hsiu and Su Shih on Calligraphy." *Harvard Journal of Asiatic Studies* 49 (2) (Dec. 1989):365–419.

———. *Word, Image, and Deed in the Life of Su Shi.* Cambridge, Mass.: Council on East Asian Studies, Harvard University, 1994.

Fong, Wen C. *Images of the Mind.* Princeton: Princeton Art Museum, 1984.

Frodsham, J. D. *The Murmuring Stream: The Life and Works of the Chinese Nature Poet Hsieh Ling-yun (385–433), Duke of K'ang-lo.* 2 vols. Kuala Lumpur: University of Malaya Press, 1967.

Fu Shen. "Huang T'ing-chien's Calligraphy and His *Scroll for Chang Ta-t'ung:* A Masterpiece Written in Exile." Ph.D. dissertation, Princeton University, 1976.

———. *Traces of the Brush: Studies in Chinese Calligraphy.* New Haven: Yale University Press, 1977.

Fu Shuqin and Ouyang Xun. *Lu Yu Chajing yizhu.* Wuhan: Hubei renmin chubanshe, 1983.

Giles, Herbert. *A Chinese Biographical Dictionary.* Reprint. Taipei: Ch'eng wen, 1975.

Goepper, Roger. *Shu-p'u: Der Traktat zur Schriftkunst des Sun Kuo-t'ing.* Wiesbaden: Franz Steiner, 1974.

Goldberg, Stephen J. "Court Calligraphy of the Early T'ang Dynasty." *Artibus Asiae* 49(3–4) (1988–1989):189–237.

Gugong fashu. Vol. 1: *Jin Wang Xizhi moji.* Taipei: National Palace Museum, 1962.

———. Vol. 5: *Tang Yan Zhenqing shu ji ji wen gao.* Taipei: National Palace Museum, 1964.

Gugong lidai fashu quanji. 30 vols. Taipei: National Palace Museum, 1977.

Gugong shuhua lu. 4 vols. Taipei: National Palace Museum, 1965.

Guo Fenghui. "Yan zi de tedian he ta de shuxie fangfa." *Shufa* 5 (1982):31–32.

Hartman, Charles. *Han Yü and the T'ang Search for Unity.* Princeton: Princeton University Press, 1986.

Hu Wensui. "Shitan Yan shu yishu chengjiu." *Shufa* 2 (1978):15–18.

Hucker, Charles O. *A Dictionary of Official Titles in Imperial China.* Stanford: Stanford University Press, 1985.

The Indiana Companion to Traditional Chinese Literature. Edited by William H. Nienhauser Jr. Bloomington: Indiana University Press, 1986.

The International Seminar on Chinese Calligraphy in Memory of Yen Chen-ch'ing's 1200th Posthumous Anniversary (Jinian Yan Zhenqing shishi yiqian erbai nian Zhongguo shufa guoji xueshu yantaohui). Taipei: Council for Cultural Planning and Development, Executive Yuan, R.O.C., 1987.

Jiang Xingyu. *Yan Lugong zhi shu xue.* Taipei: Shijie shuju, 1962.

Jin Kaicheng. "Yan Zhenqing de shufa." *Wenwu* 10 (1977):81–86.

Jin Zhongshu. "Lun Bei Song monien zhi chongshang daojiao." *Xin Ya xuebao* 7 (2) (1966):323–414 and 8 (1) (1967):187–296.

Jorgensen, John. "The 'Imperial' Lineage of Ch'an Buddhism: The Role of Confucian Ritual and Ancestor Worship in Ch'an's Search for Legitimation in the Mid-T'ang Dynasty." *Papers on Far Eastern History,* 35 (March 1987): 89–133.

Kirkland, Russell. "Huang Ling-wei: A Taoist Priestess in T'ang China." *Journal of Chinese Religions* 19 (Fall 1991):47–73.

Kracke, E. A., Jr. *Civil Service in Early Sung China, 960–1067.* Cambridge, Mass.: Harvard University Press, 1953.

———. "The Expansion of Educational Opportunity in the Reign of Hui-tsung of Sung and Its Implications." *Sung Studies Newsletter* 13 (1977):6–30.

———. "Region, Family, and Individual in the Chinese Examinations System." In *Chinese Thought and Institutions,* ed. John K. Fairbank. Chicago: University of Chicago Press, 1957.

Kroll, Paul W. "The True Dates of the Reigns and Reign-Periods of T'ang." *T'ang Studies* 2 (1984):25–30.

Lapina, Zinaida Grigor'evna. "Recherches épigraphiques de Ou-Yang Hsiu, 1007–1072." *Études Song,* n.s., 2 (1980):99–111.

Lattimore, David. "Allusion and T'ang Poetry." In *Perspectives on the T'ang,* ed. Arthur F. Wright and Denis Twitchett. New Haven: Yale University Press, 1973.

Ledderose, Lothar. *Mi Fu and the Classical Tradition of Chinese Calligraphy.* Princeton: Princeton University Press, 1979.

———. "Some Taoist Elements in the Calligraphy of the Six Dynasties." *T'oung Pao* 70 (1984):246–278.

Legge, James. *The Chinese Classics.* 5 vols. Reprint. Hong Kong: Hong Kong University Press, 1960.

Li Tianma. "Yan Lugong 'Liu Zhongshi tie.'" In *Yilin conglu* 8:40–42.

Li Yanzhu. "Yan Zhenqing beitie nianbiao." *Shupu* 63:38–44.

Liaoning sheng bowuguan cang fashu xuanji. 20 vols. Shenyang: Wenwu chubanshe, 1962.

Lin Zhijun. *Tie kao.* Hong Kong: n.p., ca. 1962.

Liu, James T. C. *Ou-yang Hsiu: An Eleventh-Century Neo-Confucianist.* Stanford: Stanford University Press, 1967.

Lu Zhangsheng. "Song ta Yan Zhenqing shu 'Dongfang Shuo hua zan bei.'" *Wenwu* 10 (1977):87.

Ma Zonghuo. *Shulin zaojian.* Taipei: Shijie shuju, 1962.

Masterpieces of Chinese Calligraphy in the National Palace Museum: Supplement. Taipei: National Palace Museum, 1973.

McCraw, David R. *Du Fu's Laments from the South.* Honolulu: University of Hawai'i Press, 1992.

McMullen, David. "Historical and Literary Theory in the Mid-Eighth Century." In *Perspectives on the T'ang,* ed. Arthur F. Wright and Denis Twitchett. New Haven: Yale University Press, 1973.

———. *State and Scholars in T'ang China.* Cambridge: Cambridge University Press, 1988.

McNair, Amy. "Engraved Calligraphy in China: Recension and Reception." *Art Bulletin* 77 (1) (March 1995):106–114.

———. "The Engraved Model-Letters Compendia of the Song Dynasty." *Journal of the American Oriental Society* 114 (2) (April–June 1994):209–225.

———. "Public Values in Calligraphy and Orthography in the Tang Dynasty." *Monumenta Serica* 43 (1995):263–278.

Nakata Yūjirō. *Bei Futsu.* Tokyo: Nigensha, 1982.

———. "Nanjing Laohushan Jin mu." *Kaogu* 6 (1959):288–295.

Nielson, Thomas P. *The T'ang Poet-Monk Chiao-jan.* Occasional Paper 3. Tempe: Center for Asian Studies, Arizona State University, 1972.

Ouyang Hengzhong. "Yan shu de tedian he linxi." *Shupu* 17:34–37.

Owen, Stephen. *The Great Age of Chinese Poetry: The High T'ang.* New Haven: Yale University Press, 1981.

———. *The Poetry of Meng Chiao and Han Yü.* New Haven: Yale University Press, 1975.

———. *Remembrances: The Experience of the Past in Classical Chinese Literature.* Cambridge, Mass.: Harvard University Press, 1986.

Pan Boying. "Bei Song shupai de xin jiu guan." In *Yilin conglu* 2:116–120.

———. "Yan Zhenqing yu Liu Gongquan." *Shupu* 16:54–59.

Perspectives on the T'ang. Edited by Arthur F. Wright and Denis Twitchett. New Haven: Yale University Press, 1973.

Pulleyblank, Edwin. "The An Lu-shan Rebellion and the Origins of Chronic Militarism in Late T'ang China." In *Essays on T'ang Society,* ed. John Curtis Perry and Bardwell C. Smith. Leiden: Brill, 1976.

———. "Neo-Confucianism and Neo-Legalism in T'ang Intellectual Life, 755–805." In *The Confucian Persuasion,* ed. Arthur F. Wright. Stanford: Stanford University Press, 1960.

Rong Geng. *Cong tie mu.* 4 vols. Hong Kong: Zhonghua shuju, 1980–1986.

Saian hirin. Edited by Nishikawa Yasashi. Tokyo: Kodansha, 1966.

Schafer, Edward H. *Mirages on the Sea of Time: The Taoist Poetry of Ts'ao T'ang.* Berkeley: University of California Press, 1985.

———. "The Restoration of the Shrine of Wei Hua-ts'un at Lin-ch'uan in the Eighth Century." *Journal of Oriental Studies* 15 (2) (1977):124–137.

Schipper, Kristopher. *L'Empereur Wou des Han dans la Légende Taoiste.* Paris: École Française d'Extrême-Orient, 1965.

Sha Menghai. "Yan Zhenqing xingshu Cai Mingyuan, Liu Taichong liang tie." *Yiyuan duoying* 18 (1982):33–35.

Shaanxi lidai beishi xuanji. Xi'an: Shaanxi renmin chubanshe, 1979.

Shi Anchang. "Guanyu 'Ganlu zishu' ji qi keben." *Gugong bowuyuan yuankan* 1 (1980):68–73.

———. *Tangdai shike zhuanwen.* Beijing: Zijincheng chubanshe, 1987.

———. *Yan Zhenqing shu Ganlu zishu.* Beijing: Zijincheng chubanshe, 1990.

Shodō geijutsu. 24 vols. Tokyo: Chūō kōron, 1971–1973.

Shodō zenshū. 27 vols. Tokyo: Heibonsha, 1930–1932.

——. 3rd ed. 26 vols. Tokyo: Heibonsha, 1966–1969.

Shoseki meihin sōkan. 208 vols. Tokyo: Nigensha, 1958–1981.

Shui Laiyou. *Cai Xiang shufa shiliao ji.* Shanghai: Shanghai shuhua chubanshe, 1983.

Song ta Tan tie. Chengdu: Sichuan cishu chubanshe, 1994.

Song taben Yan Zhenqing shu Zhongyitang tie. 2 vols. Hangzhou: Xiling yinshe chubanshe, 1994.

Strickman, Michel. "The Longest Taoist Scripture." *History of Religions* 17(3–4) (1978):331–354.

——. "The Mao Shan Revelations, Taoism and the Aristocracy." *T'oung Pao* 63 (1977):1–64.

——. *Le taoisme du Mao Chan, Chronique d'un Révélation.* Paris: Collège de France, 1981.

Su Shaoxing. *Liang Jin Nan Chao de shi zu.* Taipei: Lianjing, 1987.

Sun Kekuan. *Song Yuan daojiao zhi fazhan.* Taizhong: Donghai daxue, 1965.

A Sung Bibliography. Edited by Yves Hervouet. Hong Kong: Chinese University Press, 1978.

Sung Biographies. Edited by Herbert Franke. Wiesbaden: Franz Steiner, 1976.

Ta Tao. "Luo Zhenyu suocang Yan Zhenqing moji sizhong." *Shupu* 43:46–49.

Tang Huaisu san tie. Xi'an: Shaanxi renmin chubanshe, 1982.

Tangdai caoshujia. Edited by Zhou Ti. Beijing: Beijing Yanshan chubanshe, 1989.

Teng Ssu-yu, trans. *Family Instructions for the Yen Clan.* Leiden: Brill, 1968.

Wang Zhuanghong. *Tiexue juyao.* Shanghai: Shanghai shu hua chubanshe, 1987.

Watson, Burton. *The Complete Works of Chuang Tzu.* New York: Columbia University Press, 1968.

——. *Courtier and Commoner in Ancient China.* New York: Columbia University Press, 1974.

Wei Yazhen. "Yan Zhenqing huo Zhang Xu bichuan bifa." *Shupu* 2:23–25.

Weinstein, Stanley. *Buddhism Under the T'ang.* Cambridge: Cambridge University Press, 1987.

Wen Yan. "Yan Zhenqing de 'Zhengzuowei tie.' " *Shupu* 17:34–46.

Xiong Bingming. "Yi 'Zhang Xu caoshu sitie' shi yi linben." *Shupu* 44:18–25.

Xu Bangda. "Gu fashu jiankao xuanyao: Tang Yan Zhenqing shu 'Ji ji Jiming wengao.' " *Shupu* 31:68–69.

——. "Gu fashu jiankao xuanyao: Tang Yan Zhenqing shu 'Yingzhou tie' ji 'Liu Zhongshi tie.' " *Shupu* 30:74–75.

——. *Gu shu hua guoyan yaolu: Jin, Sui, Tang, Wudai, Song shufa.* Changsha: Hunan meishu chubanshe, 1987.

——. *Gu shu hua wei'e kaobian.* 4 vols. Nanjing: Jiangsu guji chubanshe, 1984.

Xu Wuwen. " 'Yan Zhenqing shu Zhushan lianju' bianwei." *Wenwu* 6 (1981):82–86.

"Yan Zhenqing beitie xulu." *Gugong wenwu yuekan* 17 (1984):23–37.

Yan Zhenqing shu fang sheng chi bei. 2 vols. Hangzhou: Xiling yinshe, 1983.

Yan Zhenqing shu yu Cai Mingyuan shu, song Liu Taichong xu. Hangzhou: Xiling yinshe, 1982.

Yan Zhenqing xing shu zi tie. Hangzhou: Xiling yinshe, 1986.

Yang Dianxun. *Shike tiba suoyin.* Shanghai: Commercial Press, 1941.

Yang Dunli. "Yan Zhenqing de fashu yu beitie." *Gugong wenwu yuekan* 17 (1984): 13–22.

Yang, Lien-sheng. "The Organization of Official Historiography: Principles and Methods of the Standard Histories from the T'ang through the Ming Dynasty." In *Historians of China and Japan,* ed. W. G. Beasley and E. G. Pulleyblank. London: Oxford University Press, 1961.

Yang Zhenfang. *Beitie xulu*. Chengdu: Sichuan wenyi chubanshe, 1982.

Yilin conglu. 10 vols. Hong Kong: Shangwu yinshuguan, 1961–1974.

Yu Shaosong. *Shuhua shulu jieti*. Reprint. Taipei: Zhonghua shuju, 1980.

Yuancang beitie tezhan mulu. Taipei: National Palace Museum, 1982.

Zhang Xu fashu ji. Shanghai: Shanghai shuhua chubanshe, 1992.

Zhongguo lidai fashu moji daguan. Edited by Xie Zhiliu. Shanghai: Shanghai shu-dian, 1987–.

Zhongguo meishu quanji: Shufa zhuanke bian. 6 vols. Beijing: Renmin meishu chu-banshe, 1986–1989.

Zhongguo shufa: Yan Zhenqing. Edited by Ma Ziyun and Wang Jingfen. 5 vols. Bei-jing: Wenwu chubanshe, 1981–1985.

Zhongguo shufa quanji. Vols. 25–26: *Sui Tang Wudai bian, Yan Zhenqing 1–2*, ed. Zhu Guantian. Beijing: Rongbaozhai, 1993.

Zhu Guantian. "Zhejiang bowuguan cang Song ta Yan Zhenqing 'Zhongyitang tie.' " *Shupu* 43:18–24.

Zhu Jianxin. *Jinshixue*. Reprint. Beijing: Wenwu chubanshe, 1981.

Index

About the Author

Amy McNair received her doctorate from the University of Chicago. She is currently assistant professor of Chinese art at the University of Kansas.